11.95
/9.56

ANATOMY
A COMPLETE GUIDE FOR ARTISTS

JOSEPH SHEPPARD

Dover Publications, Inc., New York

Copyright © 1975 by Watson-Guptill Publications.
All rights reserved under Pan American and International Copyright Conventions.

Published in Canada by General Publishing Company, Ltd., 30 Lesmill Road, Don Mills, Toronto, Ontario.
Published in the United Kingdom by Constable and Company, Ltd., 3 The Lanchesters, 162–164 Fulham Palace Road, London W6 9ER.

This Dover edition, first published in 1992, is an unabridged, slightly corrected republication of the work originally published by Watson-Guptill Publications, New York, in 1975.

Manufactured in the United States of America
Dover Publications, Inc., 31 East 2nd Street, Mineola, N.Y. 11501

Library of Congress Cataloging-in-Publication Data

Sheppard, Joseph, 1930–
 Anatomy : a complete guide for artists / Joseph Sheppard.
 p. cm.
 This Dover ed., first published in 1992, is an unabridged, slightly corrected, republication of the work originally published: New York : Watson–Guptill Publications, 1975.
 ISBN 0-486-27279-6
 1. Anatomy, Artistic. I. Title.
NC760.S53 1992
743′.49—dc20
 92-20645
 CIP

This Book Is Dedicated to Rita

CONTENTS

INTRODUCTION

I first started drawing bad copies of Vargas and Petty girls from men's magazines when I was twelve years old. I started art school at eighteen and happily discovered that the great periods of painting and sculpture, from the Greeks to the Baroque, used the figure as the main means of expression.

I studied at the Maryland Institute under Jacques Maroger, who not only taught painting but anatomy. Maroger stressed drawing through learning basic anatomical forms. He believed that the master draftsmen of the Renaissance had simple formulas for creating the figure, which explains the enormous amount of information many acquired while still young. Maroger used the then-out-of-print Paul Richer anatomy charts in his lectures. I found myself spending nights at the Enoch Pratt Library tracing all 110 plates from that rare book. (This book has recently been reissued by Watson-Guptill in an English translation by Robert Beverly Hale under the title *Artistic Anatomy.*)

Reginald Marsh, Maroger's close friend, would visit our class in Baltimore from time to time and was a great inspiration to the students. He would sit down in class and work beside us. Marsh was the great figure draftsman of our time and would delight in showing us simple little schemes of numbers and shapes that when put together would represent muscles and bones.

Marsh made me realize how much I didn't know about the figure. I was embarrassed to put figures in my first paintings because I drew so poorly. I told him that as soon as I learned how to draw the figure properly I was going to fill my canvases with them. He said, "Put them in anyway. You have to paint bad ones and make mistakes in order to improve. If you wait until you're good enough you'll never paint the figure." Since that time, there is hardly a canvas that I paint that doesn't have the human form represented on it.

In 1957, I went to Europe on a Guggenheim Fellowship, planning to paint and copy every Rubens painting I could find. Instead I found myself drawing from Greek and Renaissance statues. Here, all the anatomy was worked out, explained, and in the round. All one had to do was add life to it.

Eventually I found myself back at the Maryland Institute, this time as a teacher, teaching painting and life drawing. In the life class, I discovered that I couldn't teach students how to draw from the live model if they didn't have any anatomical knowledge. I looked around for an anatomy book to use in class but found them all either too medical and technical or too "artistic," loosely drawn and vague. So I made up my own charts, xeroxed them, and would inject an anatomy lesson into my life class each day.

My charts, after several years of trying, testing, and changing, finally developed into this book. It is not a medical book, but a book for artists. Because of the many variations in bone and muscle, I have chosen what I think is the simplest form for the artist to understand. I have taken liberties for the sake of clarity, omitting many of the underlying muscles and substituting the English equivalent for much of the Latin terminology.

As there are two legs, two arms, two feet, etc., I have chosen to show only the right side. That is, the right leg, the right foot, and so on. The torso and head are shown in their entirety.

The information in this book is accumulative knowledge from years of studying drawing, painting and sculpture of the great periods of art: I thank Jacques Maroger, Reginald Marsh, Michelangelo, Peter Paul Rubens, and all those other "Old Masters" for whatever knowledge I pass on to you.

Note for the Reader

The arbitrary division of the body into separate parts may make for the most efficient way of studying it, but it can also be somewhat misleading. For example, many of the arm muscles extend into the hand muscles, many of the leg muscles extend into the foot muscles, and the muscles of the neck and head are similarly interconnected. Therefore, because it is necessary to know where the muscles originate and insert in order to understand them, and the only way muscle origin and insertion can be explained is in terms of the bones, I have included the bones of the hand in the chapter on the arm, the bones of the foot in the chapter on the leg, and have combined the neck and the head in a single chapter. After the bones are studied as a unit, the muscles can be studied separately, in their natural sequence.

1.PROPORTION

Proportion varies as much as people do. However, the classical figure, Greek and Renaissance, was an eight-heads-length figure, the head being used as the unit of measure. Mannerist artists created an elongated figure, using nine, ten, or more head lengths. In nature, the average figure height is between seven and eight heads.

The eight-heads-length figure seems by far the best; it gives dignity to the figure and also seems to be the most convenient.

Landmarks

Certain bones project on the surface of the body, becoming important landmarks for the artist. These bones are always next to the skin. On a thin person they protrude and on a heavy person they show as dimples.

Key

A. Sternal notch
B. End of clavicle and scapula
C. Bottom end of sternum
D. Inside of elbow (humerus)
E. Ridge of pelvis
F. Pubis bone
G. Thumb side of wrist (radius)
H. Little finger side of wrist (ulna)
 I. Inside of upper part of knee (femur)
J. Inside of lower part of knee (tibia)
K. Kneecap (patella)
L. Head of fibula
M. Outside of ankle (fibula)
N. Inside of ankle (tibia)
O. Shinbone (tibia)
P. Nipples
Q. Navel
R. Hipbone (femur)
S. Seventh cervical vertebra
T. Bottom of scapula
U. Dimples caused by end of iliac spine
V. Back of elbow (ulna head)
W. Head of radius

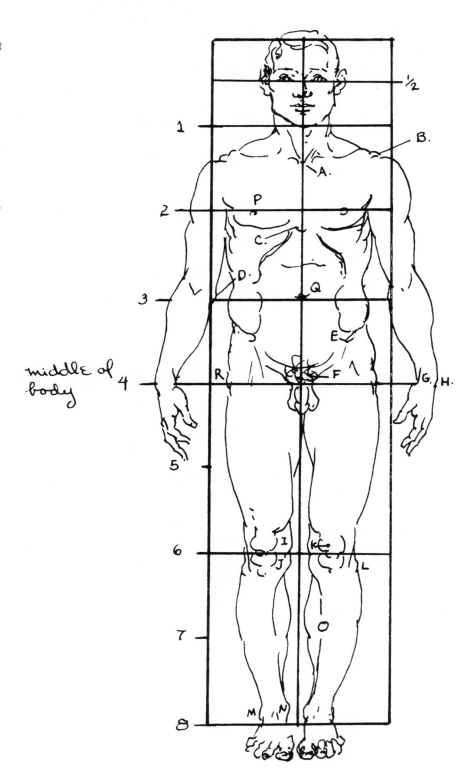

Front view, male figure, eight heads high.

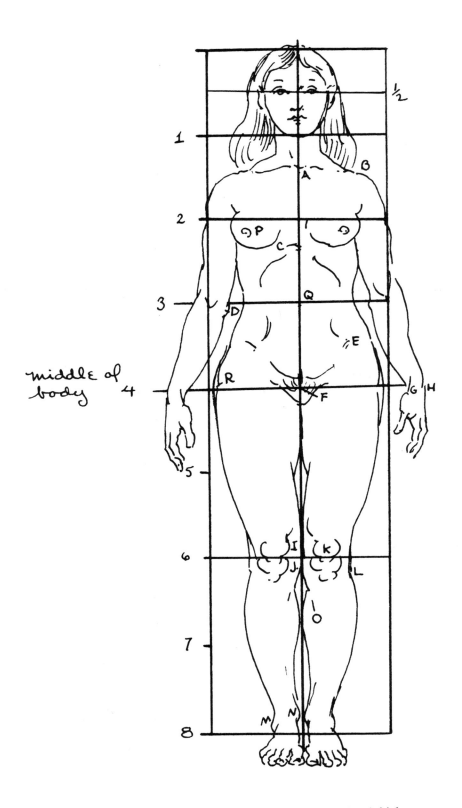

Front view, female figure, eight heads high.

For key to figures see page 12.

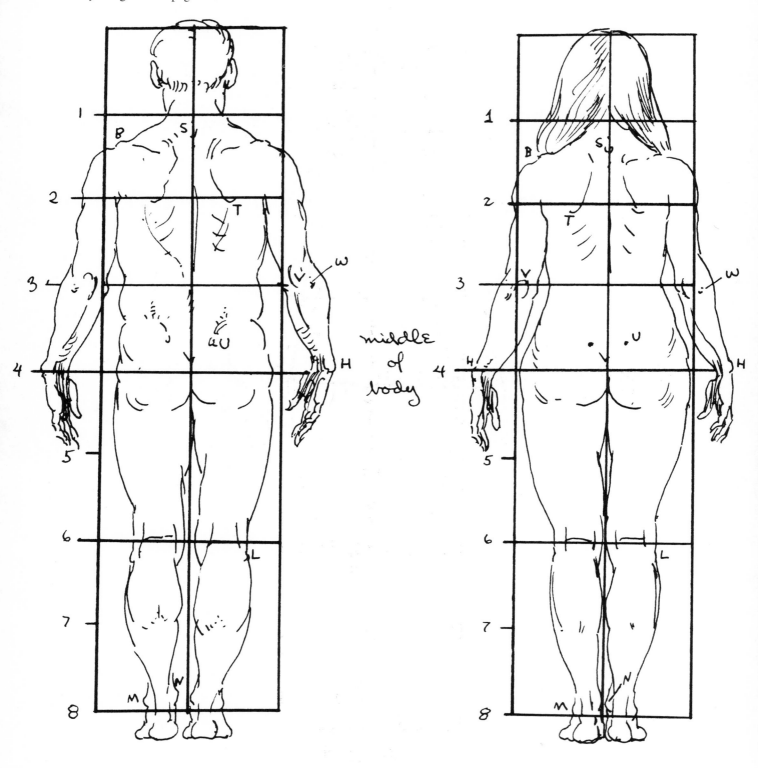

Back view, male figure, eight heads high.

Back view, female figure, eight heads high.

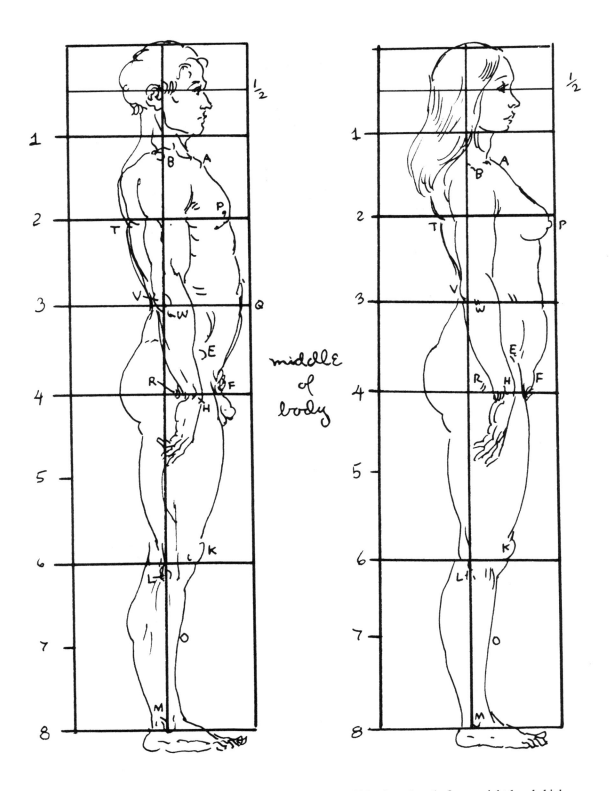

Side view, male figure, eight heads high. Side view, female figure, eight heads high.

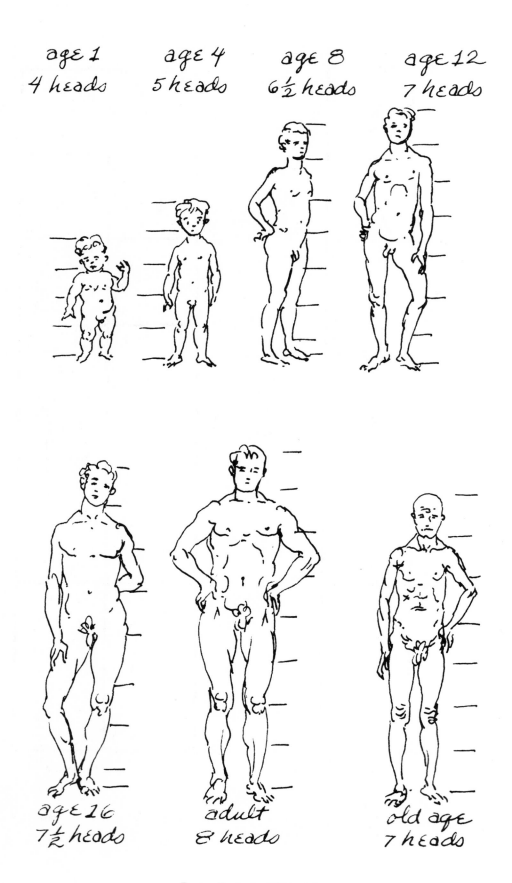

age 1
4 heads

age 4
5 heads

age 8
6½ heads

age 12
7 heads

age 16
7½ heads

adult
8 heads

old age
7 heads

Proportions at various ages.

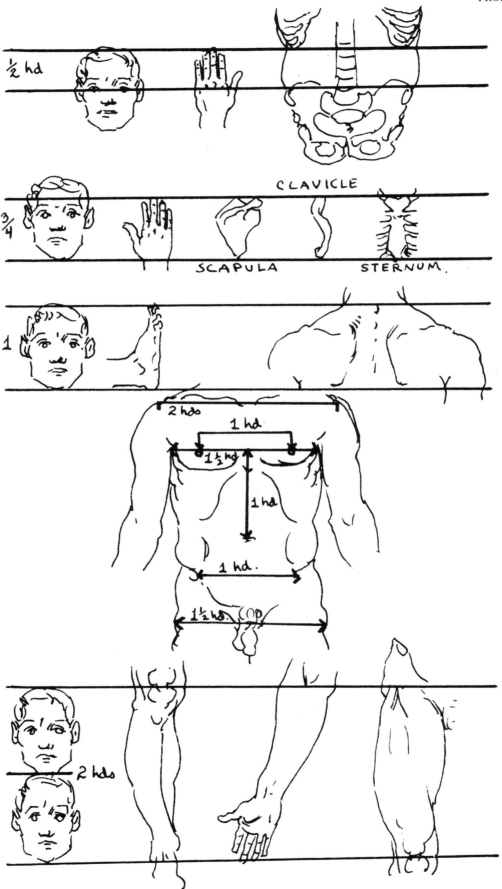

½ hd

¾

1

CLAVICLE

SCAPULA

STERNUM.

2 hds

1 hd

1½ hd

1 hd

1 hd.

1½ hd.

2 hds

Convenient measurements.

2. THE ARM

SCHEMATIC DRAWINGS

**Front View of Arm,
Palm Out (Supination)**

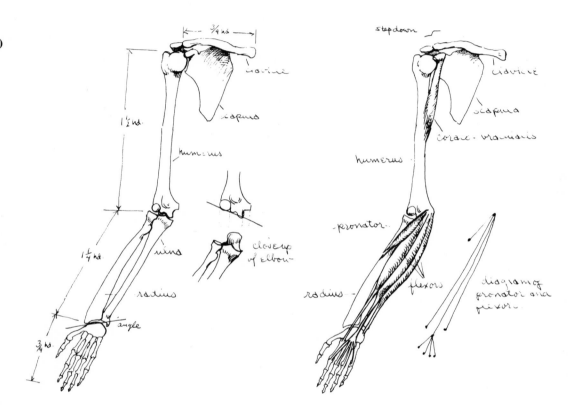

The shoulder socket is made up of two bones: the *clavicle* (collarbone) in front and the *scapula* (shoulder bone) in back. The upper arm has one bone: the *humerus*. Half its dual head is shaped like a rectangle and half like a ball, fitting into the shoulder socket. At the elbow, the humerus is divided into three equal sections: the first section is shaped like a ball; the second section is shaped like a spool and forms an angle downward toward the torso; the third section protrudes and can be seen and felt on the inside of the elbow. The forearm has two bones: the *radius* and the *ulna*. The radius is on the outside of the elbow and on the thumb side of the wrist. It is smaller at the elbow and larger at the wrist. The head of the radius is round and flat and rotates on the small ball of the humerus. The head of the ulna rises up behind the humerus and rides on the spool of the humerus.

There is a slight drop, or stepdown, where the clavicle meets the scapula. The muscle that attaches from the scapula to the inside of the humerus is called the *coracobrachialis*. It raises the arm. The small muscle attached to the inside of the humerus at the elbow is a *pronator* and turns the radius so that the palm of the hand faces in. The other three muscles are *flexors* of the wrist and fingers.

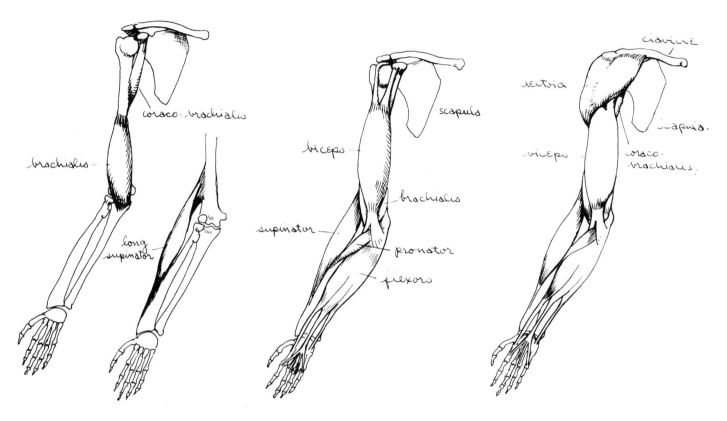

The muscle attached to the lower front of the humerus and the ulna is called the *brachialis*. It flexes the forearm. The *long supinator* attaches to the outside of the humerus and along the edge of the radius near the thumb. It pulls the radius to the supinated position (palm out). The long supinator and the pronator of the radius turn the forearm in opposite directions (see next drawing).

The largest muscle on the front of the arm is the *biceps*. It has two heads that attach to the scapula. At its base, the biceps also splits in two. The primary function of the biceps is to flex the forearm. It also helps rotate the radius outward.

Attached to the external third of the clavicle and to the scapula is the *deltoid*. It overlaps the biceps and coracobrachialis and inserts into the outside of the humerus. The deltoid elevates the arm and helps draw it forward and backward.

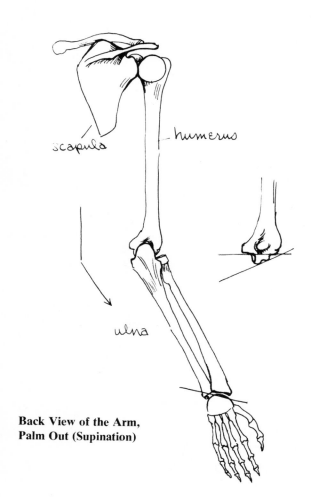

**Back View of the Arm,
Palm Out (Supination)**

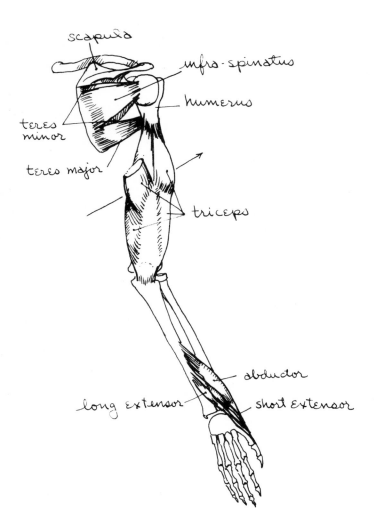

The ball of the humerus fits into the shoulder socket of the scapula. Note that the angle of the forearm away from torso is in a supinated position. This angle is caused by the angle of the spool on the end of the humerus (see detail at right). The hook of the ulna fits up into the back of the humerus. Note the angle at wrist.

On the back of the scapula are two overlapping muscles that attach to the head of the humerus. They are called the *infraspinatus* and *teres minor*. They help rotate the arm and pull it in toward the body. On the lower part of the back of the scapula is a muscle that inserts in front of the humerus and helps rotate the arm inward. It is called the *teres major*. The large muscle attached to the humerus and the hook part of the ulna is called the *triceps*. It has three heads. The long head is shown cut so that the underlying inner head can be seen. The external head is the highest, forming an angle on the back of the arm. There are three muscles that arise from the ulna and radius and insert into the thumb: the muscle that attaches highest is the *abductor of the thumb,* which draws the thumb toward the back of the hand—its tendon is noticeable in this action; the other two muscles are the *short* and *long extensors of the thumb.*

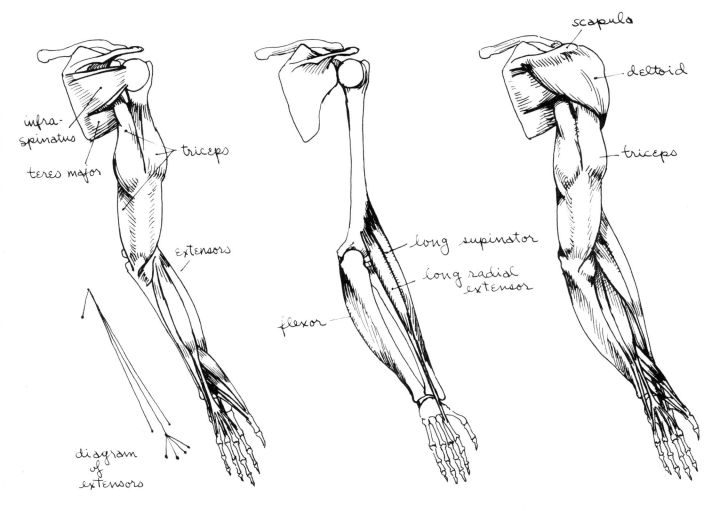

infra-
spinatus

teres major

triceps

extensors

diagram
of
extensors

scapula

deltoid

triceps

long supinator

long radial
extensor

flexor

The long head of the triceps passes between the infraspinatus and teres major muscles and attaches to the edge of the scapula. The triceps is the large extensor of the forearm. The one short and three long muscles originating on the external side of the humerus at the elbow are all extensors of the forearm, wrist, and fingers. The diagram of extensors for the back of the arm is the same as the extensors for the front of the arm.

The shape of the inside of the forearm is made by the *flexor* muscle from the front of the arm. High on the outside of the arm is the *long supinator*. Just below it is the *long radial extensor* of the wrist.

The *deltoid* is attached to the entire extent of the spine of the scapula and overlaps the muscles of the scapula and the triceps, where it inserts into the outside of the humerus.

Front View of the Arm,
Palm In (Pronation)

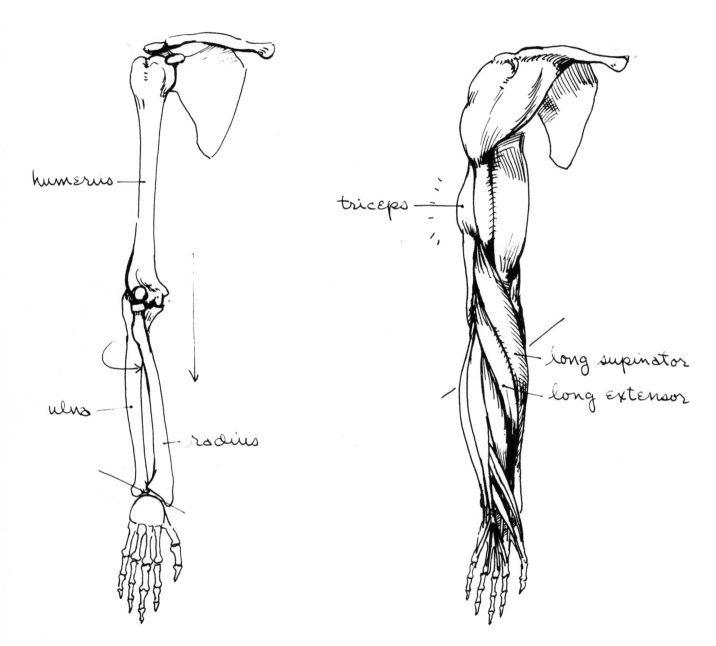

humerus

ulna

radius

triceps

long supinator
long extensor

The radius turns the palm in and crosses over the ulna at the wrist. The hook of the ulna is forced to the outside at the elbow, and the humerus turns slightly. The angle of of the wrist changes. The whole arm is straight in this position, as compared with the angle created in supination.

The external head of the triceps becomes prominent. The mass of muscle of the long supinator and long extensor of the wrist crosses over, with the thumb making the inside silhouette of the forearm higher than the outside.

**Back View of the Arm,
Palm In (Pronation)**

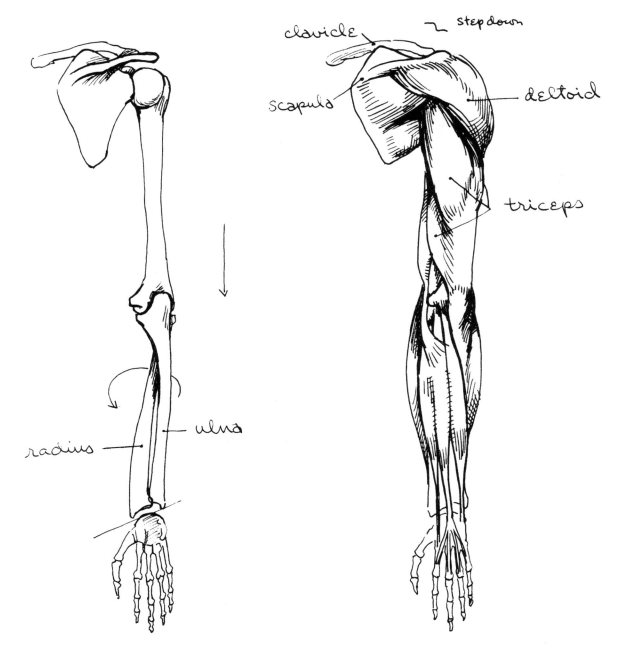

The hook of the ulna is on the outside of the elbow. The radius has crossed over the front of the ulna, creating a reverse angle at the wrist. The whole arm is straight.

The deltoid and long head of the triceps are stretched. Note stepdown from clavicle to scapula.

**Inside of the Arm,
Supinated**

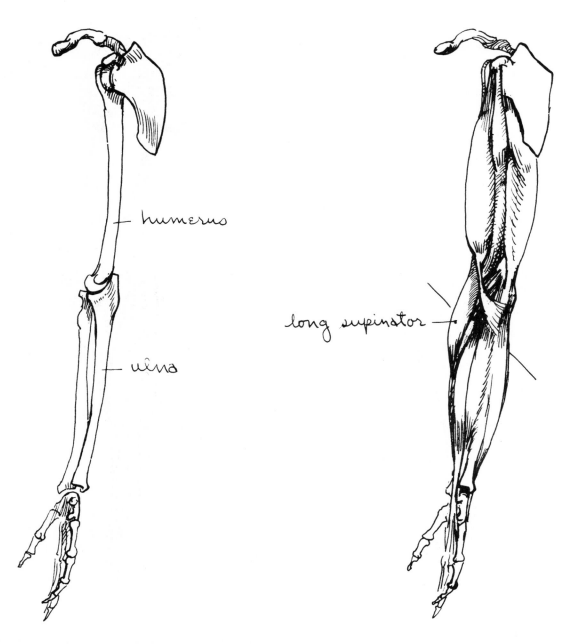

humerus

ulna

long supinator

The hook of the ulna riding on the spool of the humerus is clearly seen in this drawing. Even though the ulna is the shorter bone, it is very prominent at the wrist and can be easily seen and felt.

The long supinator forms a high angle on the top exterior side of the forearm. The muscles in the upper part of the arm are relaxed in this position.

**Inside of the Arm,
Pronated**

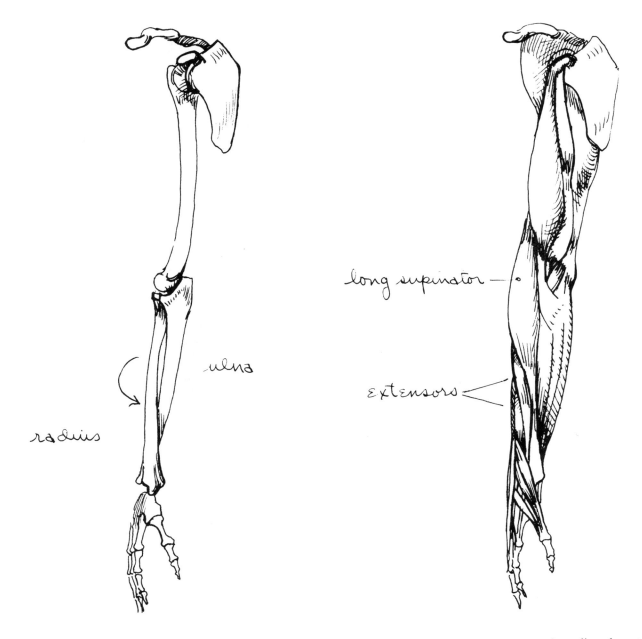

When palm is in pronation, the radius crosses over the ulna and brings the thumb to the inside.

The long supinator crosses over the radius; the extensors of the wrist and fingers follow.

**Outside of the Arm,
Supinated**

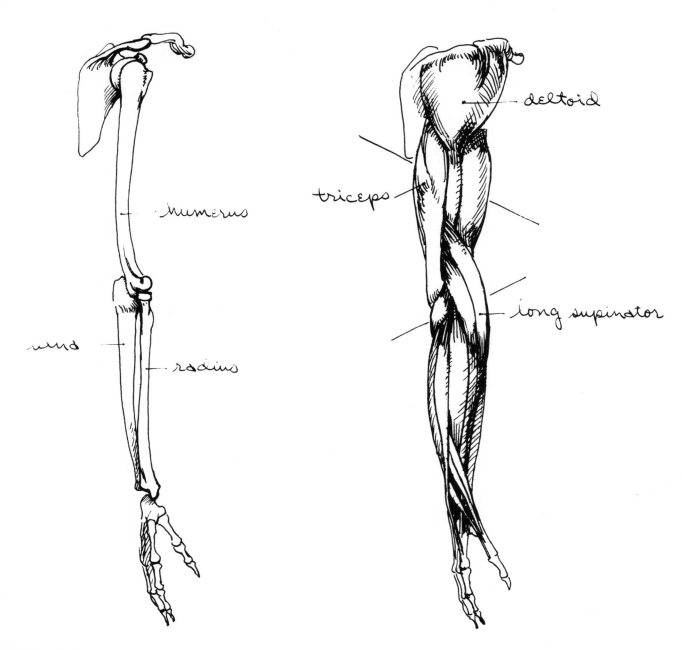

The ball of the humerus fits into the shoulder socket. The head of the radius sitting on the small ball of the humerus can be easily seen from this view. The hook of the ulna sitting behind the radius rides on the spool of the humerus. The radius at the wrist overlaps the wrist and is on the thumb side.

The deltoid inserts into the external side of the humerus about midway down. The triceps is higher in the back than the biceps in the front, forming an angle. The long supinator attaches into the humerus just a few inches below the deltoid, forming a reverse angle at the forearm.

**Outside of the Arm,
Pronated**

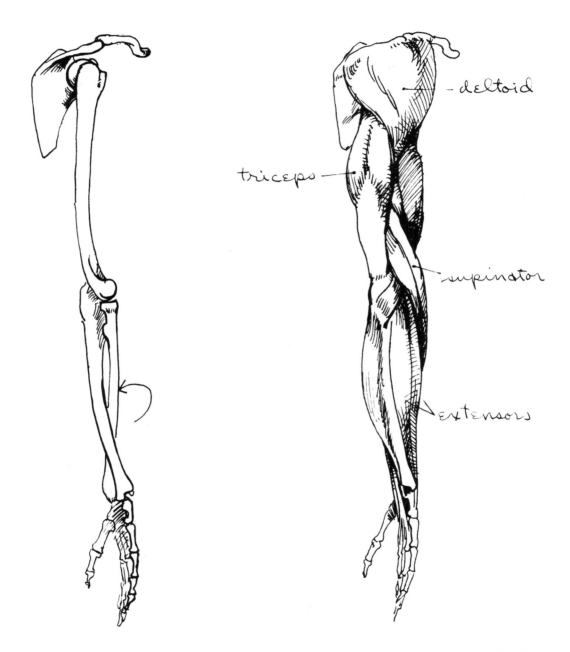

The radius crosses over the ulna at the wrist, leaving the ulna prominent on the outside. The radius rotates in on the small ball of the humerus.

The front part of the deltoid hardens as it helps rotate the arm. The external head of the triceps swells in this position. Supinator and extensors follow the radius.

Front View, Arm Raised Away from Body

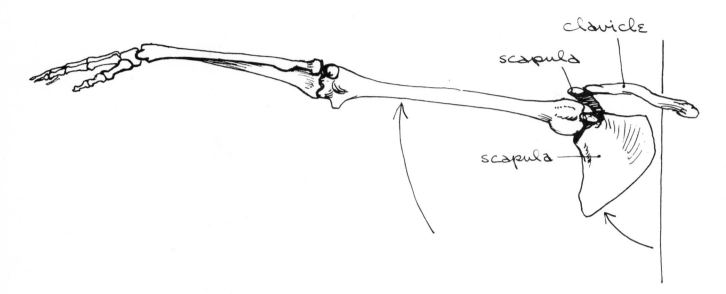

When the arm is raised, the scapula and clavicle follow with it.

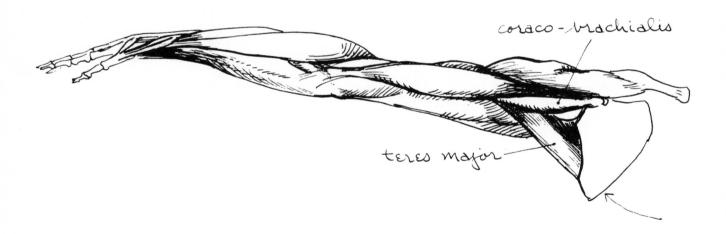

The teres major muscle stretches. The coracobrachialis becomes prominent as it elevates the arm.

Back View, Arm Raised Away from Body

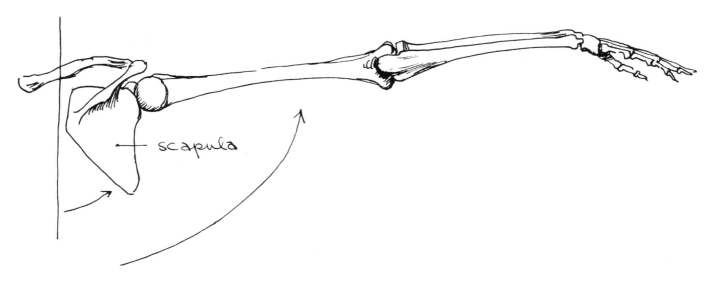

scapula

The scapula raises with the arm.

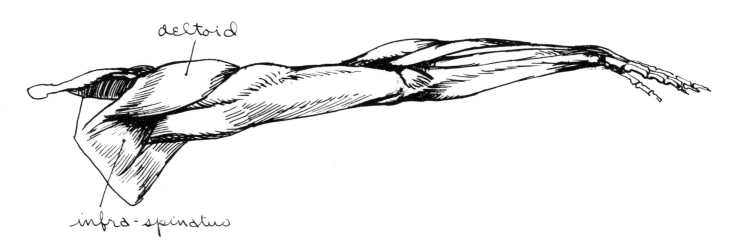

deltoid

infra-spinatus

The infraspinatus flexes as it helps raise the arm. The deltoid also helps elevate the arm.

**Outside View,
Biceps Flexed**

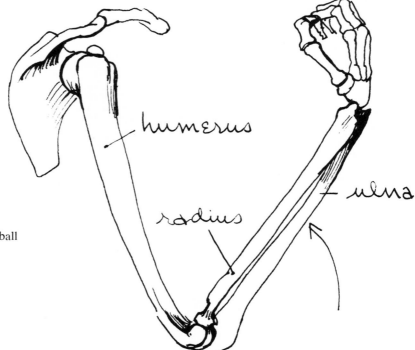

The radius and the ulna ride on the ball
and spool of the humerus.

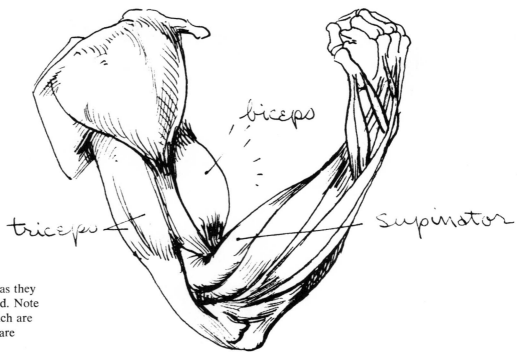

The biceps and supinator swell as they
flex. The triceps remains relaxed. Note
that the bones of the elbow, which are
not covered with muscle bulk, are
prominent.

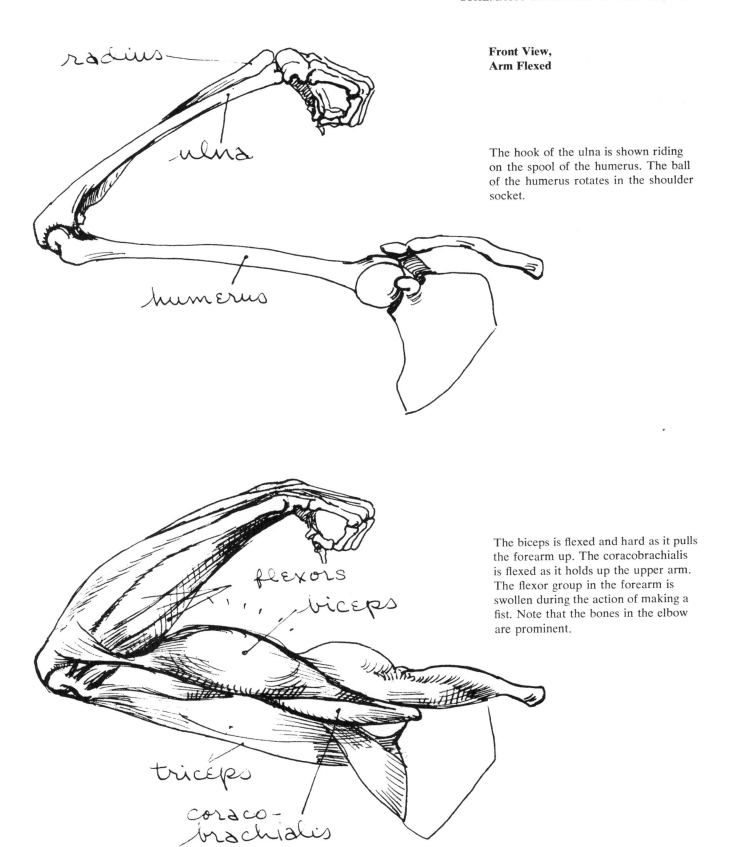

**Front View,
Arm Flexed**

The hook of the ulna is shown riding on the spool of the humerus. The ball of the humerus rotates in the shoulder socket.

The biceps is flexed and hard as it pulls the forearm up. The coracobrachialis is flexed as it holds up the upper arm. The flexor group in the forearm is swollen during the action of making a fist. Note that the bones in the elbow are prominent.

BONES

Shoulder Socket

The shoulder socket is made up of two bones: the *clavicle* in front and the *scapula* in back.

Key

Parts of the Clavicle

a. Shaft
b. Sternal end
c. Acromion end

Parts of the Scapula

1. Glenoid fossa (for head of humerus)
2. Spine
3. Acromion process
4. Coracoid process
5. Superior angle
6. Inferior angle
7. Exterior border
8. Internal border
9. Superior border
10. Surface for clavicle attachment
11. Supraspinous fossa
12. Infraspinous fossa
13. Anterior surface
14. Glenoid cavity

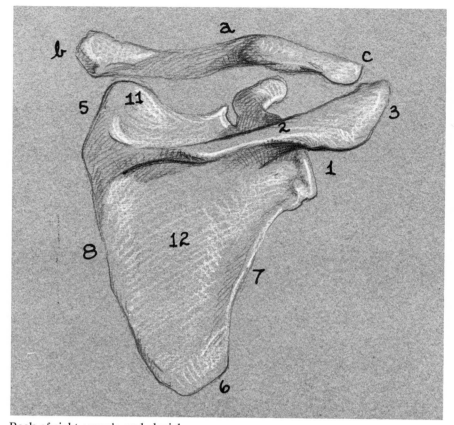

Back of right scapula and clavicle.

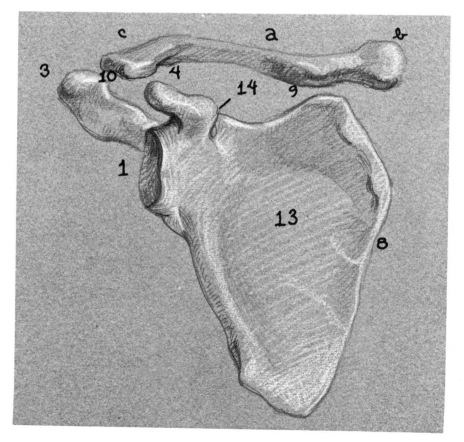

Front of right scapula and clavicle.
Back and front views of scapula
are in the shape of a holster and gun.

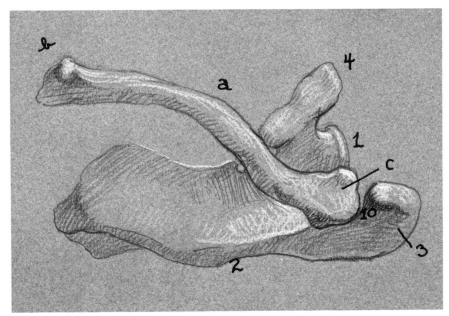

Top view. Clavicle is in the shape of italic *S*.

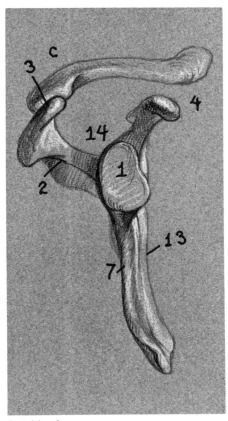

Outside view.

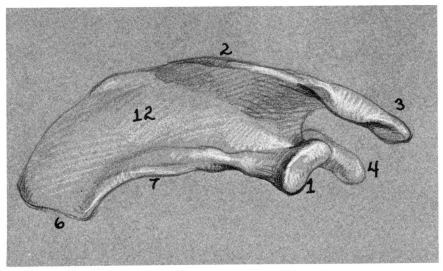

Bottom view.

Upper Arm (Humerus)

Key

1. Head
2. Greater tuberosity
3. Lesser tuberosity
4. Bicipital groove
5. Deltoid impression
6. Internal condyle
7. External condyle
8. Capitulum for articulation with radius
9. Trochlear surface for articulation with ulna
10. External condyle ridge
11. Internal condyle ridge
12. Coronoid depression
13. Olecranon depression

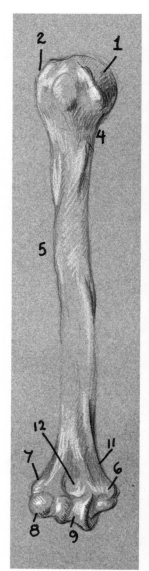

Front view.

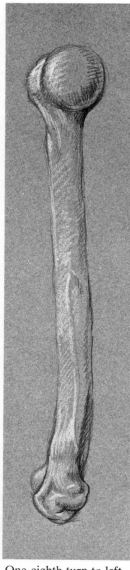

One-eighth turn to left.

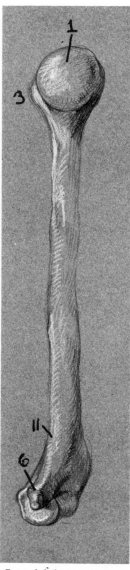

One-eighth turn more, inside view.

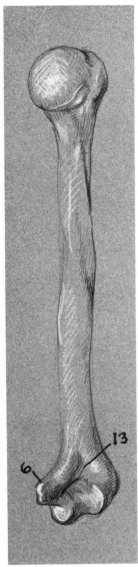

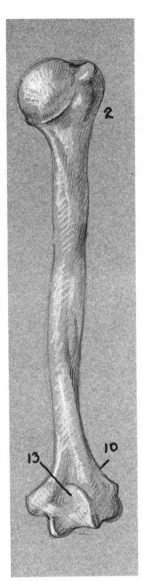

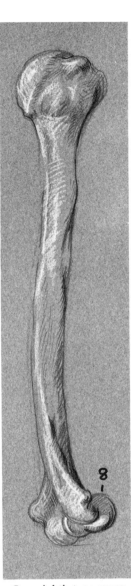

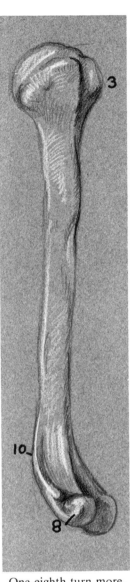

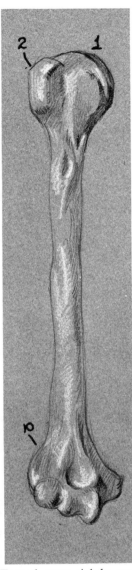

One-eighth turn more.

One-eighth turn more,
back view.

One-eighth turn more.

One-eighth turn more,
outside view.

Turned seven-eighths away
to the left.

Upper Arm (Humerus)

Key

1. Head
2. Greater tuberosity
3. Lesser tuberosity
4. Bicipital groove
5. Deltoid impression
6. Internal condyle
7. External condyle
8. Capitulum for articulation with radius
9. Trochlear surface for articulation with ulna
10. External condyle ridge
11. Internal condyle ridge
12. Coronoid depression
13. Olecranon depression

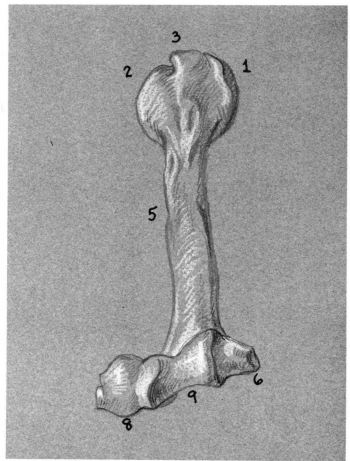

Head turned away, foreshortened view.

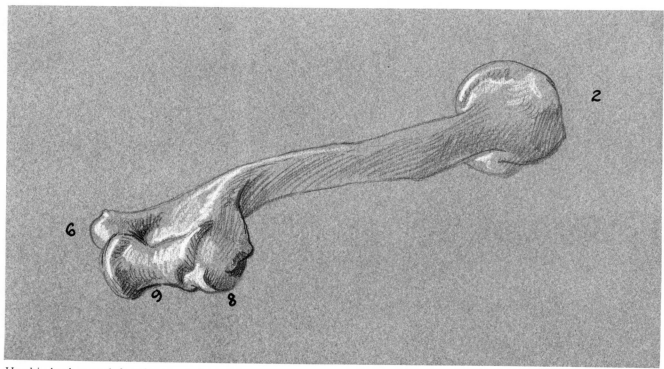

Head in background, foreshortened view.

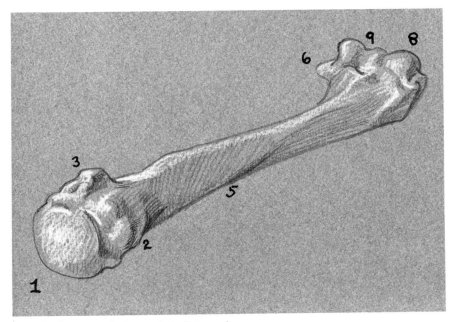

Head in foreground, front of shaft turned up.

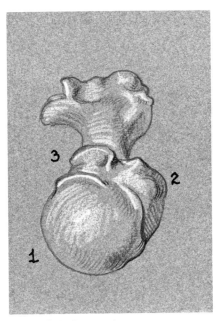

Front of shaft turned up,
extremely foreshortened.

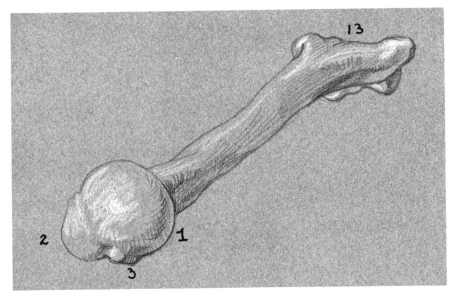

Head in foreground, front of shaft turned down.

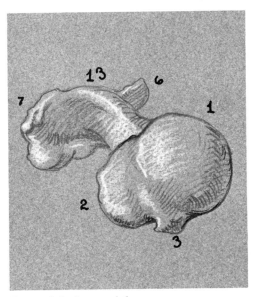

Front of shaft turned down,
extremely foreshortened.

Shoulder Joint

Key

1. Clavicle

 a. Sternal end
 b. Acromion end

2. Scapula

 c. Acromion process
 d. Coracoid process
 e. Glenoid fossa

3. Humerus
4. Ribcage

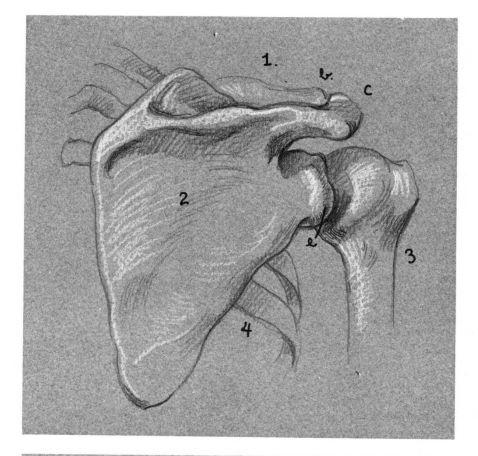

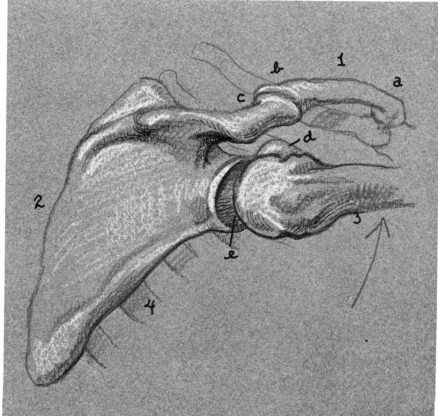

(Above) Back view of scapula with humerus in relaxed position. Head of humerus fits into shoulder socket.

Outside view of socket with humerus raised forward. Scapula follows humerus.

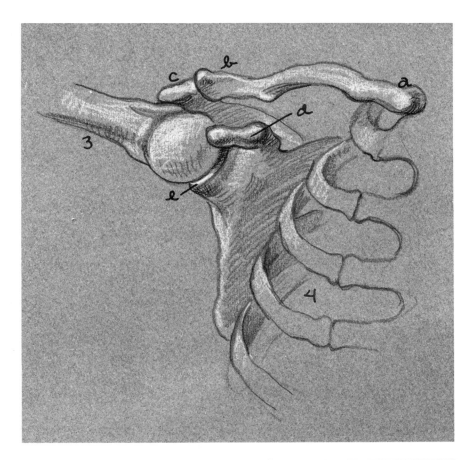

Front view of socket with humerus extended out and away from ribcage. Scapula follows humerus and clavicle raises.

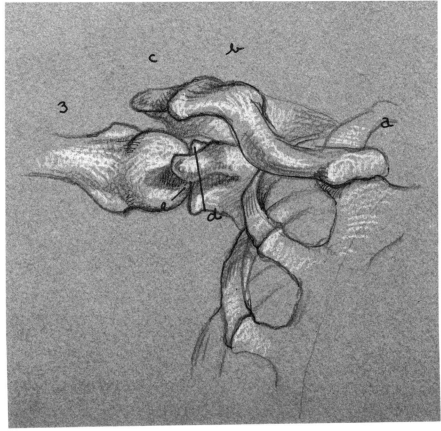

Front view turned one-fourth to the left. Humerus extended out and away from ribcage.

Forearm (Radius and Ulna)

There are two bones in the forearm: the *radius* and the *ulna*. The radius is always on the outside of the elbow and the thumb side of the wrist. The upper end, at the elbow, is small; the lower end, at the wrist, is large. The ulna is on the inside of the elbow. And, conversely, its upper end is large and its lower end is small.

Key

1. Radius

 a. Head of radius
 b. Bicipital tuberosity
 c. Insertion of the pronator radii teres
 d. Expanded lower end of radius
 e. Styloid process of radius

2. Ulna

 f. Olecranon process
 g. Coronoid process
 h. Greater sigmoid notch
 i. Attachment of brachialis anticus
 j. Triangular subcutaneous surface
 k. Styloid process of ulna
 l. Crest of the posterior border
 m. Lower end of ulna

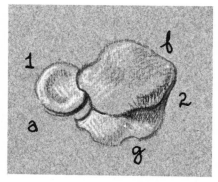

Radius and ulna seen from the top. The radius fits into the lesser sigmoid notch of ulna head.

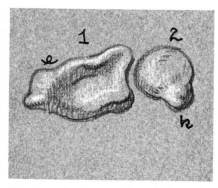

Radius and ulna seen from below. The lower end of the radius rides on the ulna.

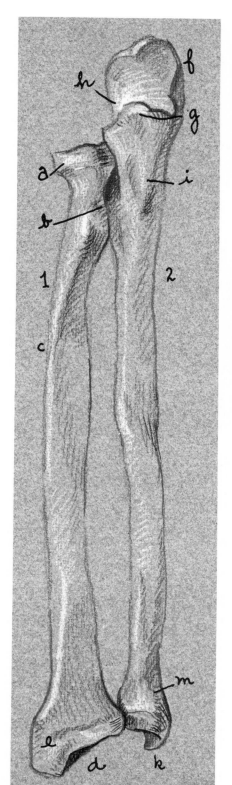

Front view, supinated. In this position, in which the forearm is held with the palm of the hand face up, the radius and ulna lie parallel to each other.

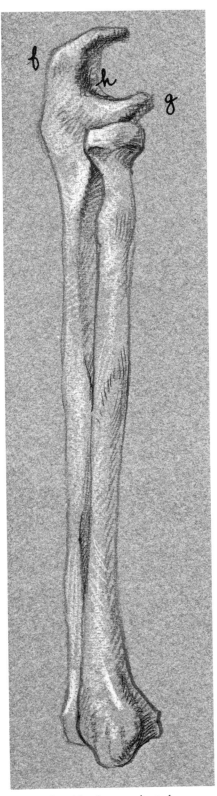

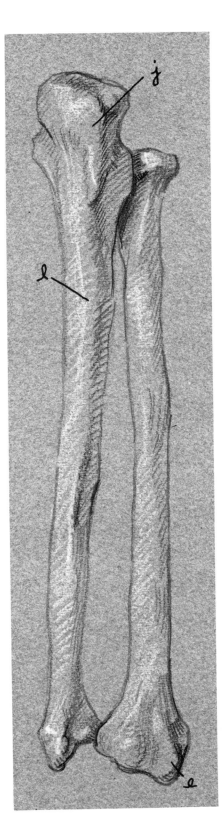

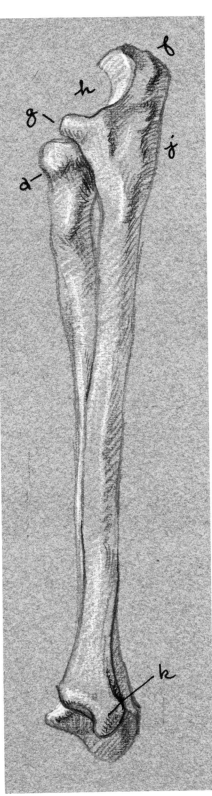

Outside view, supinated. Back view, supinated. Inside view, supinated.

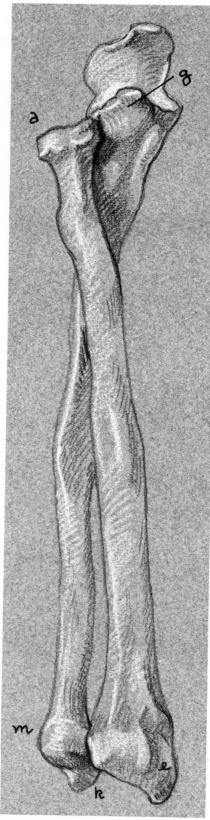

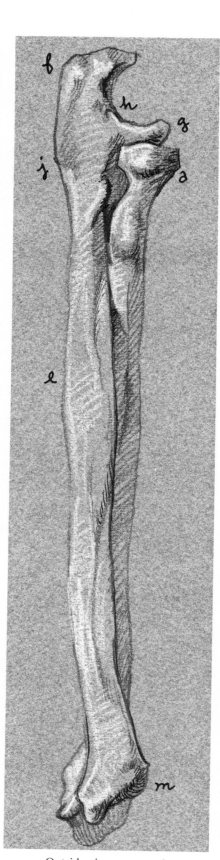

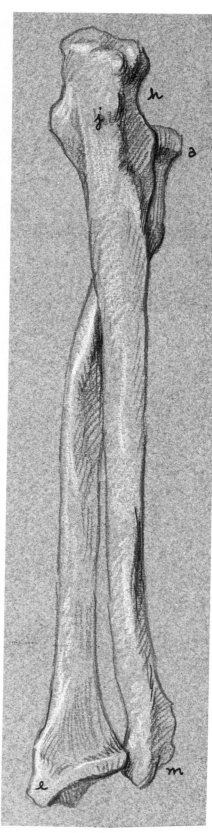

Front view, pronated. In this position, in which the palm of the hand is turned down, the outer bone (the radius) crosses obliquely over the ulna.

Outside view, pronated.

Back view, pronated.

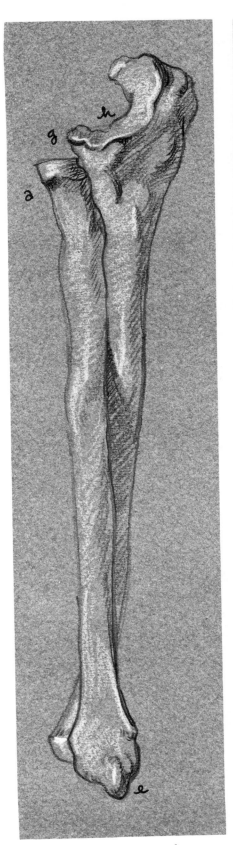

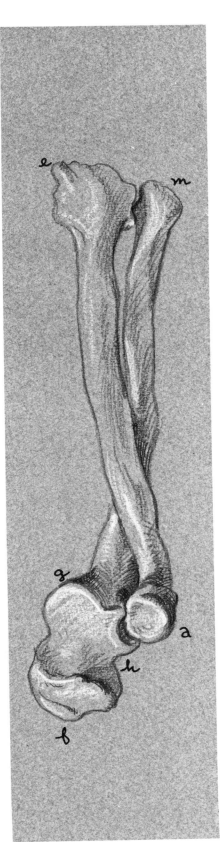

Forearm (Radius and Ulna)

Key

1. Radius

 a. Head of radius
 b. Bicipital tuberosity
 c. Insertion of the pronator radii teres
 d. Expanded lower end of radius
 e. Styloid process of radius

2. Ulna

 f. Olecranon process
 g. Coronoid process
 h. Greater sigmoid notch
 i. Attachment of brachialis anticus
 j. Triangular subcutaneous surface
 k. Styloid process of ulna
 l. Crest of the posterior border
 m. Lower end of ulna

Inside view, pronated.

Foreshortened view with elbow in foreground and forearm pronated.

Elbow Joint

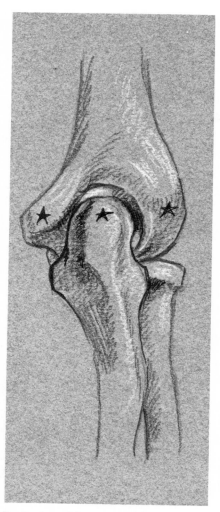

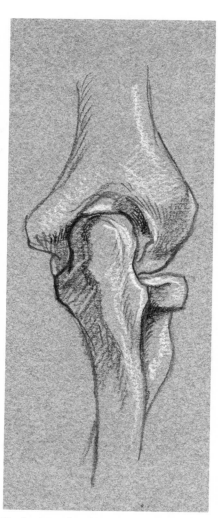

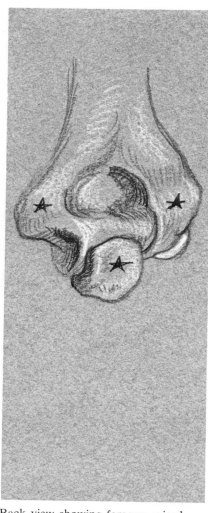

Back view of humerus and ulna with forearm supinated. The olecranon process of the ulna is locked in the olecranon depression of the humerus. The three prominent protruberances of the elbow are in a straight line (three stars).

Back view, showing radius crossed over in pronated position.

Back view showing forearm raised. Olecranon process of ulna drops down on spool of humerus. The three prominent protruberances now form a triangle (three stars).

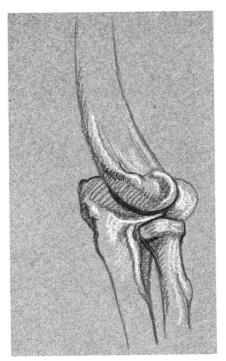

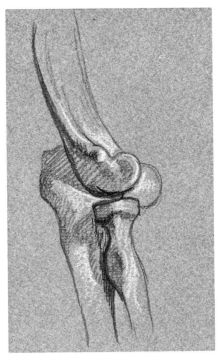

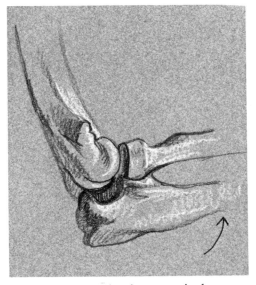

Outside view showing radius in supinated position.

Outside view showing radius in pronated position.

Outside view showing forearm raised. Note hook of ulna riding on spool and radius on ball of humerus.

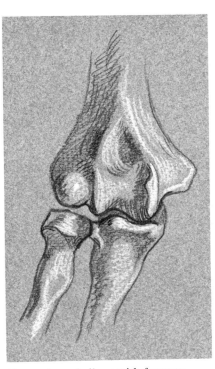

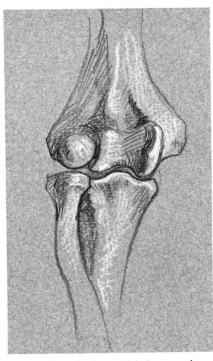

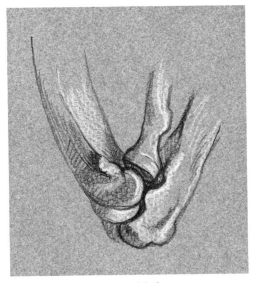

Outside view of elbow with forearm flexed to its maximum.

Front view of elbow with forearm supinated. Note how the coronoid process of the ulna fits onto the trochlear surface of the humerus and how the head of the radius rides on the capitulum of the ulna. Forearm angles away from the body in this position.

Front view of elbow with forearm in pronated position. Head of radius rotates on the capitulum of the ulna and the angle of the forearm ceases to exist, with the forearm pointing straight down.

Bones of the Hand and Wrist

The hand is composed of three parts: the *wrist*, the *palm*, and the *fingers*. The bones of the wrist are called the *carpals*, those of the palm are the *metacarpals*, and the fingers are the *phalanges*.

Key

1. Wrist

 Top Row of Four Bones

 a. Pisiform (like a small pea)
 b. Triangular
 c. Lunate
 d. Scaphoid

 Second Row of Four Bones

 e. Hamate
 f. Capitate
 g. Trapezoid
 h. Trapezium
 (formed like a saddle; the thumb sits on it like a rider sitting on a saddle, and can move backward, forward, or to either side)

2. Palm

 i. Five metacarpal bones

3. Fingers

 j. First phalanges, five in number
 k. Second phalanges, five in number
 l. Third phalanges, four in number

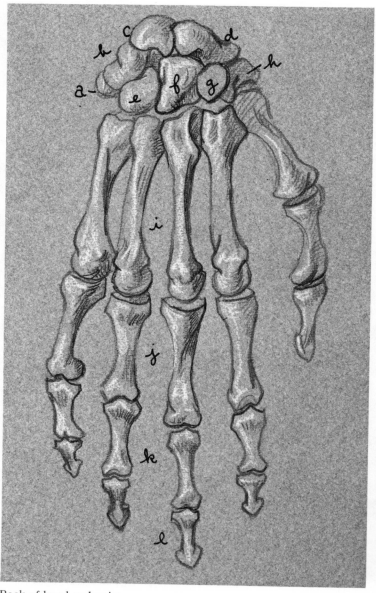

Back of hand and wrist.

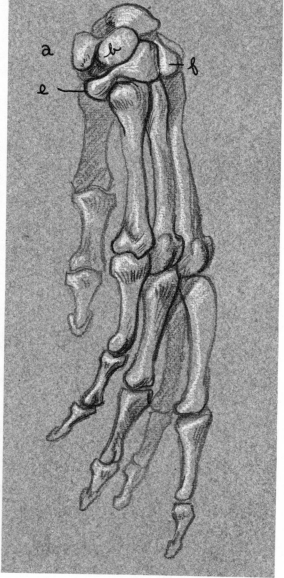

Little finger side of hand.

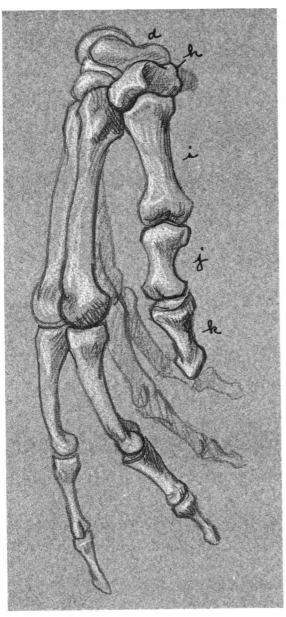

Thumb side of hand.

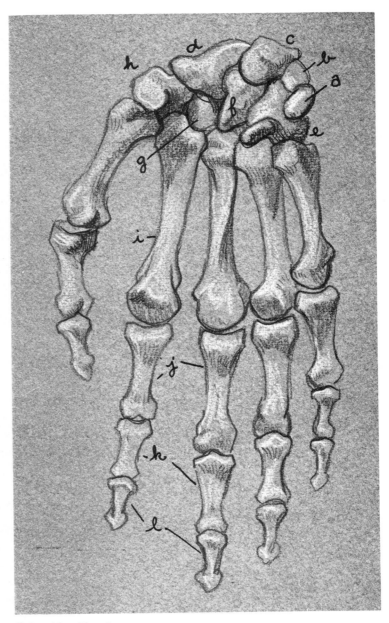

Palm side of hand.

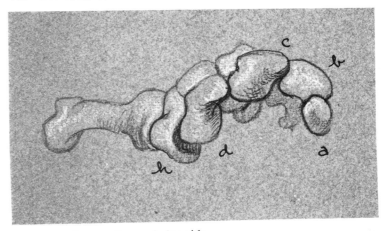

Wrist seen from radius and ulna side.

Wrist Joint

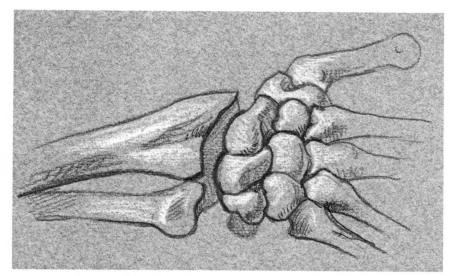

Back of hand with radius and ulna in pronated position. Note the angle formed at the wrist, with radius longer than ulna.

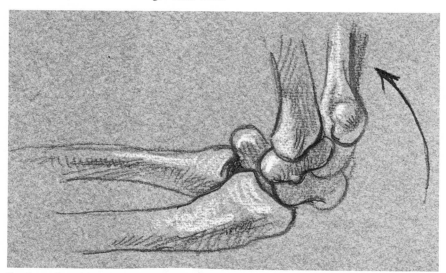

Supinated position from the outside. The hand is bent upward. Radius and ulna form socket for wrist to move in.

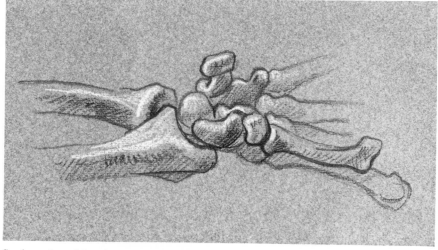

Supinated position from the outside. The hand is in straight angle with the forearm.

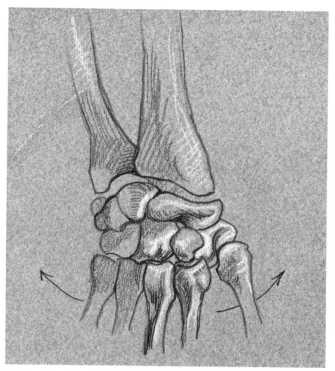

Back of hand with radius and ulna in supinated position. Arched socket formed by ulna and radius allows lateral movement of wrist.

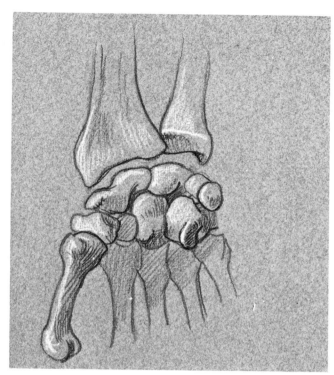

Palm of hand with forearm in supinated position.

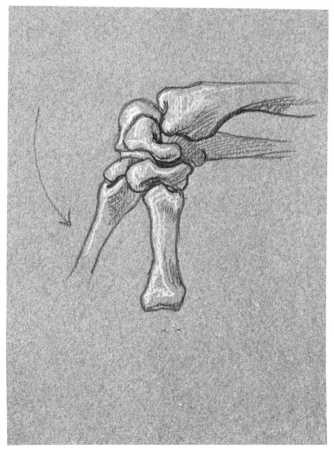

Thumb side with hand bent down.

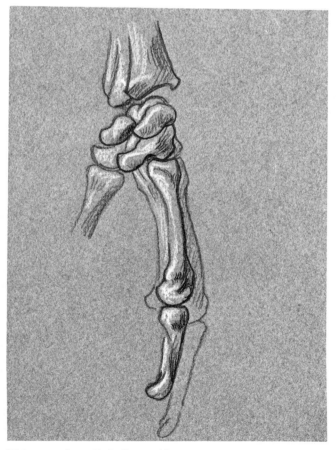

Wrist seen from little finger side.

MUSCLES

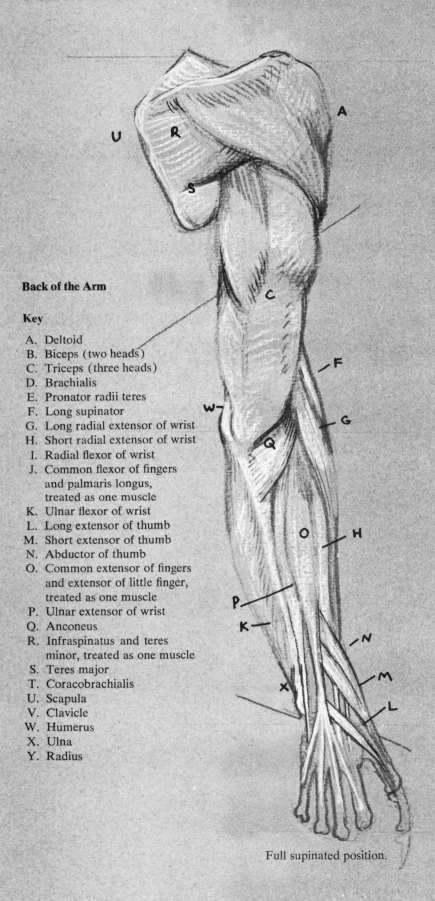

Back of the Arm

Key

A. Deltoid
B. Biceps (two heads)
C. Triceps (three heads)
D. Brachialis
E. Pronator radii teres
F. Long supinator
G. Long radial extensor of wrist
H. Short radial extensor of wrist
I. Radial flexor of wrist
J. Common flexor of fingers
 and palmaris longus,
 treated as one muscle
K. Ulnar flexor of wrist
L. Long extensor of thumb
M. Short extensor of thumb
N. Abductor of thumb
O. Common extensor of fingers
 and extensor of little finger,
 treated as one muscle
P. Ulnar extensor of wrist
Q. Anconeus
R. Infraspinatus and teres
 minor, treated as one muscle
S. Teres major
T. Coracobrachialis
U. Scapula
V. Clavicle
W. Humerus
X. Ulna
Y. Radius

Full supinated position.

Supinated position
with palm facing into body.

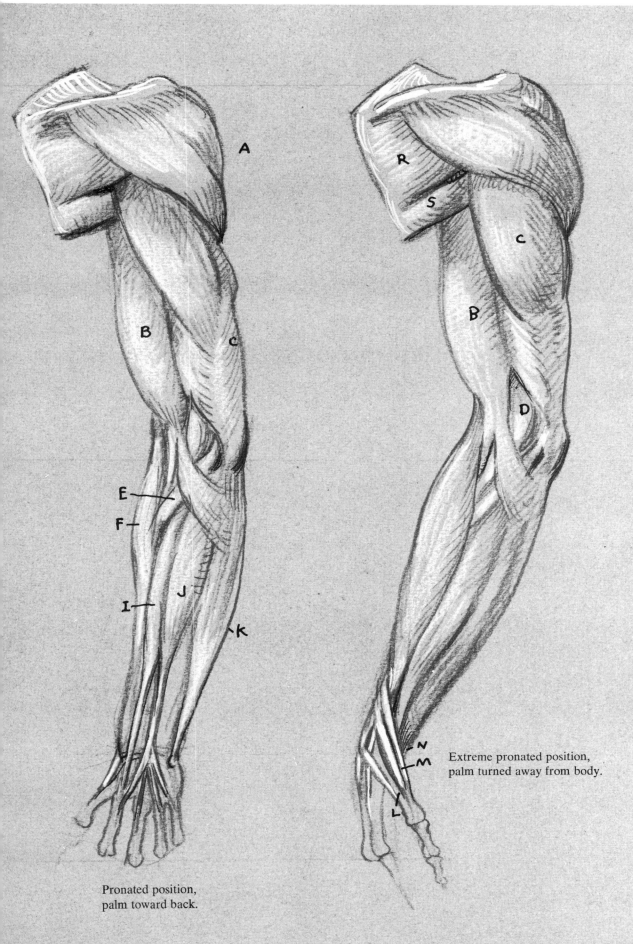

Pronated position,
palm toward back.

Extreme pronated position,
palm turned away from body.

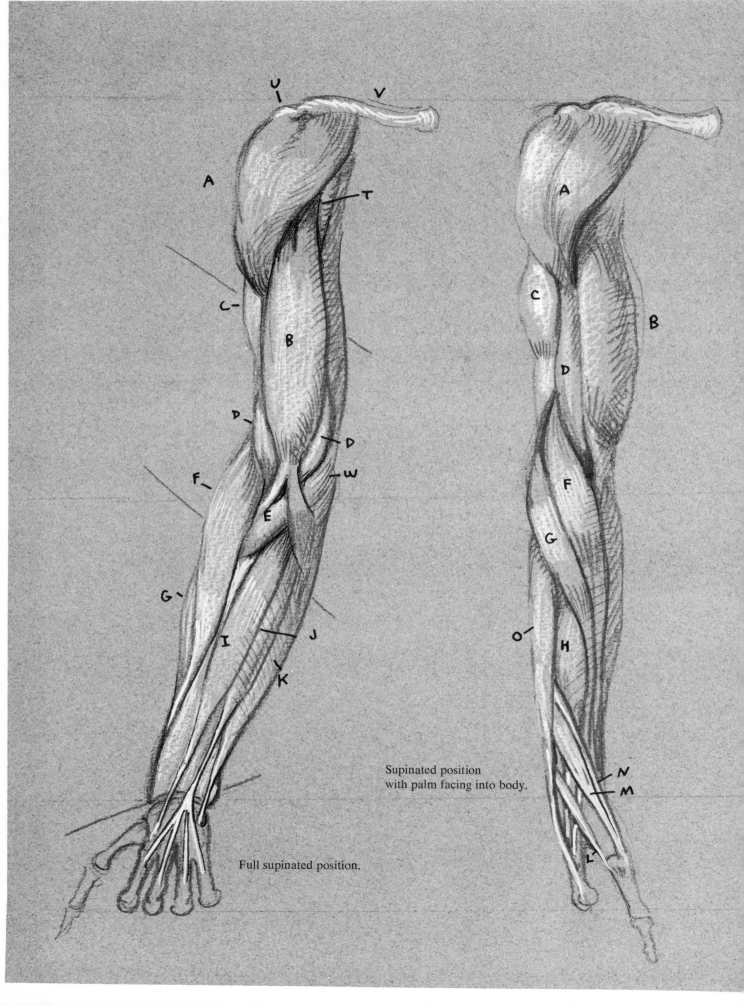

Supinated position
with palm facing into body.

Full supinated position.

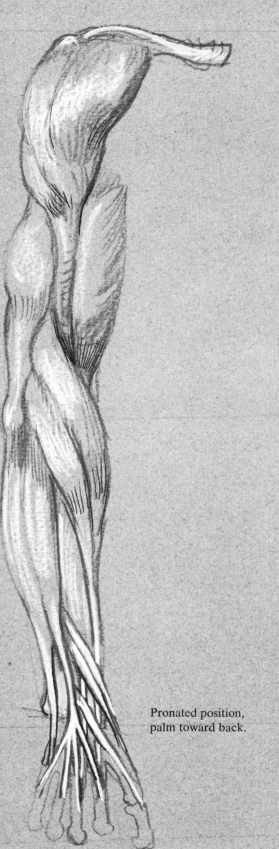

Front of the Arm

Key

A. Deltoid
B. Biceps (two heads)
C. Triceps (three heads)
D. Brachialis
E. Pronator radii teres
F. Long supinator
G. Long radial extensor of wrist
H. Short radial extensor of wrist
I. Radial flexor of wrist
J. Common flexor of fingers
 and palmaris longus,
 treated as one muscle
K. Ulnar flexor of wrist
L. Long extensor of thumb
M. Short extensor of thumb
N. Abductor of thumb
O. Common extensor of fingers
 and extensor of little finger,
 treated as one muscle
P. Ulnar extensor of wrist
Q. Anconeus
R. Infraspinatus and teres
 minor, treated as one muscle
S. Teres major
T. Coracobrachialis
U. Scapula
V. Clavicle
W. Humerus
X. Ulna
Y. Radius

Pronated position,
palm toward back.

Extreme pronated position,
palm turned away from body.

Outside of the Arm

Key

A. Deltoid
B. Biceps (two heads)
C. Triceps (three heads)
D. Brachialis
E. Pronator radii teres
F. Long supinator
G. Long radial extensor of wrist
H. Short radial extensor of wrist
I. Radial flexor of wrist
J. Common flexor of fingers
 and palmaris longus,
 treated as one muscle
K. Ulnar flexor of wrist
L. Long extensor of thumb
M. Short extensor of thumb
N. Abductor of thumb
O. Common extensor of fingers
 and extensor of little finger,
 treated as one muscle
P. Ulnar extensor of wrist
Q. Anconeus
R. Infraspinatus and teres
 minor, treated as one muscle
S. Teres major
T. Coracobrachialis
U. Scapula
V. Clavicle
W. Humerus
X. Ulna
Y. Radius

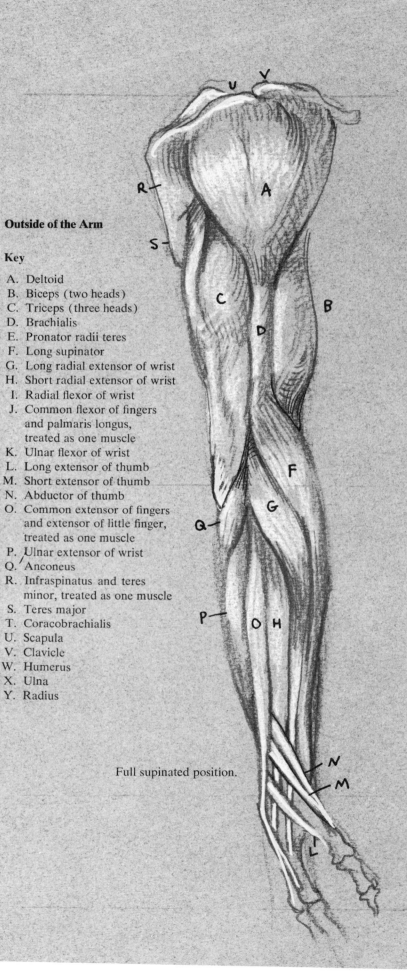

Full supinated position.

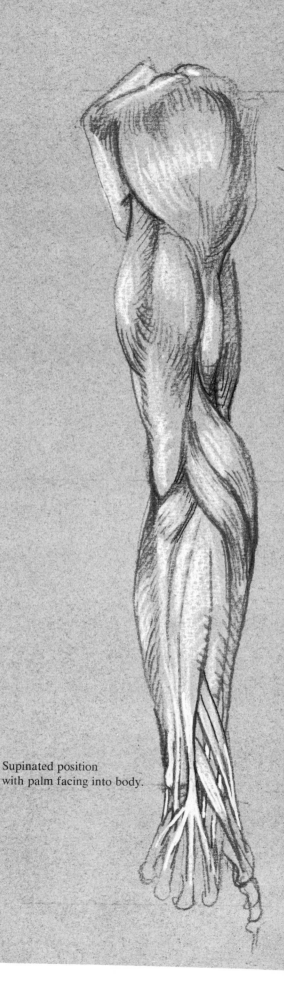

Supinated position
with palm facing into body.

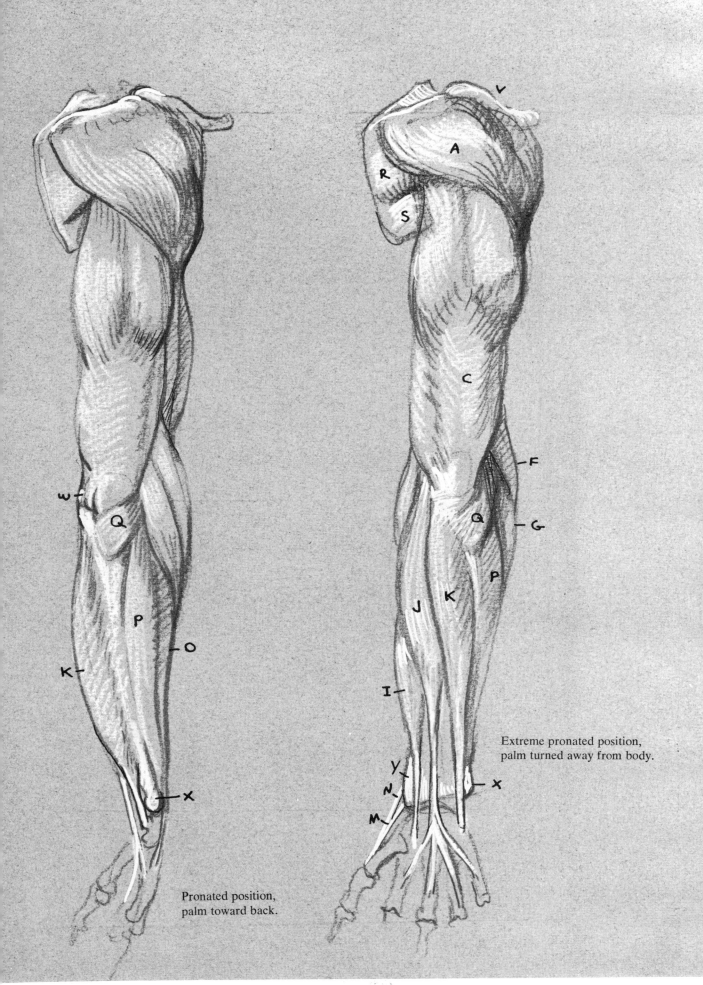

Extreme pronated position,
palm turned away from body.

Pronated position,
palm toward back.

TABLE OF MUSCLE ORIGINS AND INSERTIONS

MUSCLE	ORIGIN	INSERTION	ACTION
A. Deltoid	External third of clavicle and acromion and spine of scapula	Deltoid impression of humerus	Elevates arm: anterior part draws arm forward and rotates it inward; posterior part draws arm backward and rotates it outward
B. Biceps			
Long head	Glenoid cavity of scapula	Aponeurotic expansion: passes over mass of flexor muscles in forearm	Primary function is to flex forearm; also helps to rotate radius outward
Short head	Coracoid process of scapula	Tendon proper: bicipital tuberosity of radius	
C. Triceps			
Long head	Below glenoid cavity in scapula between infraspinatus and teres major muscles	Internal side of flat triceps tendon	Long head adducts arm; the three heads extend forearm
External head	Upper part of back surface of humerus	External side of triceps tendon	
Internal head	Lower part of back surface of humerus	Internal side of triceps tendon; triceps tendon inserts into olecranon process of ulna	
D. Brachialis	Lower front of humerus	Base of the coronoid process of ulna	Flexes forearm
E. Pronator radii teres	Coronoid process of ulna and internal condyle of humerus	Surface of radius just below bicipital tuberosity, concealing insertion of the biceps tendon	Pronates and flexes forearm
F. Long supinator	External side of humerus just below deltoid	Outer side of styloid process of ulna	Draws back radius to supinated position
G. Long radial extensor of wrist	External condyloid ridge of humerus	Base of second (index finger) metacarpal on back of hand	Extends wrist and hand, flexes forearm
H. Short radial extensor of wrist	External condyle of humerus	Base of third (middle finger) metacarpal on back of hand	Extends wrist and abducts hand
I. Radial flexor of wrist	Internal condyle of humerus	Base of second (index finger) metacarpal on palm side	Pronates forearm and flexes and abducts hand
J. Common flexor of fingers and palmaris longus, treated as one muscle	Internal condyle of humerus	Fans out into palm of hand	Pronates forearm and flexes hand
K. Ulnar flexor of wrist	Internal condyle of humerus, olecranon process, and crest of ulna	Pisiform bone of wrist	Flexes and adducts hand
L. Long extensor of thumb	Back surface of ulna	Second phalanx of thumb	Adducts thumb, extends phalanges
M. Short extensor of thumb	Back surface of radius	First phalanx of thumb	Abducts thumb, extends first phalanx
N. Abductor of thumb	Back surface of radius and ulna	Base of first (thumb) metacarpal	Draws thumb toward back of hand
O. Common extensor of fingers and extensor of little finger, treated as one muscle	External condyle of humerus	Spreads out at the wrist and passes to each finger	Straightens fingers and spreads them apart
P. Ulnar extensor of wrist	Back of external condyle of humerus and crest of ulna	Base of fifth (little finger) metacarpal	Adducts and extends hand
Q. Anconeus	External condyle of humerus	Back surface of ulna	Extends forearm
R. Infraspinatus and teres minor, treated as one muscle	Infraspinous fossa of scapula	Great tuberosity of humerus	Abducts and adducts arm; also rotates it
S. Teres major	Lower part of infraspinous fossa	Passes in front of humerus and into bicipital groove	Pulls arm into body and helps rotate it inward
T. Coracobrachialis	Coracoid process of scapula	Middle of internal side of humerus	Raises arm forward and helps pull it back toward body

U. Scapula
V. Clavicle
W. Humerus Bones visible on surface, not covered by muscle
X. Ulna
Y. Radius

SURFACE ANATOMY

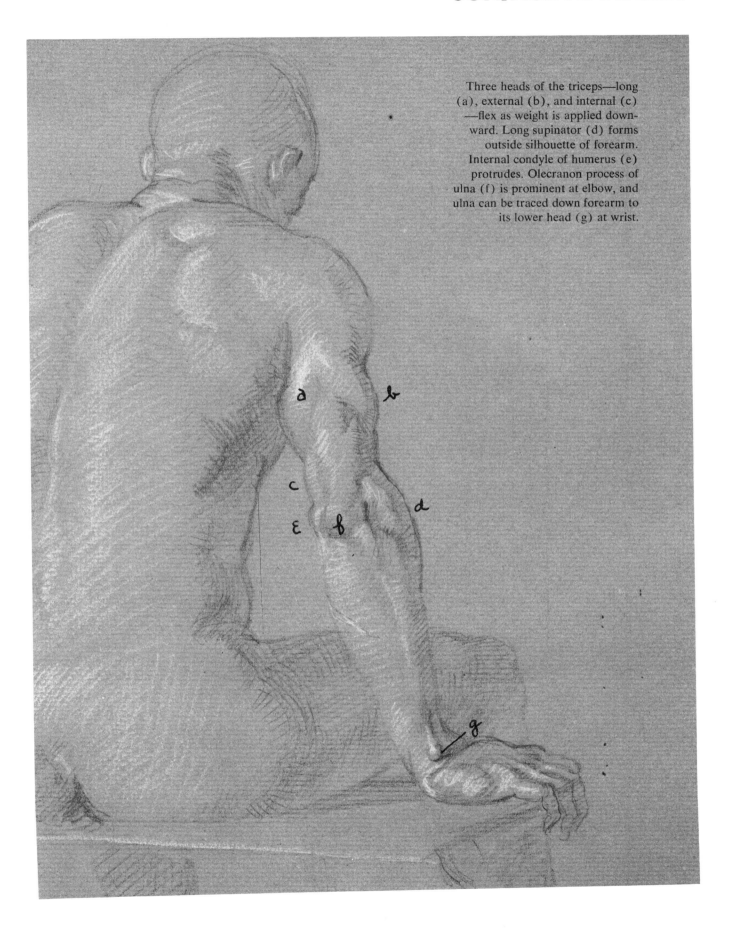

Three heads of the triceps—long (a), external (b), and internal (c) —flex as weight is applied downward. Long supinator (d) forms outside silhouette of forearm. Internal condyle of humerus (e) protrudes. Olecranon process of ulna (f) is prominent at elbow, and ulna can be traced down forearm to its lower head (g) at wrist.

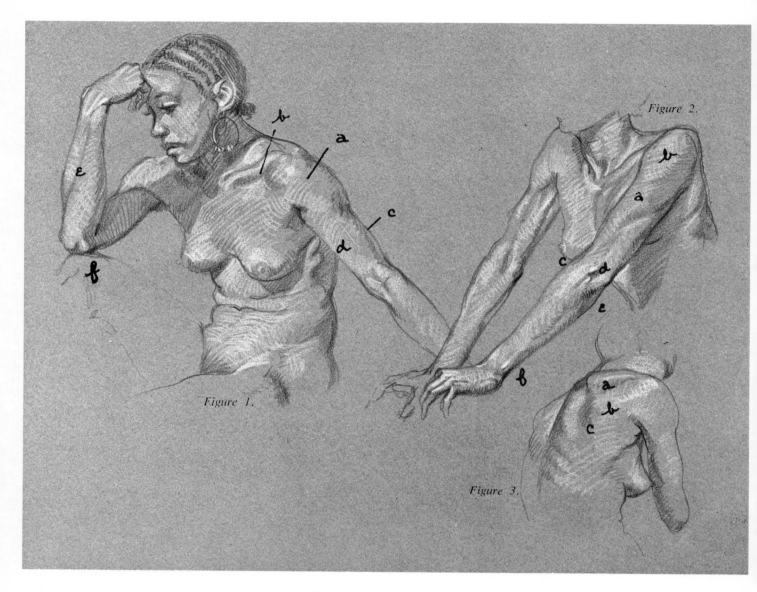

Figure 1.

Figure 2.

Figure 3.

Figure 1. Deltoid (a) attaches to clavicle (b) and inserts into upper arm between triceps (c) and biceps (d). Edge of ulna is prominent (e), as is the internal condyle of the humerus (f).

Figure 2. External head of triceps (a) follows direction of deltoid (b). Long supinator (c) lies above head of radius (d). Ulna is seen from elbow (e) to little finger side of wrist (f).

Figure 3. Infraspinatus (a) and teres major (b) pull from internal border of scapula (c) toward arm.

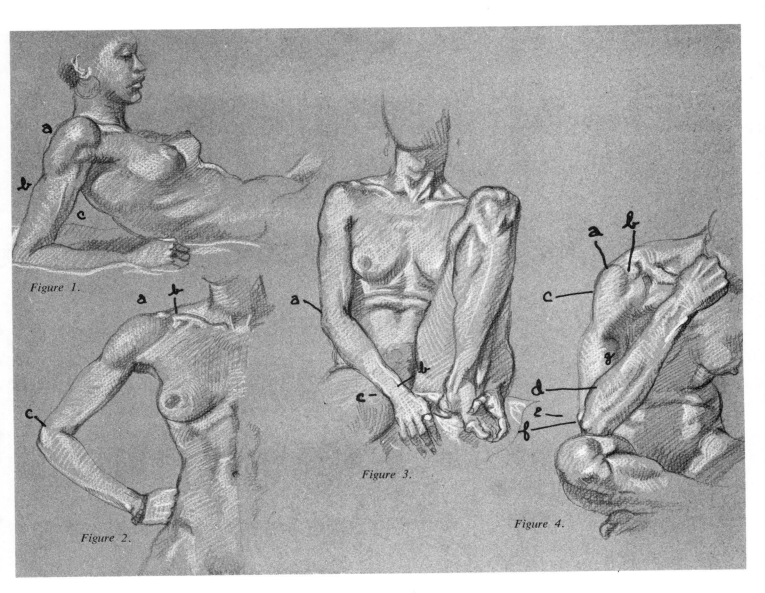

Figure 1. Deltoid flexed (a): triceps high in back (b) forms angle with lower bulge of biceps (c) in front.

Figure 2. Acromion process of scapula (a) meets clavicle (b). Long supinator bends through elbow (c).

Figure 3. Long supinator (a) gives higher contour to topside of forearm. Angle at wrist caused by radius (b) being longer than ulna (c).

Figure 4. Acromion process of scapula (a) wraps around clavicle (b). Division of deltoid visible (c). Extensor of fingers (d) can be seen between radius (e) and ulna (f) and in upper part of forearm. The short radial extensor of wrist (g) lies next to it.

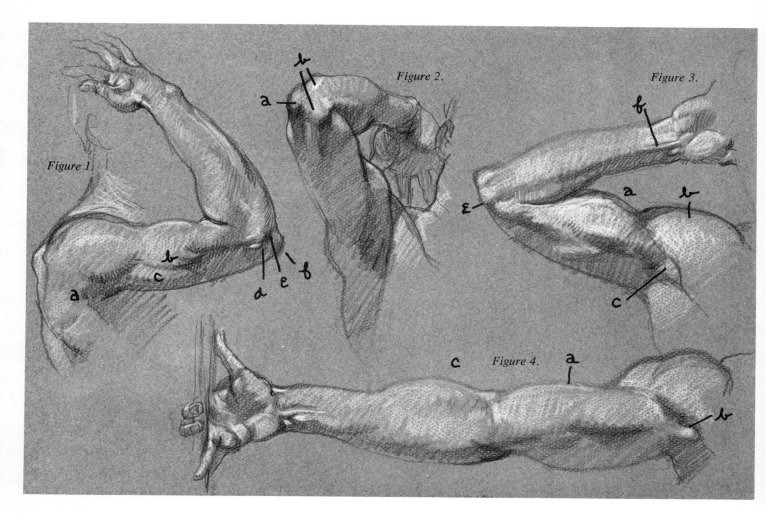

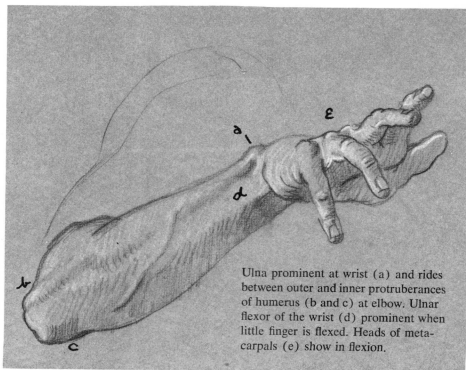

Figure 1. In armpit, muscles of scapula (a) can be seen pulling out into arm. Extending out under deltoid, external head (b) and long head (c) of triceps are defined. Humerus (d), radius (e), and ulna (f) are all obvious at elbow. At wrist, long abductor of the thumb is clear.

Figure 2. Ulna (a) and lower head of humerus (b) form triangle of three protruberances.

Figure 3. Biceps (a) swells as it flexes arm. Under deltoid (b), coracobrachialis (c) can be seen. At elbow, hook of ulna stands out with internal condyle of humerus (e) prominent. Radial flexor of wrist (f) is also noticeable.

Figure 4. Biceps (a) and coracobrachialis (b) emerge from underneath the deltoid. Long supinator (c) creates high silhouette on top of forearm.

Ulna prominent at wrist (a) and rides between outer and inner protruberances of humerus (b and c) at elbow. Ulnar flexor of the wrist (d) prominent when little finger is flexed. Heads of metacarpals (e) show in flexion.

Head of radius (a) lies just under long supinator (b) as it bends with elbow. Internal condyle (c) and external condyle (d) of humerus support the olecranon process (e) of ulna. Ulna (f) prominent at wrist.

3. THE HAND

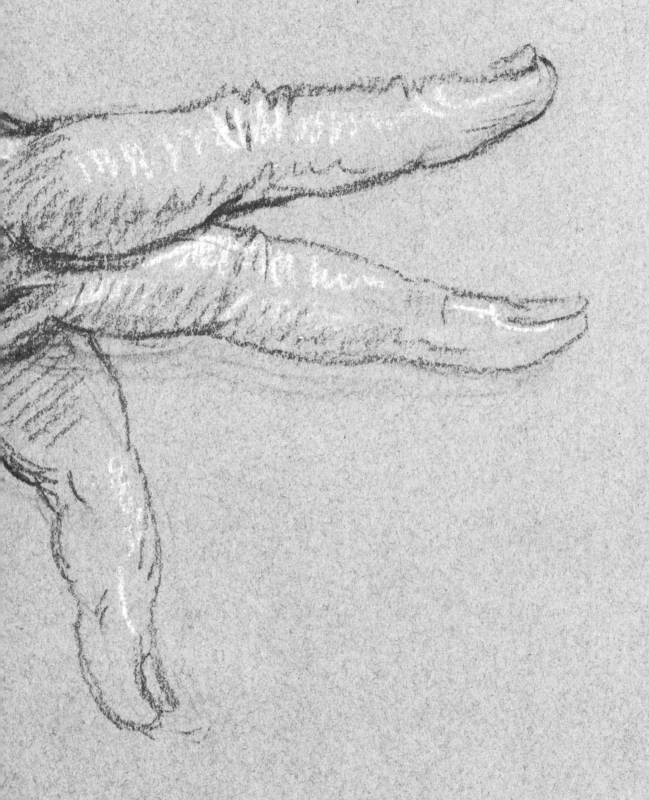

SCHEMATIC DRAWINGS

Palm Side

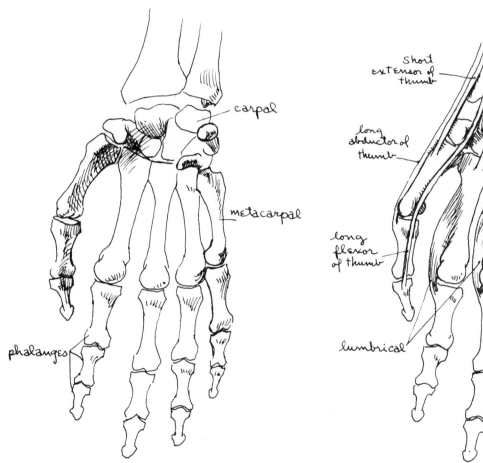

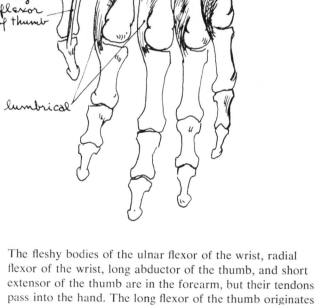

The hand is composed of three parts: the wrist bones, called *carpals*; the bones of the palm, the *metacarpals*; and the finger bones, the *phalanges*.

The fleshy bodies of the ulnar flexor of the wrist, radial flexor of the wrist, long abductor of the thumb, and short extensor of the thumb are in the forearm, but their tendons pass into the hand. The long flexor of the thumb originates deep in the forearm and inserts into the second phalanx of the thumb. Four small lumbrical muscles help flex the fingers.

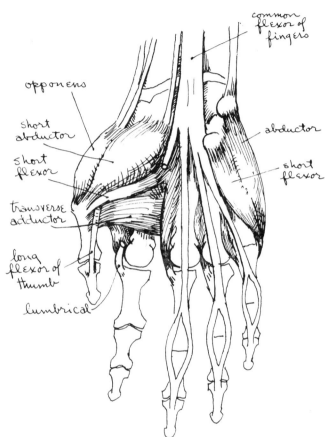

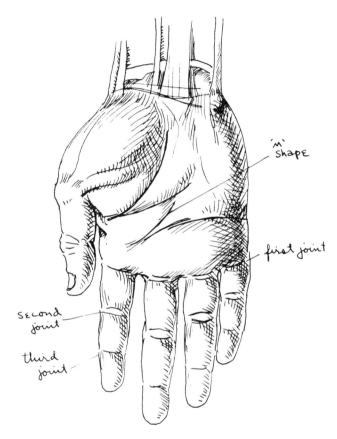

The "ball" of the thumb is formed by the opponens of the thumb, short abductor, and short flexor. In this illustration, the index lumbricalis is cut off to show the transverse adductor which draws the thumb across the palm of the hand. The common flexor of the fingers becomes more obscure in the palm. The abductor and short flexor of the little finger form the "heel" of the hand.

The third joint of the fingers has one fold, the second joint, two folds. The first joint of the fingers has one fold on the index and little fingers and two folds on the middle and ring fingers. The muscles of the palm form an M shape. The webbing between the fingers reaches to the middle of the first phalanx.

Back of the Hand

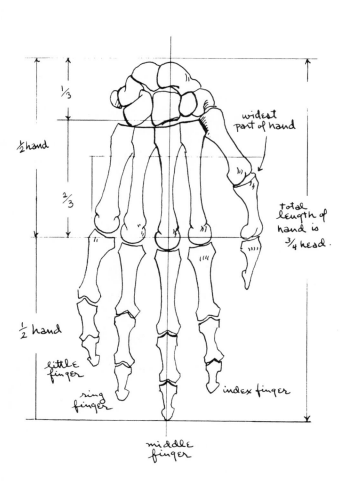

The middle finger is the straightest and longest. The ring finger is second in length, and the index finger is third. The little finger is the shortest and ends next to the last joint of the ring finger. The thumb ends short of the second joint of the index finger. The widest part of the hand is between the knuckles of the little finger and the thumb. The first joint of the middle finger divides the hand in half. The length of the wrist is one-third of the upper half.

The ulnar extensor of the wrist and the short and long radial extensors attach into the heads of the metacarpal bones. The ulnar flexor of the wrist can be seen on the palm side. The abductor of the little finger forms the outside contour. The interossei muscles fill the interspaces between the metacarpal bones, with only the thumb interosseous muscle affecting the surface. The transverse adductor draws the thumb across the hand and the opponens draws it forward.

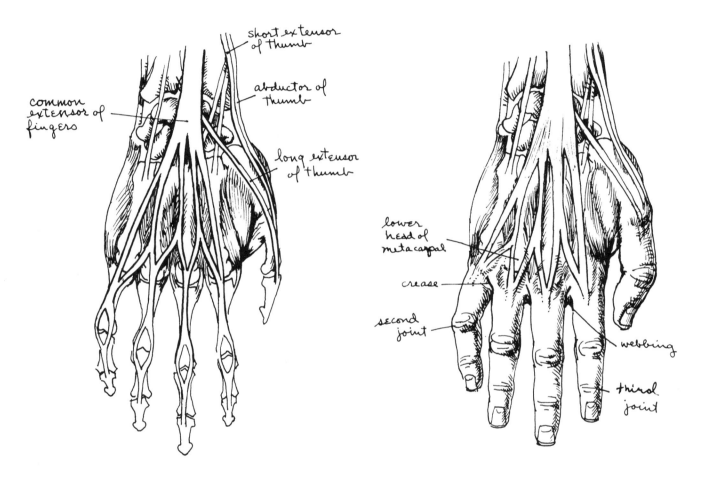

The common extensor of the fingers and the long extensor of the little finger are treated as one muscle and insert down into the fingers. The long extensor of the thumb lies obliquely across the wrist. The short extensor and the abductor of the thumb form a straight edge at the wrist.

The second joint of the fingers has raised, fleshy folds. The third joint has flat folds. The webbing of skin between the fingers starts beyond the heads of the metacarpal bones. The creases where the middle finger attaches to the hand point away from the center. The crease on the ring finger points toward the outside of the hand.

Little Finger Side

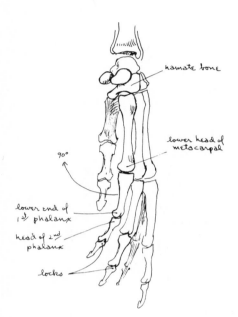

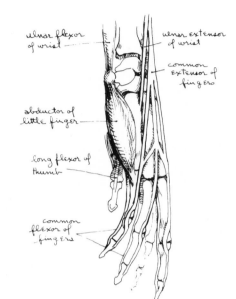

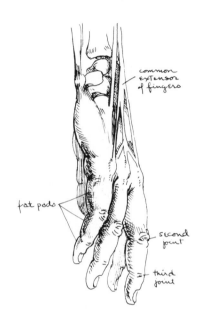

The hamate bone joins with the metacarpal bone of the little finger, allowing little flexion. The lower head of the metacarpal is ball-shaped. The first phalanx rides on it, permitting the little finger to bend up to a 90° angle and rotate in all directions. The lower end of the first phalanx is shaped like a spool, which enables the head of the second phalanx to bend on it in a hinge manner. The small protruberances in front of the bones act as locks to keep the joints from bending backward.

The shape of the hand is mostly formed by bones and the tendons of muscles that originate in the forearm and insert into the hand. The abductor of the little finger creates the "heel" of the hand.

The common extensor of the fingers is visible on the back of the hand and over the knuckles as it disappears into the fingers. The fat pads are round in shape on the palm side of the fingers. The second joint of the fingers has fleshy folds; the third joint has flat folds.

Thumb Side

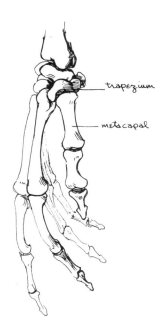

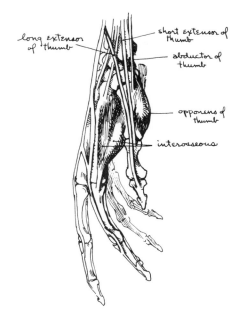

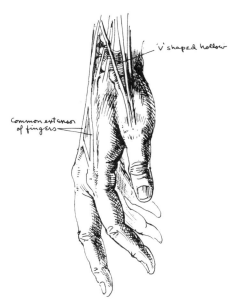

The thumb has one joint fewer than the other fingers. The metacarpal of the thumb rides on a saddle-shaped bone (trapezium) of the wrist. The thumb sits on it like a rider sitting in a saddle, able to move backward, forward, or toward either side.

The long extensor of the thumb cuts diagonally across the wrist. The short extensor and abductor of the thumb come straight down the edge of the radius. The interosseous muscle of the thumb fills the space between the thumb and the index finger. The opponens of the thumb forms the "ball" of the thumb.

The V-shaped hollow formed by the long and short extensors of the thumb is called the "snuff box." The common extensor of the fingers disappears into the fingers beyond the knuckles.

MUSCLES

Note: For the bones of the hand and wrist, see pages 49–51.

Key

A. Ulnar flexor of wrist
B. Ulnar extensor of wrist
C. Short radial extensor of wrist
D. Long radial extensor of wrist
E. Abductor of little finger
F. Interossei
G. Transverse adductor of thumb
H. Common extensor of fingers
 and long extensor of little finger,
 treated as one muscle
I. Long extensor of thumb
J. Short extensor of thumb
K. Abductor of thumb
L. Opponens of thumb
M. Short abductor of thumb
N. Common flexor of fingers
O. Long flexor of thumb
P. Lumbricales
Q. Radial flexor of wrist
R. Short flexor of thumb
S. Short flexor of little finger
T. Annular ligament of wrist

U. Heads of metacarpals } Bones visible
V. Ulna } on surface,
 not covered
 by muscle

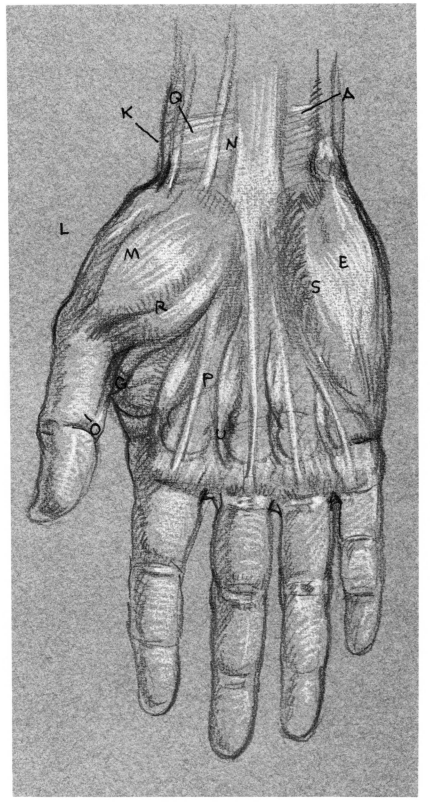

Full view of palm side.

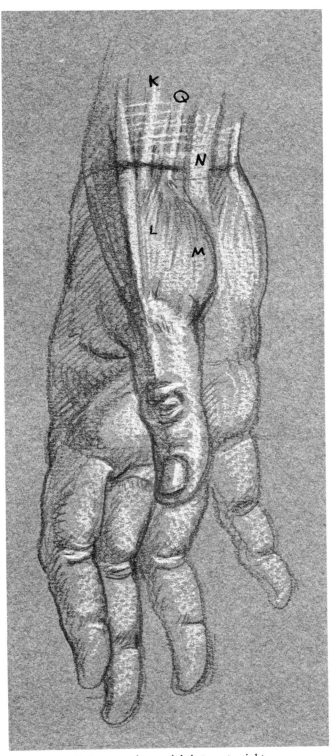

Palm turned one-eighth turn to right.

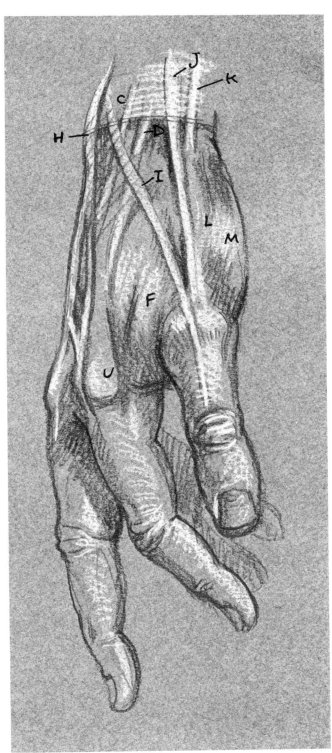

Full view of thumb side.

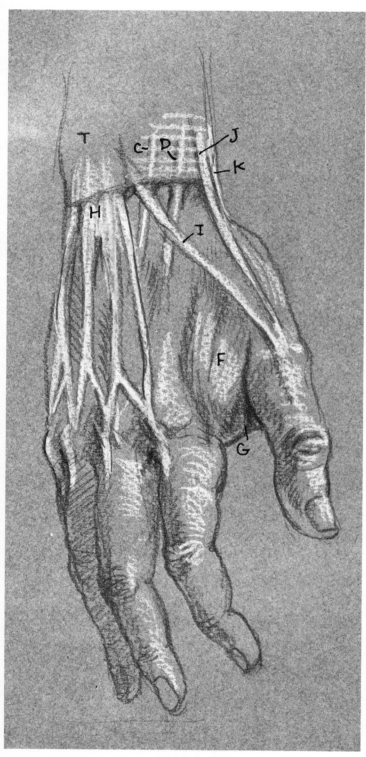

Thumb side turned one-eighth turn to right.

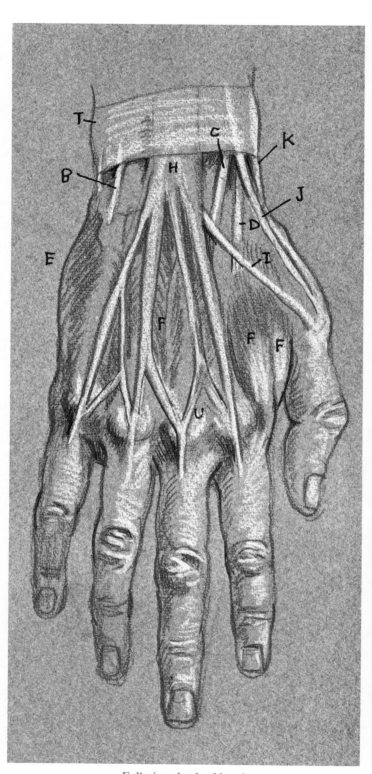

Full view, back of hand.

For key to figures see page 72 .

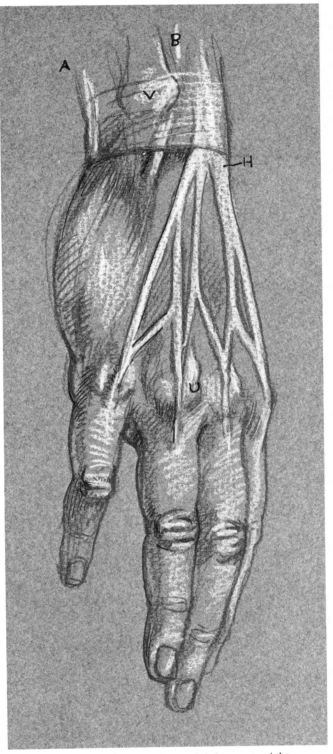

Back of hand turned one-eighth turn to right.

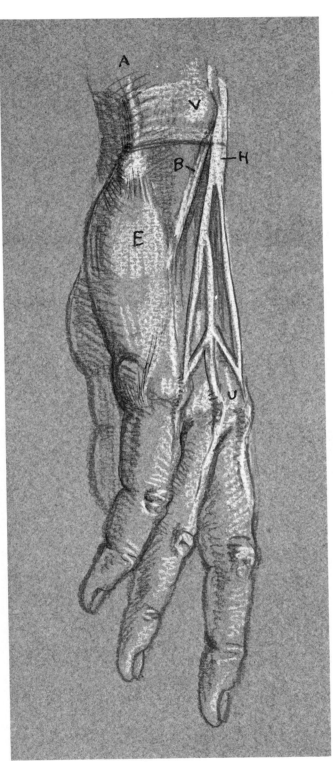

Full view of little finger side.

TABLE OF MUSCLE ORIGINS AND INSERTIONS

MUSCLE	ORIGIN	INSERTION	ACTION
A. Ulnar flexor of wrist			
B. Ulnar extensor of wrist			
C. Short radial extensor of wrist	See *Table of Muscle Origins and Insertions* for the arm in Chapter 2		
D. Long radial extensor of wrist			
E. Abductor of little finger	Pisiform bone of wrist	Base of first phalanx of little finger	Draws little finger forward, flexes first phalanx, extends second and third phalanges; also pulls little finger away from center of hand
F. Interossei	Fill the interspaces between metacarpals		
(only thumb, or first dorsal, interosseous affects surface)	First and second metacarpals	First phalanx of index finger	Flexes thumb, adducts thumb and abducts index finger
G. Transverse adductor of thumb	Third metacarpal on palm side	Base of first phalanx of thumb	Draws thumb across palm of hand and draws it forward
H. Common extensor of fingers and long extensor of little finger, treated as one muscle			
I. Long extensor of thumb	See *Table of Muscle Origins and Insertions* for the arm in Chapter 2		
J. Short extensor of thumb			
K. Abductor of thumb			
L. Opponens of thumb	Trapezium bone of wrist	Entire length of outer border of first metacarpal as well as base of first phalanx of thumb	Draws thumb forward
M. Short abductor of thumb	Scaphoid and trapezium bones of wrist	Base of first phalanx of thumb	Draws thumb forward, flexes first phalanx, extends second phalanx
N. Common flexor of fingers	See *Table of Muscle Origins and Insertions* for the arm in Chapter 2		
O. Long flexor of thumb	Deep in forearm	Second phalanx of thumb	Flexes second phalanx, draws thumb toward back of hand
P. Lumbricales (four)	Common flexor of fingers	External border of first phalanx of each finger	Small flexors
Q. Radial flexor of wrist	See *Table of Muscle Origins and Insertions* for the arm in Chapter 2		
R. Short flexor of thumb	Scaphoid and trapezium bones of wrist	Base of first phalanx of thumb and inside shaft of first metacarpal	Flexes first phalanx and extends second phalanx of thumb
S. Short flexor of little finger	Hamate bone of wrist	Base of first phalanx of little finger	Flexes first phalanx of little finger
T. Annular ligament of wrist	Wraps around wrist and holds tendons in place		
U. Heads of metacarpals	Bones visible on surface, not covered by muscle		
V. Ulna			

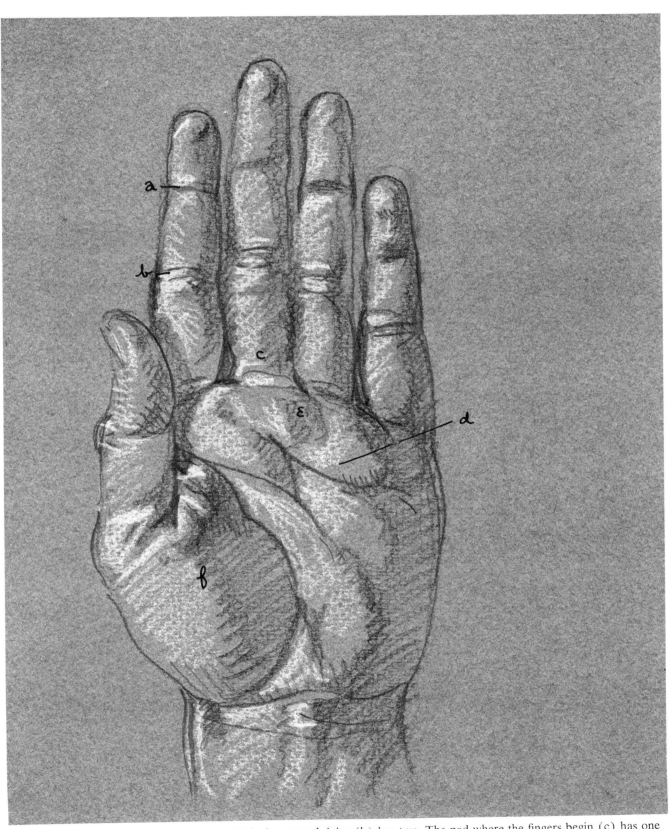

The third joint of the fingers (a) has one fold, the second joint (b) has two. The pad where the fingers begin (c) has one fold on the index and little fingers and two folds on the middle and ring fingers. Pad (e) covers heads of metacarpals. Thumb group of muscles (f) help form M shape.

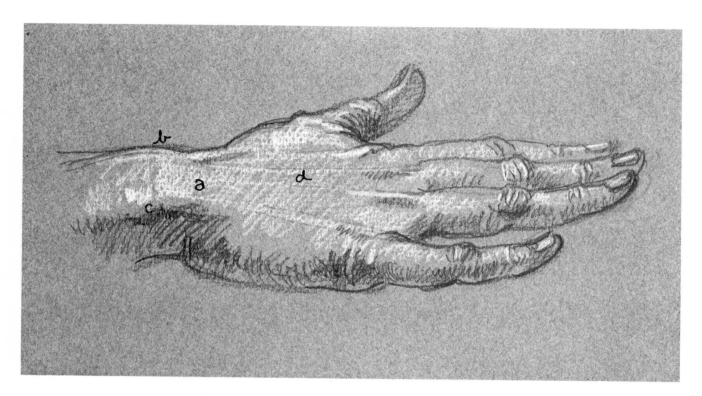

(Above) Tendons (a) form a ramp, making a transition at the wrist. Heads of radius (b) and ulna (c) are visible. When fingers are extended, the common extensor (d) shows on the surface.

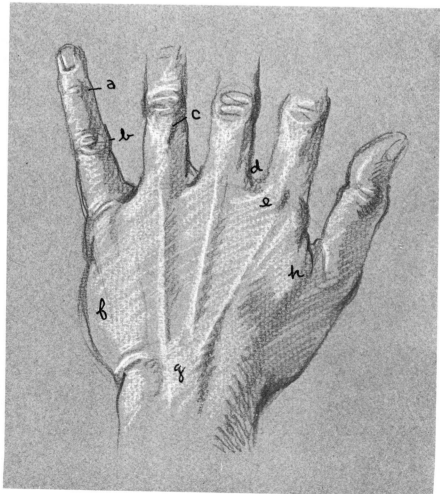

Flat folds of third joint(a)differ from fleshy folds of second joint(b).Common extensor tendon (c) splits around joint. Skin webbing (d) between fingers extends to beyond heads of metacarpal bones (e). Back-of-hand muscles— abductor of little finger (f), common extensor of fingers (g), and thumb interosseous (h) —are all visible.

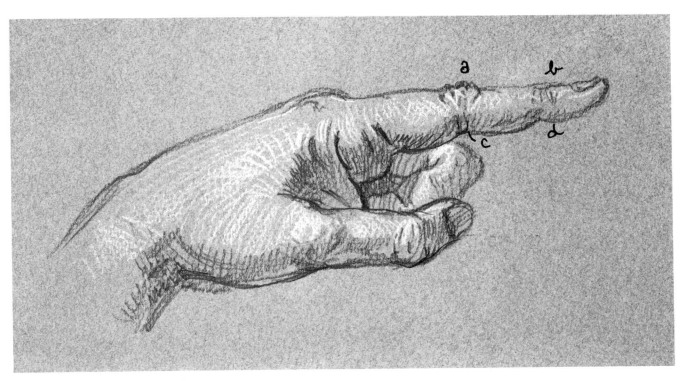

(Above) Fleshy folds on top of finger at second joint (a) and flat folds at third joint (b). Two folds on palm side of finger at second joint (c), one fold at third joint (d).

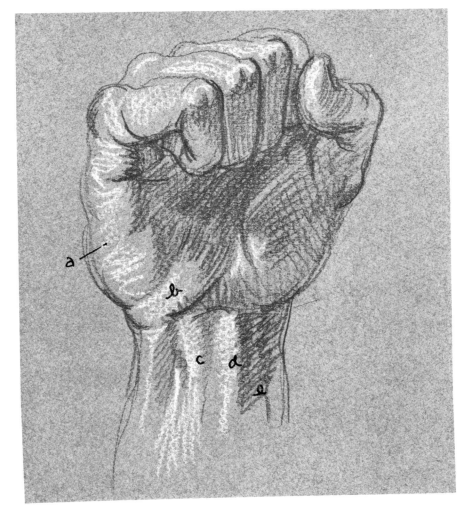

Abductor (a) and short flexor of little finger (b) swell when fist is made. Flexors—ulnar (c), common flexor of fingers (d), and radial (e)—are pronounced at wrist.

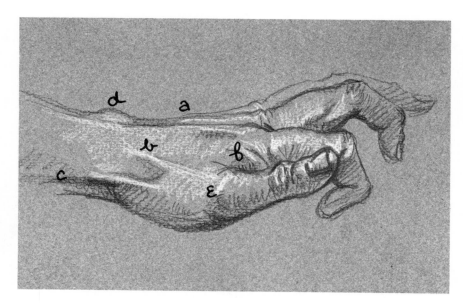

When the fingers are hyperextended, the common extensor (a) becomes taut. The long extensor (b) and abductor (c) of the thumb form a hollow called the "snuff box." The ulna (d) and the head of the thumb metacarpal (e) are prominent, as is the interosseous muscle of the thumb (f).

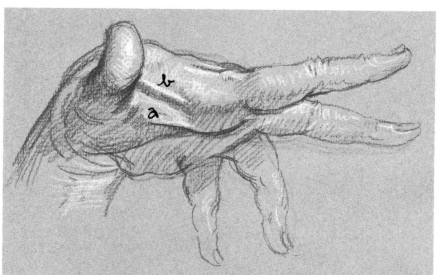

Transverse adductor (a) and interosseous of thumb (b) are evident as thumb pulls away from hand. Little finger is flexed to its full 90°.

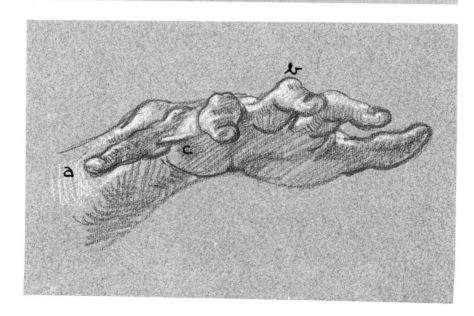

Tips of fingers are oval (a). Heads of bones show at joints (b) and webbing between fingers (c) stretches when fingers are spread apart.

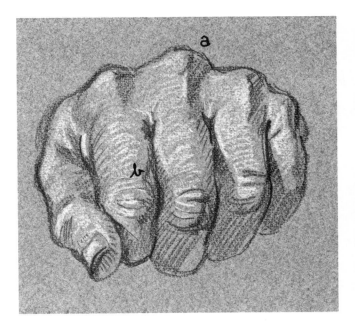

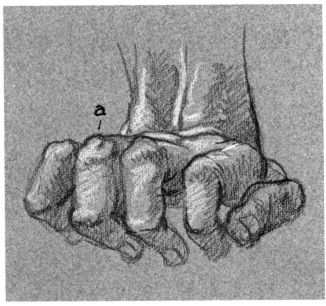

(Above left) The knuckles form an arch (a) with the middle finger the highest point. Tendon of extensor (b) splits at knuckle and disappears into finger.

(Above right) Heads of bones show at joints (a) when fingers are flexed.

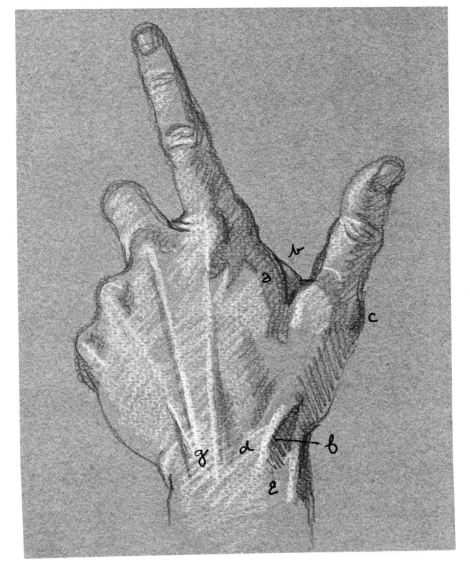

Interosseous muscle (a) overlaps transverse adductor of thumb (b). Head of thumb metacarpal (c) is prominent. Long extensor (d) and abductor of thumb (e) form hollow called "snuff box" (f). Common extensor (g) pulls on index and middle fingers.

4. THE LEG

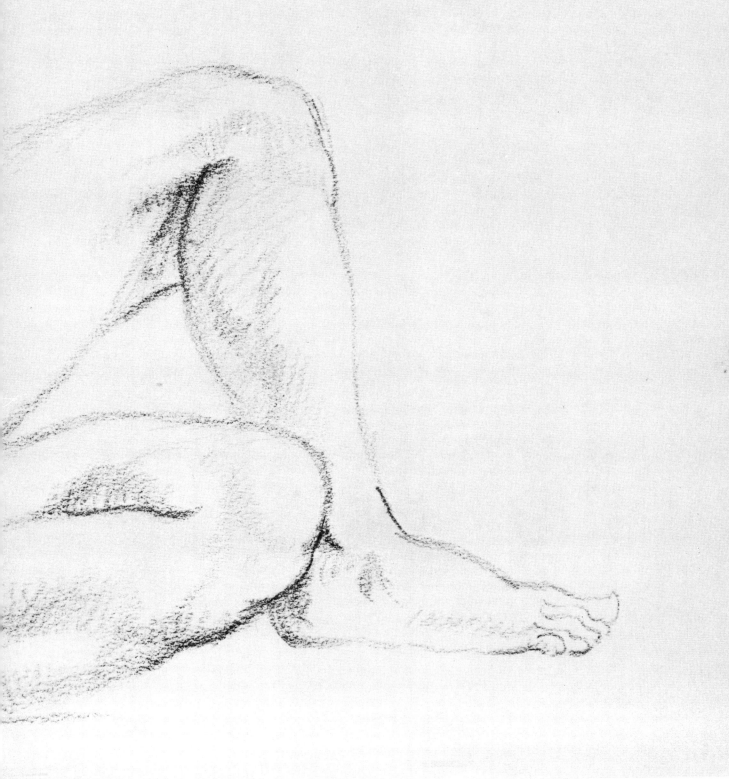

SCHEMATIC DRAWINGS

Front View

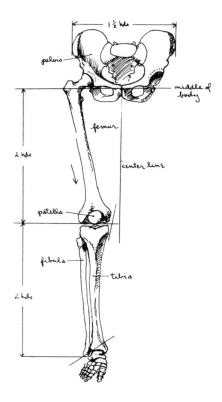

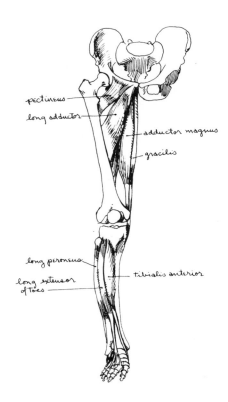

The thigh has one bone. It is two heads in length and is called the *femur.* It can rotate in all directions from its ball-and-socket joint with the pelvis. The male pelvis is one-and-a-half heads wide, while the female pelvis is two heads wide. The femur angles down under the pelvis toward the center line. On the female the knees touch; on the male they are slightly apart. The *patella* (kneecap) is about the shape of, but slightly larger than, a silver dollar. It rides against the lower head of the femur. The lower part of the leg has two bones: the *tibia,* which is the largest, and the *fibula,* which is attached to the outside of the tibia. The fibula is longer at the ankle and makes an angle with the shorter tibia. Hence the inside of the ankle is always higher than the outside. The length of the lower part of the leg is two heads.

The groin muscles—*pectineus, long adductor, adductor magnus,* and *gracilis*—adduct (bring legs together) and flex the thigh. The *long peroneus* attaches to the fibula and inserts behind the ankle into the sole of the foot. It points and adducts the foot. The *long extensor of the toes* attaches to the head of the tibia between the long peroneus and tibialis anterior. The *tibialis anterior* flexes the foot inward and raises it.

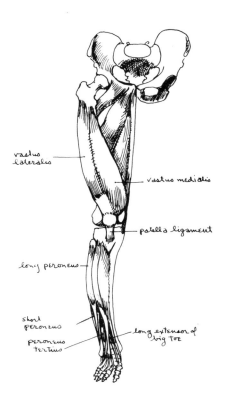

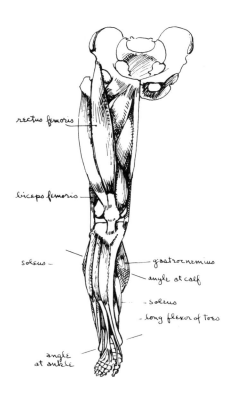

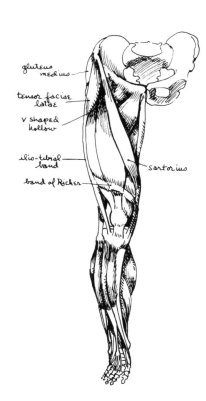

The *vastus lateralis* and *vastus medialis* form a large teardrop shape overlapping the groin muscles. The *patella ligament* supports the patella. The *short peroneus* lies under the *long peroneus*. The *peroneus tertius* fills in the space between the long peroneus and the long extensor of the toes and inserts under the foot. The *long extensor of the big toe* fills in the space between the long extensor of the toes and the tibialis anterior.

The *rectus femoris* flexes and abducts the thigh as well as extends the leg. It attaches to the patella in a beltlike tendon. The calf muscles—*gastrocnemius, soleus,* and *long flexor of the toes*—can be seen from the front, making the outside of the leg appear higher than the inside. This makes an opposite angle with the ankle. The *tendon of the biceps femoris* can be seen attaching into the head of the fibula.

The *tensor faciae latae* and *sartorius* form an upside down V-shaped hollow. The sartorius descends obliquely down the leg and is the longest muscle in the body. The *iliotibial band* is like a stripe down the outside of the leg. The *band of Richer* shows when the leg is extended and disappears when the leg is flexed.

Back View

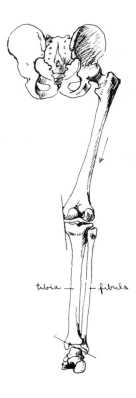

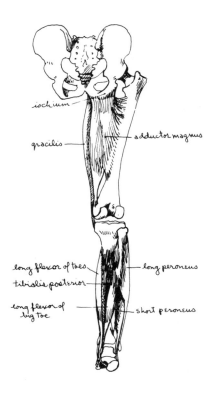

The *femur* angles down under the pelvis toward the center of the figure. The inside of the knee has a slight angle and the fibula attaches to the back of the head of the tibia on the outside. The angle of the ankle is caused by the longer length of the fibula.

The *gracilis* forms the inside contour of the thigh. The *adductor magnus* originates at the ischium and attaches along the femur. The *long flexor of the toes*, the *tibialis posterior*, and the *long flexor of the big toe* are all underlying muscles and only show behind the ankle. The *long peroneus* and *short peroneus* attach on the outer surface of the fibula and insert down behind the ankle.

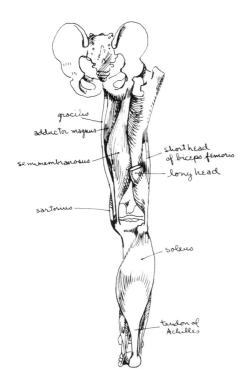 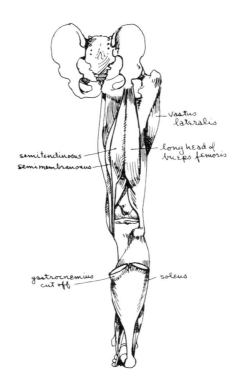 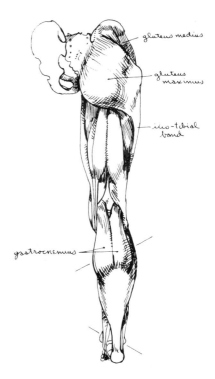

The *semimembranosus* is an extensor and adductor. The *sartorius* wraps around the inside of the knee from the front side. In this illustration, the long head of the *biceps femoris* has been cut to show the attachment of the short head. The *soleus* covers the lower part of the back of the leg, originating on the head of the fibula and back side of the tibia and fibula and inserting in the Achilles tendon.

The *vastus lateralis* can be seen from the front view, helping to form the outside contour of the leg. The *semitendinosus* lies on top of the *semimembranosus* and meets the long head of the biceps femoris in a straight line down the middle of the back of the leg. The *gastrocnemius,* shown here with the muscle cut off, attaches to the same tendon as the soleus.

The *gastrocnemius* attaches to the condyles of the femur, and flexes the leg as well as points the foot. The *gluteus maximus* is the large buttock muscle that extends the thigh backward, adducts it, and helps rotate it outward. The *gluteus medius* abducts the thigh.

Outside

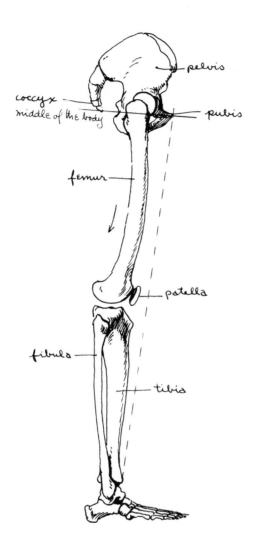

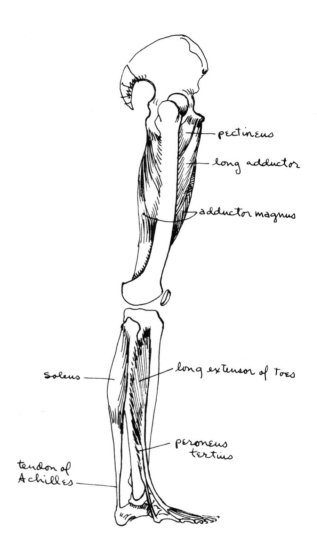

The *coccyx* and the *pubis* are in a line and mark the fourth head measurement (middle of the body). The *femur* curves down and back under the pelvis. The *patella* rides in front of the femur, acting as a lock to prevent the leg from bending forward. The *fibula* attaches to the back of the head of the tibia and intersects the tibia at the ankle. The front of the tibia has a slight curve to it.

The *pectineus, long adductor,* and *adductor magnus* form the groin muscles (the gracilis does not show from this angle). The *soleus* attaches to the Achilles tendon and rises up to the head of the fibula. The *long extensor of the toes* and *peroneus tertius* originate on the fibula and tibia and insert down into the foot.

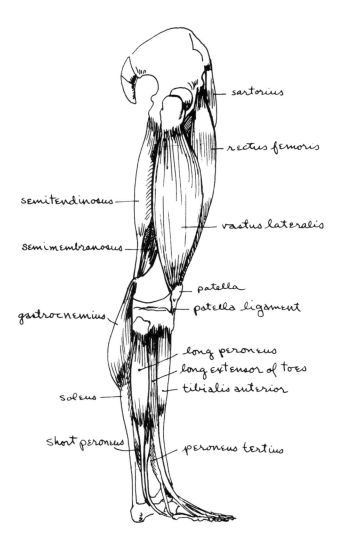

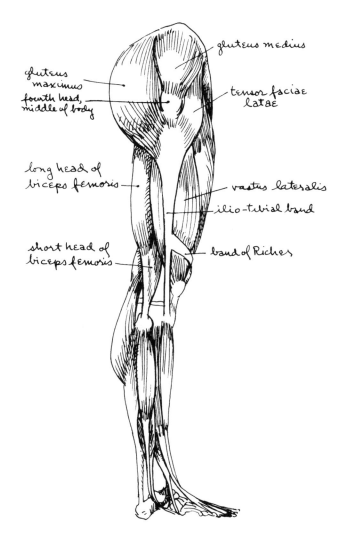

The *sartorius* and *rectus femoris* give shape to the front of the leg. The *vastus lateralis* is the large flank muscle of the thigh, and it attaches to the patella. The *patella ligament* holds the patella in place. Three muscles in a row give roundness to the outside of the lower leg: the *long peroneus,* the *long extensor of the toes,* and the *tibialis anterior.* The *tendons of the short and long peroneus* go behind the ankle. The *tendon of the peroneus tertius* goes in front of the ankle. The *gastrocnemius* grows out of the soleus and attaches up on the femur. The *semitendinosus* and the *semimembranosus* can be seen as they come up from the inside of the leg.

The *gluteus maximus* joins with the *tensor faciae latae* below the mid-point of the body. The *iliotibial band* comes down the outside of the leg like a stripe on a pair of pants; it cuts through the vastus lateralis. The *band of Richer* wraps around the muscles on the front of the thigh. The long and short heads of the *biceps femoris* create the silhouette of the back of the thigh.

Inside

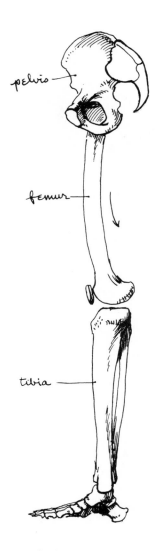

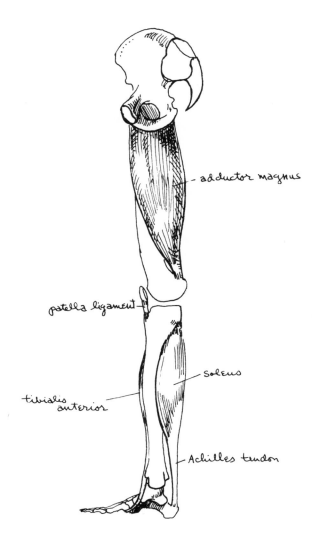

The *femur* curves back under the pelvis. The front of the *tibia* has a slight S curve to it. The tibia sits farther forward at the ankle than the fibula.

The *adductor magnus* covers the entire inside of the thigh. The *tibialis anterior* adds to the S shape of the tibia. It crosses over the foot at the ankle and attaches on the big toe side. The *soleus* originates on the tibia and head of the fibula and attaches to the Achilles tendon. The *patella ligament* holds the patella in place.

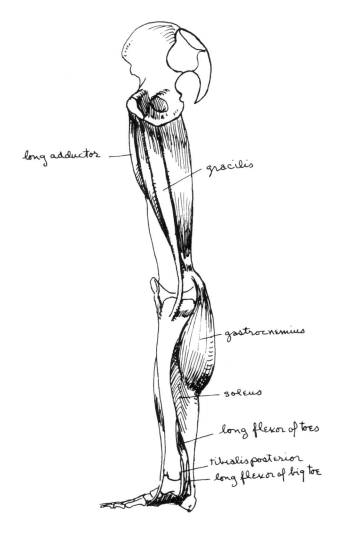

long adductor

gracilis

gastrocnemius

soleus

long flexor of toes

tibialis posterior

long flexor of big toe

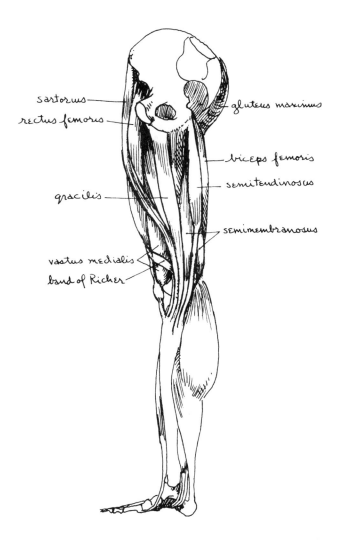

sartorius

rectus femoris

gracilis

vastus medialis

band of Richer

gluteus maximus

biceps femoris

semitendinosus

semimembranosus

The *gracilis* divides the adductor magnus and inserts into the front inside of the head of the tibia. The *gastrocnemius* originates on the back of the femur and attaches into the same tendon as the soleus. The *tendons of the long flexor of the toes, tibialis posterior,* and the *long flexor of the big toe* emerge behind the ankle and insert into the arch under the inside of the foot. The shinbone is exposed on the inner side of the leg.

The *band of Richer* and the *tendons of the sartorius, gracilis, semimembranosus,* and *semitendinosus* form a solid band that wrap around the inside head of the tibia, accenting the shape of the bone underneath. The band of Richer holds in the rectus femoris and the vastus medialis and can be seen when the knee is extended or contracted. The *gluteus maximus* and *biceps femoris* are both muscles on the outside of the leg that make up the silhouette of the back of the buttocks and thigh.

Front View,
Leg Extended with Toes Pointing Out

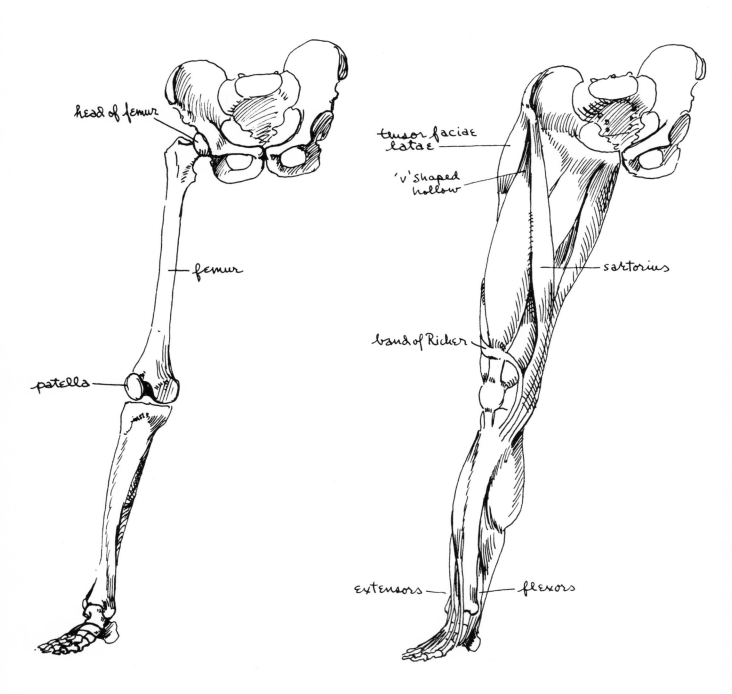

The head of the femur turns toward the back and the patella is forced to the outside at the knee.

A V-shaped hollow is made by the sartorius and tensor faciae latae. The sartorius cuts obliquely across the thigh. The band of Richer contracts and holds muscles firm, causing a groove above the knee. The flexors enter the foot from behind the ankle and insert into the arch. The extensors come down the outside of the leg and enter the foot on the top front side. The shinbone is exposed on the inside of the leg.

Back View,
Leg Extended with Toes Pointing Out

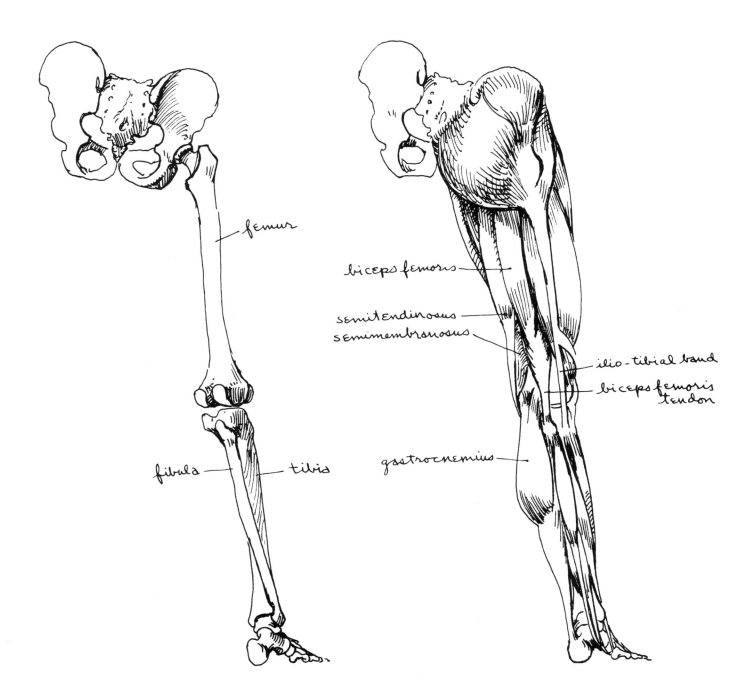

The head of the femur is twisted toward the back, throwing the front of the knee to the outside. The head of the fibula attaches to the outside back of the tibia and intersects it at the ankle.

The iliotibial band and the biceps femoris tendon form two straps on the outside of the knee. The biceps femoris, the semitendinosus, and the semimembranosus form "tongs" that wrap around the gastrocnemius and grab hold below the knee.

**Outside View,
Leg in Flexed Position**

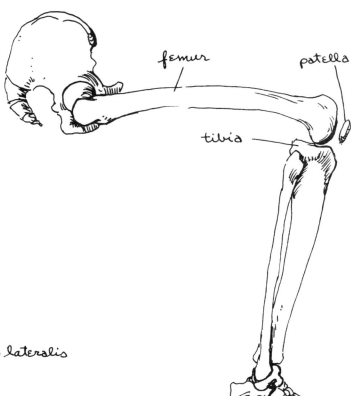

femur

patella

tibia

The round lower head of the femur rides on the flat top of the tibia as the leg is bent to a 90° angle. The patella stays in place as a lock to prevent the knee from bending forward.

tensor faciae latae

vastus lateralis

gluteus maximus

biceps femoris Tendon

The tensor faciae latae bulges when it flexes the thigh and the gluteus maximus relaxes and stretches. The vastus lateralis creates a deep groove in the outside of the leg. The biceps femoris hardens and its tendon becomes prominent.

**Inside View,
Leg in Flexed Position**

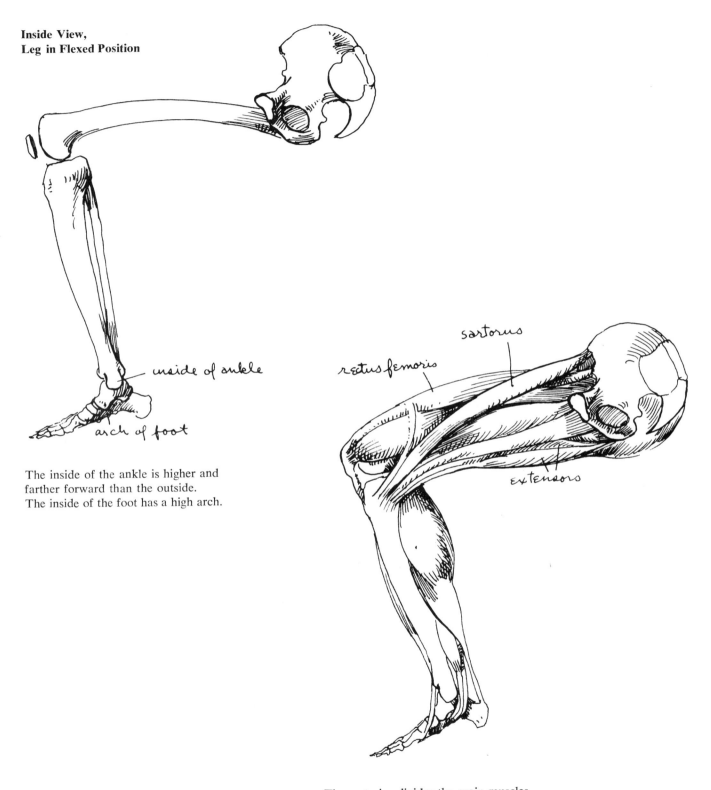

inside of ankle

arch of foot

The inside of the ankle is higher and
farther forward than the outside.
The inside of the foot has a high arch.

sartorius

rectus femoris

extensors

The sartorius divides the groin muscles
from the muscles of the front of the
leg. The rectus femoris flexes the
thigh as well as extends the leg. The
extensors are relaxed.

**Front View, Inside of Flexed Leg,
with Knee Pointed Out**

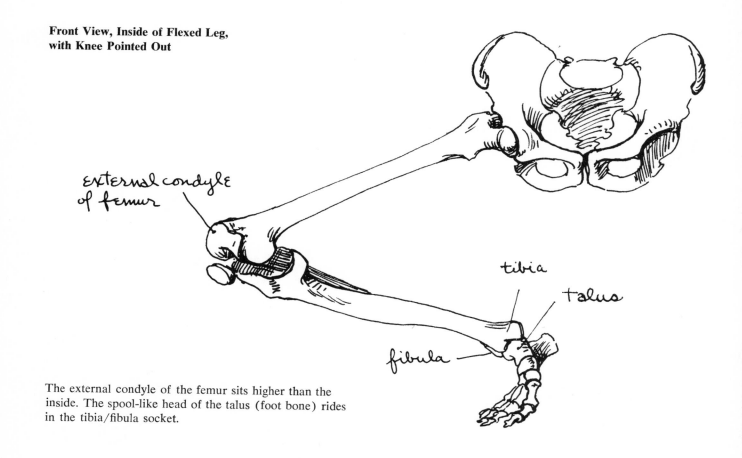

The external condyle of the femur sits higher than the
inside. The spool-like head of the talus (foot bone) rides
in the tibia/fibula socket.

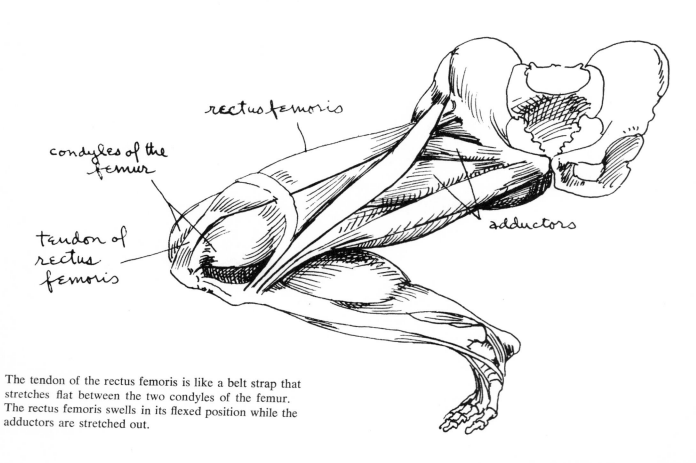

The tendon of the rectus femoris is like a belt strap that
stretches flat between the two condyles of the femur.
The rectus femoris swells in its flexed position while the
adductors are stretched out.

Pelvis

The pelvis is two heads wide in the female and one-and-a-half heads wide in the male. Its height is equal to one head. The inclination of the male pelvis, in a standing position, is more upright than that of the female. In the female the crest of the ilium projects more forward.

Key

1. Ilium
2. Pubis
3. Ischium
4. Iliac crest
5. Anterior superior iliac spine
6. Anterior inferior iliac spine
7. Acetabulum
8. Pubic arch
9. Pubic symphysis
10. Iliac tuberosity
11. Spine of ischium
12. Tuberosity of ischium
13. Coccyx
14. Sacrum
15. Sacroiliac joint

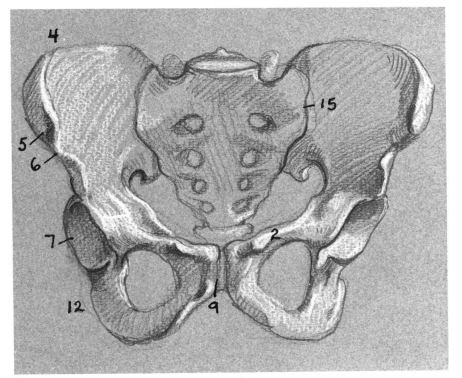

Front view.

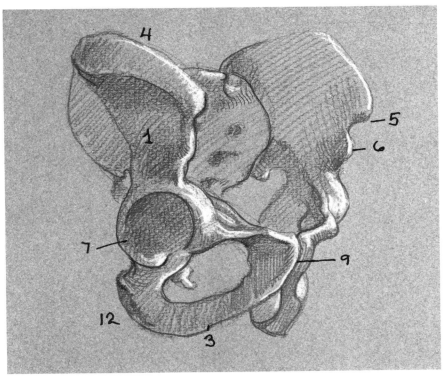

One-quarter turn to right.

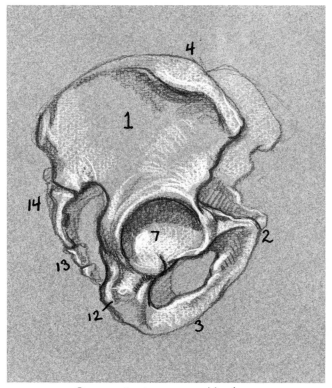

One-quarter turn more, side view.

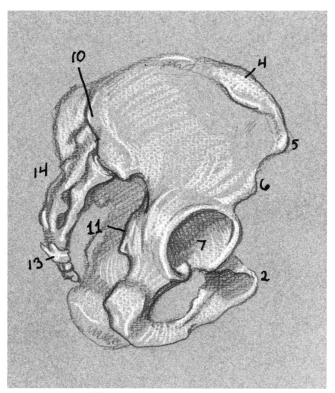

Three-quarters turn to right.

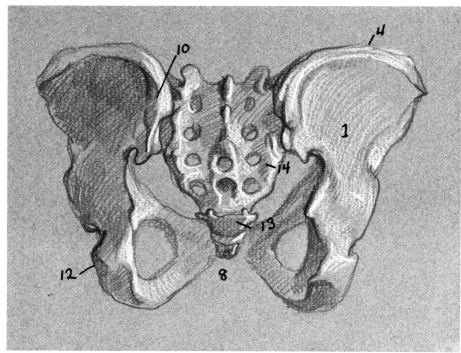

Back view.

Pelvis

Key

1. Ilium
2. Pubis
3. Ischium
4. Iliac crest
5. Anterior superior iliac spine
6. Anterior inferior iliac spine
7. Acetabulum
8. Pubic arch
9. Pubic symphysis
10. Iliac tuberosity
11. Spine of ischium
12. Tuberosity of ischium
13. Coccyx
14. Sacrum
15. Sacroiliac joint

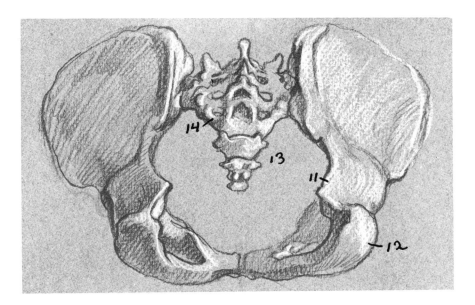

Back view, viewed from underneath.

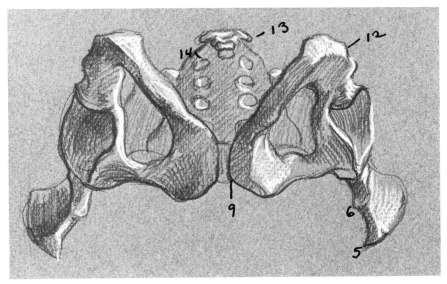

Viewed from directly underneath.

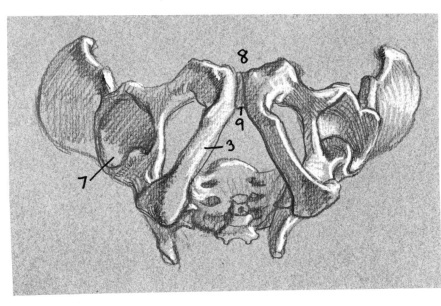

Front view, viewed from underneath.

Upper Leg (Femur)

Key

1. Head
2. Neck
3. Great trochanter
4. Small trochanter
5. Shaft
6. Linea aspera
7. Surface for attachment of gluteus maximus
8. External condyle
9. Internal condyle
10. Adductor tubercle
11. Patella surface
12. Intercondylar notch

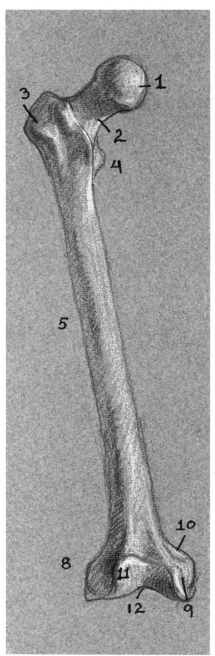

Front view.

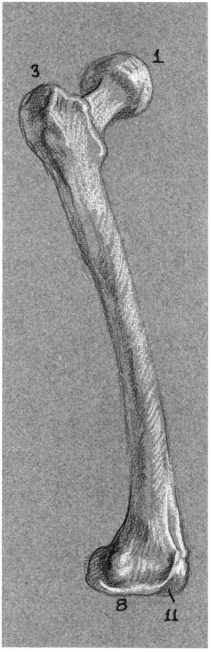

One-eighth turn to right.

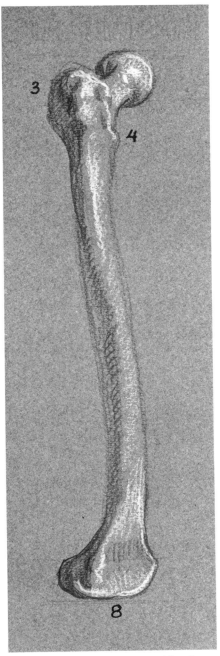

One-eighth turn more, outside view.

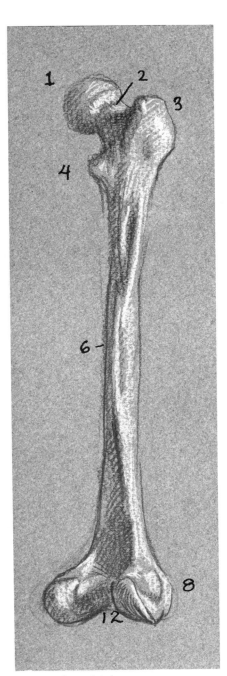

One-eighth turn more.

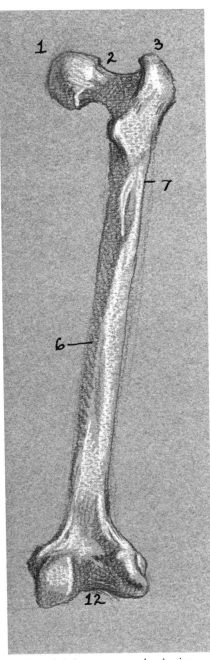

One-eighth turn more, back view.

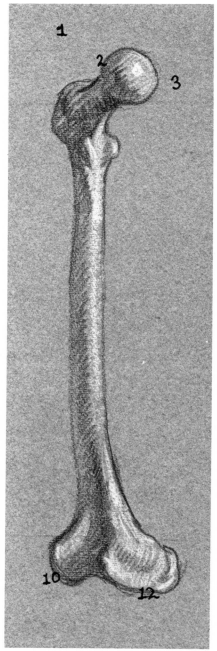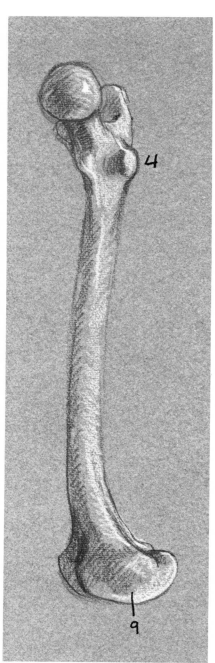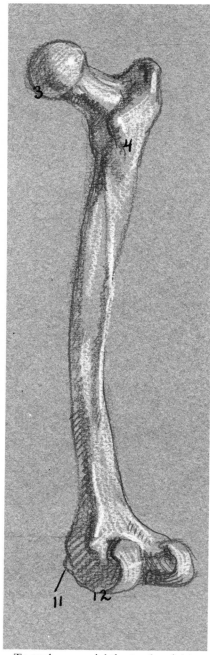

One-eighth turn more. One-eighth turn more, inside view. Turned seven-eighths to the right.

Upper Leg (Femur)

Key

1. Head
2. Neck
3. Great trochanter
4. Small trochanter
5. Shaft
6. Linea aspera
7. Surface for attachment

 of gluteus maximus
8. External condyle
9. Internal condyle
10. Adductor tubercle
11. Patella surface
12. Intercondylar notch

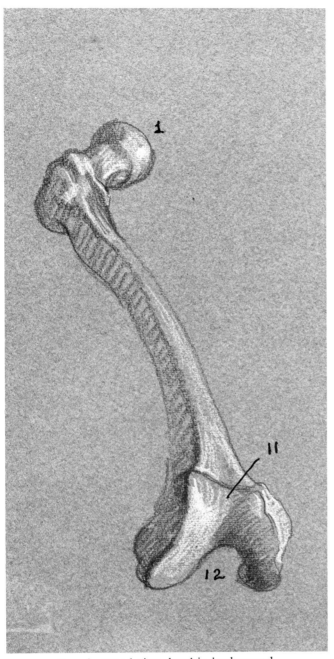

Foreshortened view, head in background.

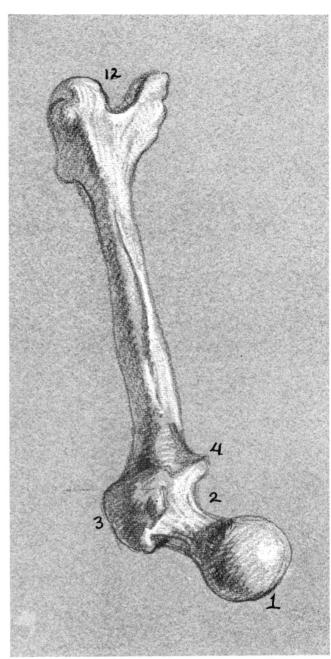

Foreshortened view, head in foreground.

Hip Joint

The head of the femur fits into the acetabulum of the pelvis in a ball-and-socket joint that enables the femur to rotate freely in all directions.

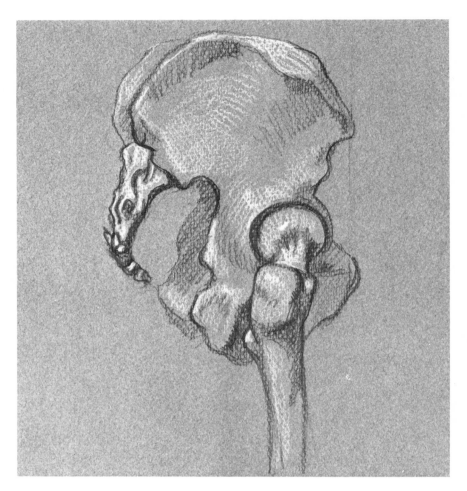

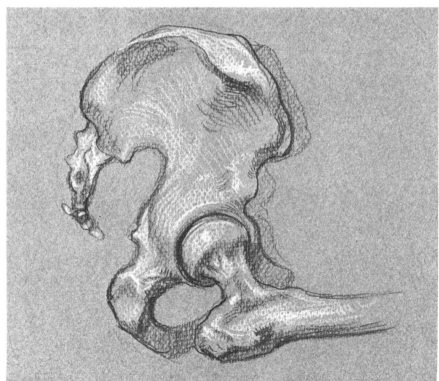

(Above) Outside view of the pelvis with the femur in a normal stand-up position. The great trochanter and the pubis are in a line and designate the fourth head measurement (middle) of the body.

Outside view of the pelvis with the femur raised forward. The head rides in the acetabulum socket.

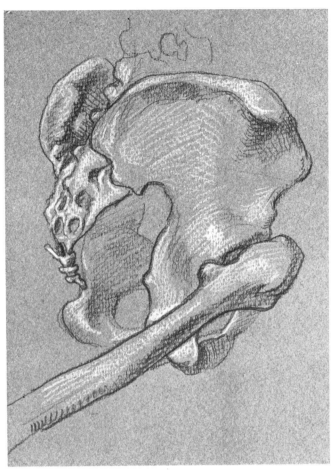

Outside view of the pelvis with leg pulled back.

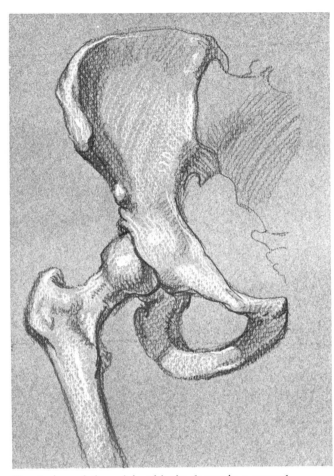

Front view of the pelvis with the femur in a normal stand-up position. Note downward angle of femur under the pelvis.

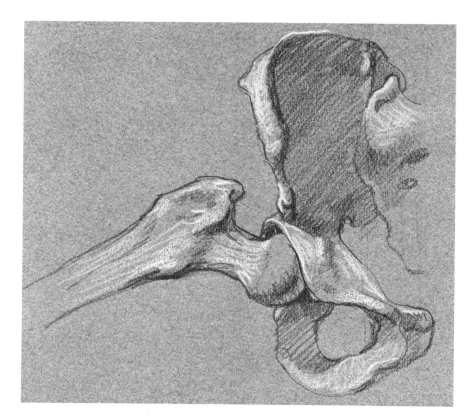

Front view of the pelvis with the leg
pulled out and away from the center.

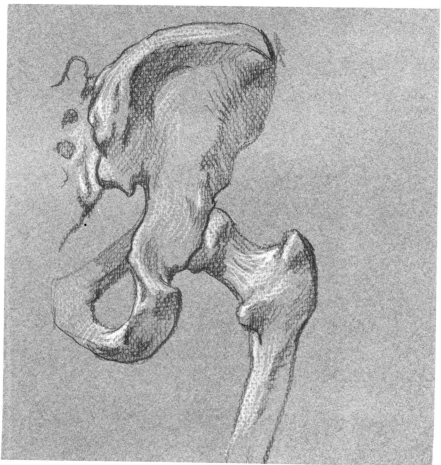

Back view of the pelvis with the femur
in a normal stand-up position.

Lower Leg (Tibia and Fibula)

There are two bones in the lower part of the leg: the *tibia* and the *fibula*. The tibia is the larger bone and the fibula attaches to it. The fibula attaches to the rear of the tibia head and intersects the tibia at the ankle, where it is the longer bone. The kneecap, called the *patella,* is attached to the tibia by a strong ligament (not shown) and rides in front of the femur.

Key

1. Tibia

 a. Tubercle of tibia, to which the ligament of the patella is attached
 b. External tuberosity
 c. Internal tuberosity
 d. Internal malleolus
 e. Crest of tibia

2. Fibula

 f. Head of fibula
 g. External malleolus
 h. Groove for tendons of peroneal muscles

3. Patella

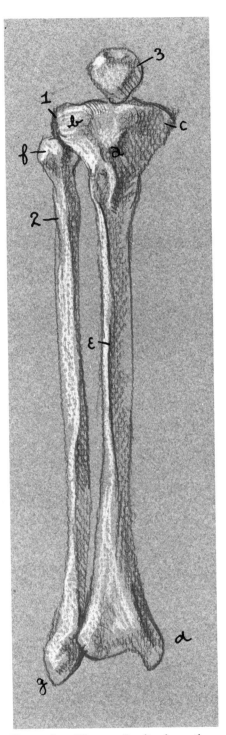

Front view. The patella sits above the head of the tibia. The fibula is longer at the ankle, making the outside of the ankle always lower than the inside. The tubercle and the external tuberosity and internal tuberosity of the tibia form a triangle seen on the front part of the leg.

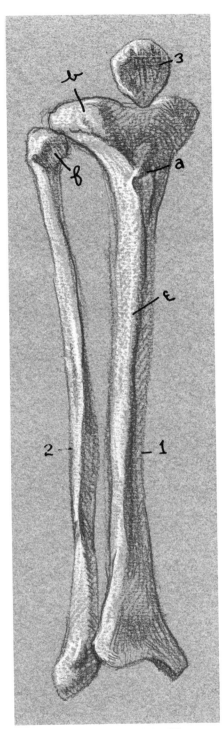

One-eighth turn to the right. The crest of the tibia (shinbone) has an S curve to it.

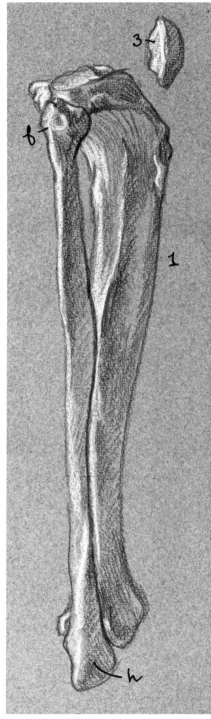

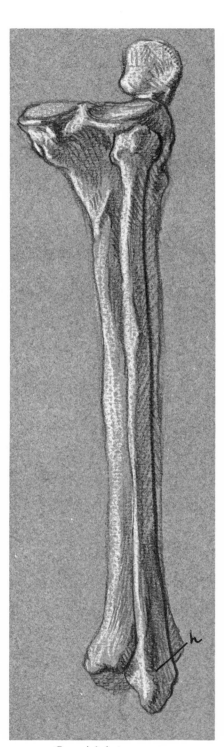

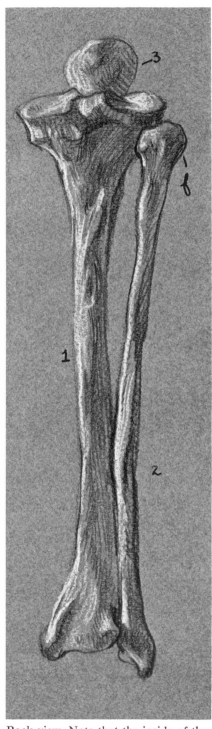

Outside view. The fibula intersects the distal end of the tibia, fitting into a notch on the tibia.

One-eighth turn more.

Back view. Note that the inside of the ankle is higher than the outside. The head of the fibula fits onto the back part of the head of the tibia.

For key to figures see page 107.

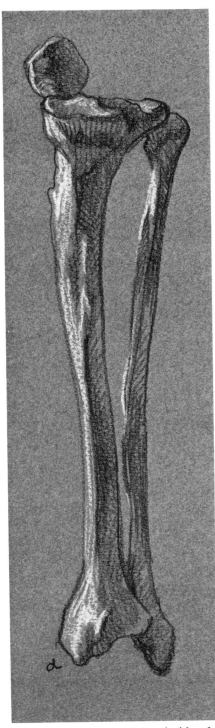

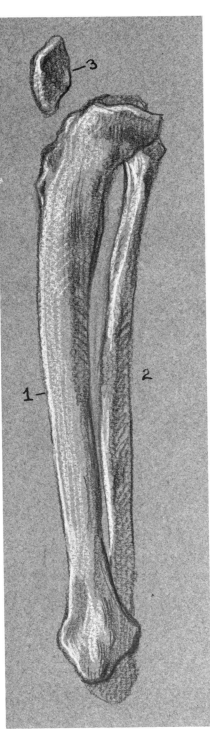

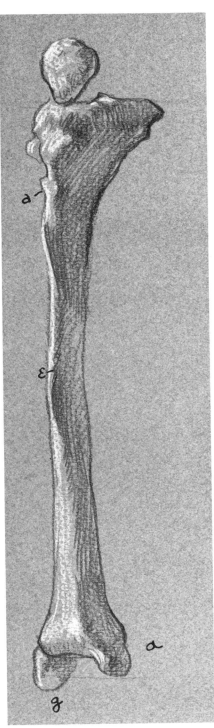

One-eighth turn more. Note inside of
the ankle is larger than the outside.

Inside view.

Turned seven-eighths to the right.

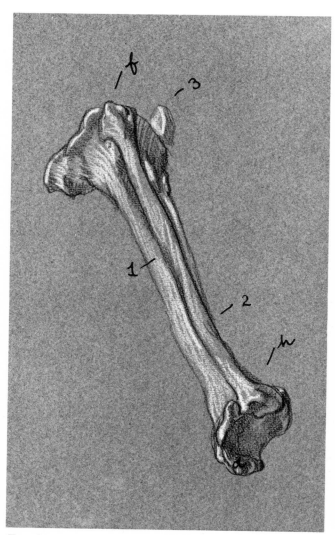

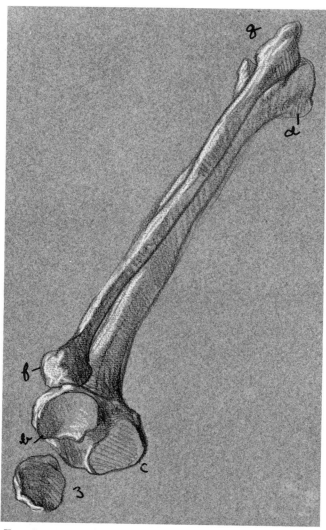

Foreshortened with the distal end in the foreground.

Foreshortened with the proximal end in the foreground. Note the flat articular surfaces of the external and internal tuberosities.

Lower Leg (Tibia and Fibula)

Key

1. Tibia

 a. Tubercle of tibia, to which the ligament of the patella is attached.
 b. External tuberosity
 c. Internal tuberosity
 d. Internal malleolus
 e. Crest of tibia

2. Fibula

 f. Head of fibula
 g. External malleolus
 h. Groove for tendons of peroneal muscles

3. Patella

Knee Joint

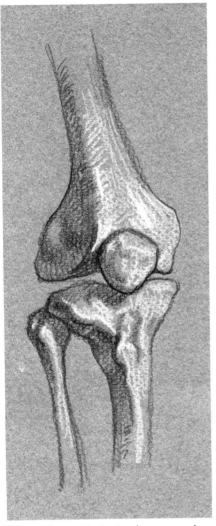

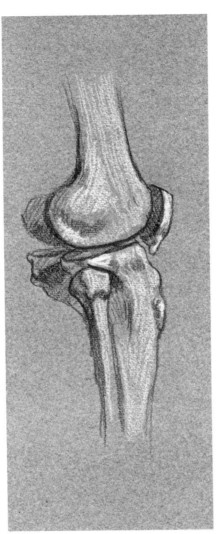

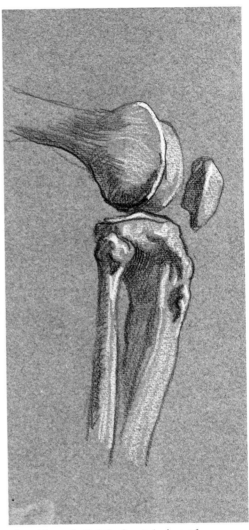

Front view with the leg in a normal standing position. The patella locks against the patella surface of the femur, preventing the leg from bending forward.

Outside and slightly rear view with the knee in a straight, locked position.

Outside and slightly frontal view of the knee bent at a 90° angle. The condyles of the femur roll on the tuberosities of the tibia and the patella stays in place.

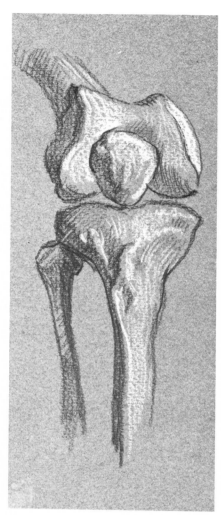

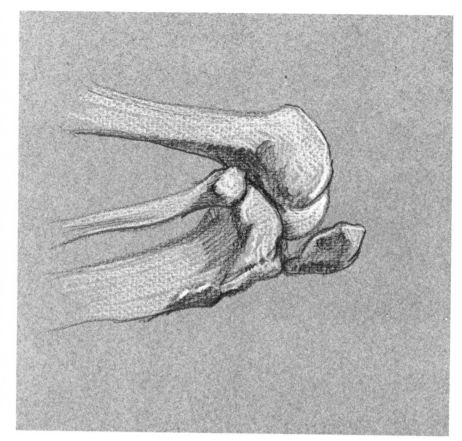

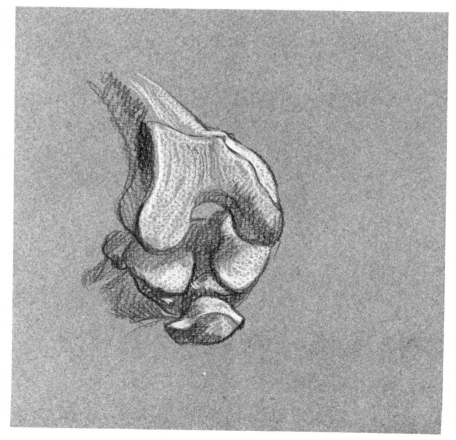

(Above) Front view of the knee bent at a 90° angle. The external condyle of the femur is higher than the inside. The patella sits in the intercondylar notch of the femur.

(Above right) Outside view, seen slightly from below. The knee is bent as far as possible.

Front view of the knee bent as far as possible. Note the condyles of the femur riding on the flat surfaces of the tuberosities of the tibia.

Bones of the Foot

The foot is composed of three parts: the *tarsals, metatarsals,* and the *phalanges.* There are two important arches that are formed which serve as springs and absorb much of the body weight. One arch runs from heel to toe and is more evident on the inside of the foot. The other runs from side to side and consists of the tarsal and metatarsal bones; the big toe side is the highest point of the arch.

Key

1. Tarsals

 a. Talus
 b. Fibular surface of the talus
 c. Tarsal cavity
 d. Navicular
 e. Cuboid
 f. First cuneiform
 g. Second cuneiform
 h. Third cuneiform
 i. Calcaneus
 j. Ledge of calcaneus
 k. Tibial surface of talus

2. Metatarsals

 l. Five metatarsal bones, numbered 1 to 5 beginning with the big toe
 m. Tuberosity of the fifth metatarsal

3. Phalanges

 n. Five first phalanges (proximal phalanx)
 o. Five second phalanges
 p. Four third phalanges
 q. Sesamoid

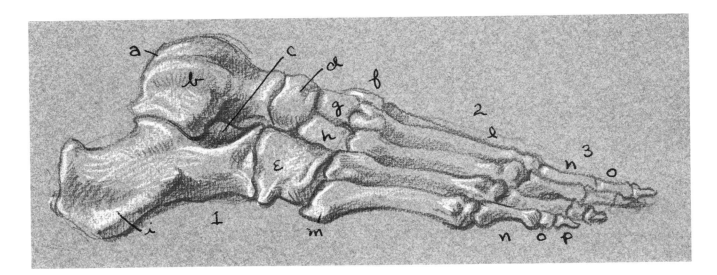

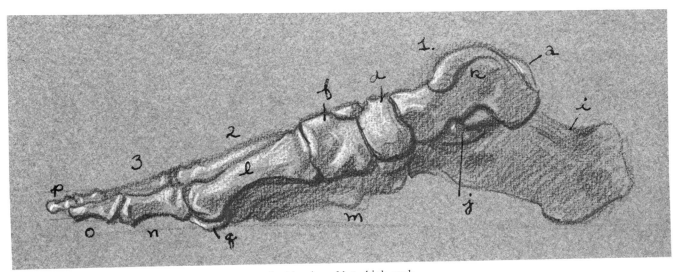

Inside view. Note high arch.

For key to figures see page 113.

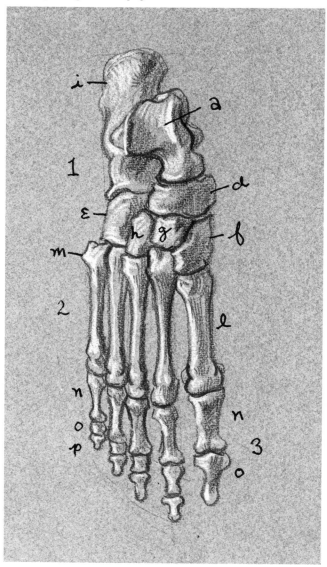

Top of foot.

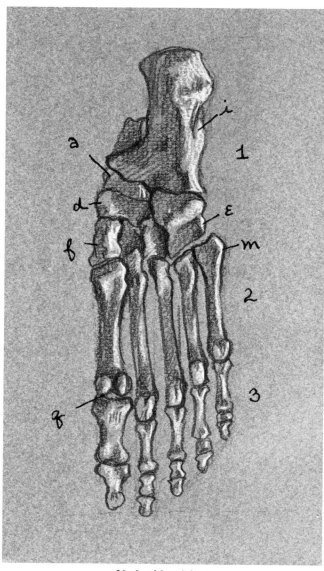

Underside of foot.

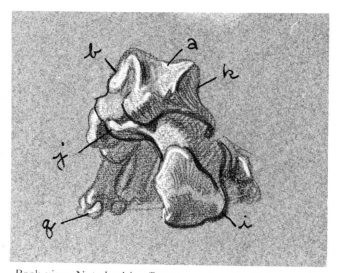

Back view. Note heel is off-center and on the little toe side.

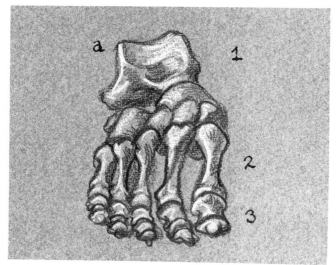

Front view. The tarsals and metatarsals form arch.

Ankle Joint

The movements of the foot on the ankle are more limited than those of the hand on the wrist. The major movement is hinge-like.

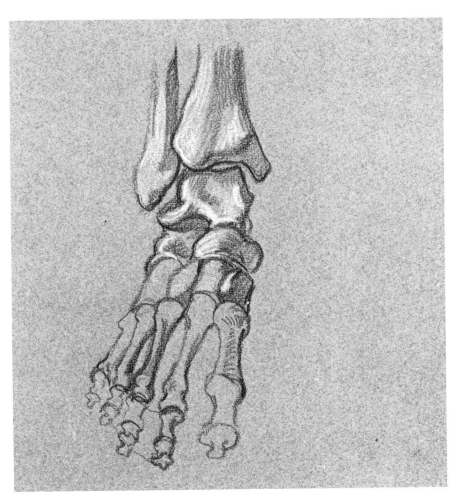

(Right) Front view seen from slightly above. The external malleolus of the fibula rides on the fibular surface of the talus. The internal malleolus of the tibia rides on the spool-shaped tibial surface of the talus. The inside of the ankle is higher than the outside.

(Below) Inside view with the toes pointed down. The internal malleolus rides farther forward on the talus than the external malleolus.

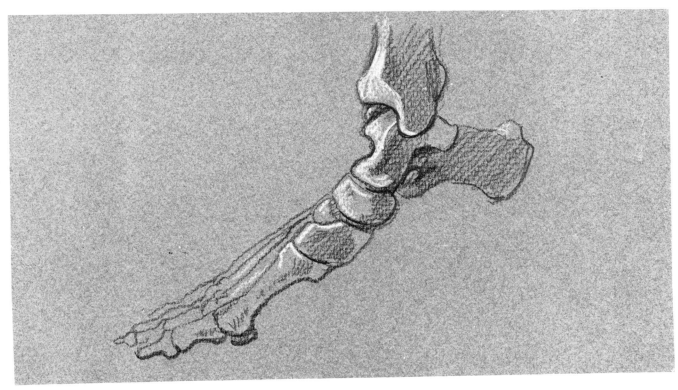

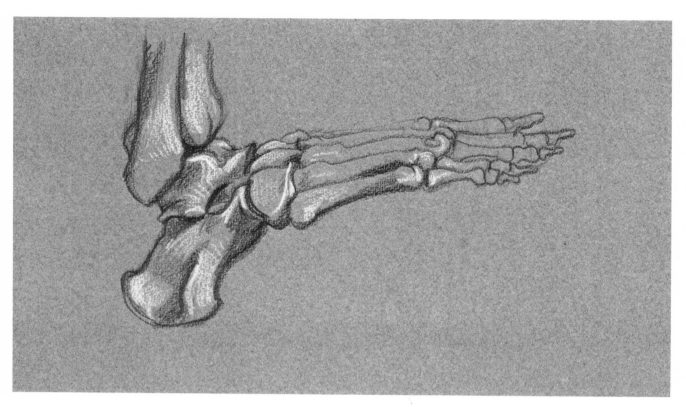

(Above) Outside view with the front of the foot raised. The external malleolus of the fibula sits farther back than the internal side.

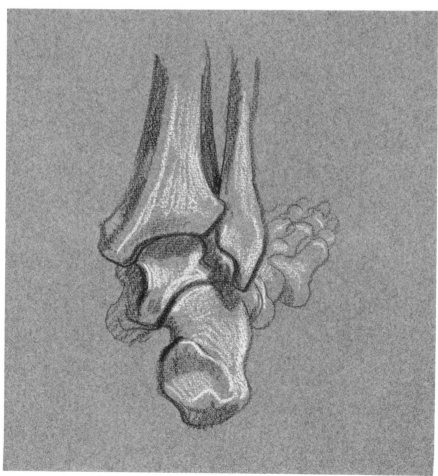

Back view seen from slightly above. The tibia and fibula form a socket for the talus to ride in.

The Leg

Key

A. Gluteus medius
B. Tensor fasciae latae
C. Sartorius
D. Pectineus
E. Long adductor
F. Adductor magnus
G. Gracilis
H. Rectus femoris
I. Vastus lateralis
J. Vastus medialis
K. Band of Richer
L. Iliotibial band
M. Long peroneus
N. Tibialis anterior
O. Long extensor of toes
P. Patella ligament
Q. Short peroneus
R. Peroneus tertius
S. Long extensor of big toe
T. Biceps femoris (two heads)
U. Soleus
V. Gastrocnemius
W. Long flexor of toes
X. Tibialis posterior
Y. Semimembranosus
Z. Achilles tendon
A1. Long flexor of big toe
B1. Semitendinosus
C1. Gluteus maximus
D1. Patella
E1. Head of fibula
F1. Iliac crest ⎫
G1. Pubis ⎪ Bones
H1. Internal malleolus ⎬ visible
I1. External malleolus ⎪ on surface,
J1. Great trochanter ⎭ not covered
by muscle

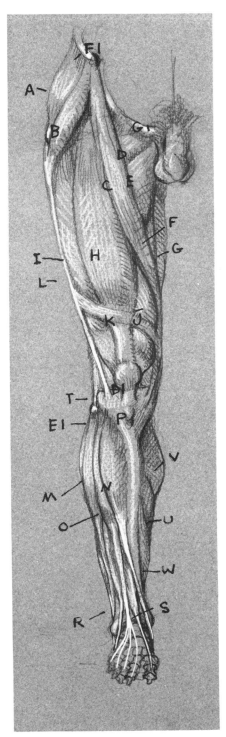

Front view.

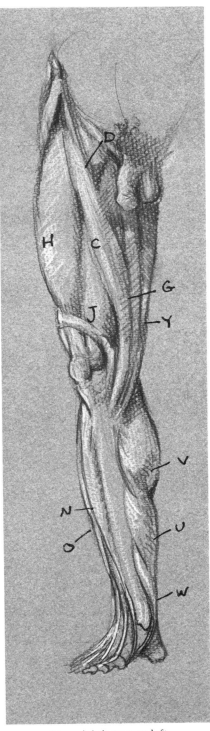

One-eighth turn to left.

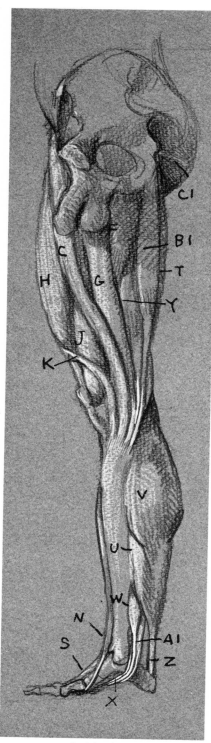

Inside view.

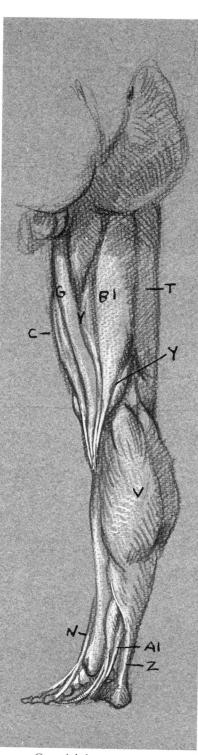

One-eighth turn more.

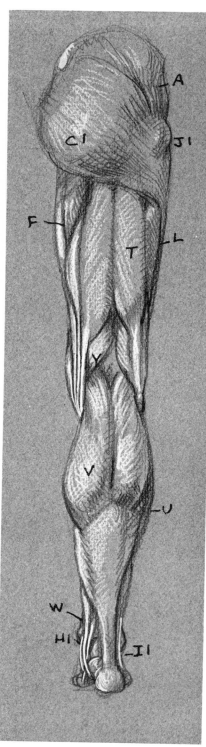

Back view.

For key to figures see page 117.

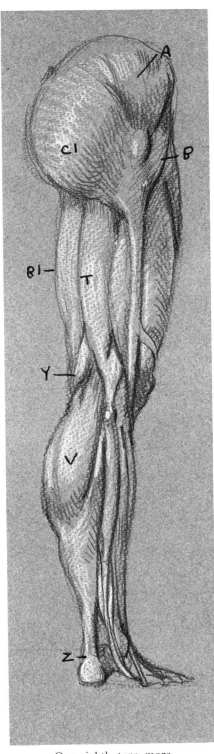

One-eighth turn more.

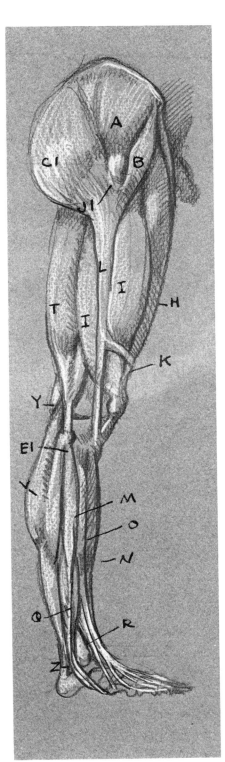

Outside view.

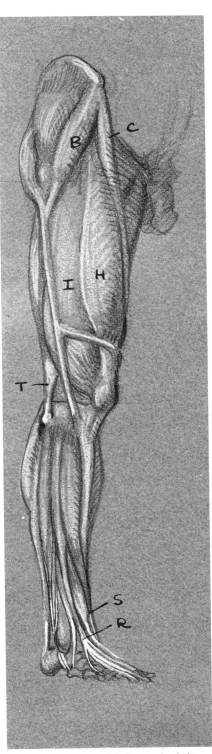

Turned seven-eighths to the left.

TABLE OF MUSCLE ORIGINS AND INSERTIONS

MUSCLE	ORIGIN	INSERTION	ACTION
A. Gluteus medius	Lateral surface of ilium	Great trochanter of femur	Abducts thigh
B. Tensor fasciae latae	Anterior superior iliac spine	Iliotibial band	Flexes and abducts thigh, helps to rotate it inward
C. Sartorius	Anterior superior iliac spine	Behind internal condyle of femur to internal tuberosity of tibia	Flexes and abducts thigh, rotates it outward; helps to flex leg
D. Pectineus	Pubis	Below small trochanter of femur	Adducts and flexes thigh, rotates it outward
E. Long adductor	Pubis	Linea aspera of femur	Adducts and flexes thigh
F. Adductor magnus	Ischium	Linea aspera and internal condyle of femur	Adducts and extends thigh
G. Gracilis	Pubis and ischium	Tuberosity of tibia behind sartorius	Adducts and flexes thigh; helps to flex leg and rotate it inward
H. Rectus femoris	Anterior inferior iliac spine	Tendon to patella (common tendon with vastus laterialis and vastus medialis)	Extends leg, flexes and abducts thigh
I. Vastus lateralis	Great trochanter and linea aspera of femur	Tendon to patella	Extends leg
J. Vastus medialis	Linea aspera of femur	Tendon to patella	Extends leg
K. Band of Richer	iliotibial band	Tuberosity of tibia in front of sartorius	Encloses the lower part of thigh muscles
L. Iliotibial band	Great trochanter area	External tuberosity of tibia	Binds long thigh muscles
M. Long peroneus	Head and outer surface of fibula	Sole of foot	Flexes foot and big toe, inverts and adducts foot
N. Tibialis anterior	External tuberosity of tibia	Underside of first cuneiform and base of first metatarsal	Raises foot, inverts and adducts it
O. Long extensor of toes	External tuberosity of tibia, head and crest of fibula	Down front of ankle, splits into four tendons, then to second–fifth phalanges	Raises foot, raises toes two–five
P. Patella ligament	Tubercle of tibia	Patella	Holds patella in place
Q. Short peroneus	Outer surface of fibula	Tuberosity of fifth metatarsal	Points foot, abducts foot
R. Peroneus tertius	Long extensor of toes	Base of fifth metatarsal	Raises foot, raises toes two–five
S. Long extensor of big toe	Surface of fibula shaft	Base of second phalanx of big toe	Raises foot and big toe, abducts foot
T. Biceps femoris *Short head* *Long head*	Linea aspera of femur } Tuberosity of ischium }	Head of fibula	Extends thigh backward, adducts it, rotates it outward
U. Soleus	Head of fibula, back of fibula and tibia shafts	Achilles tendon to calcaneus	Points foot, inverts and adducts foot
V. Gastrocnemius	Above external and internal condyles of femur	Achilles tendon to calcaneus	Points foot, inverts and adducts foot
W. Long flexor of toes	Back surface of tibia shaft	Behind ankle into sole of foot	Flexes second phalanx of toes two–five, points foot
X. Tibialis posterior	Back surface of tibia shaft	Navicular bone	Adducts, inverts, and flexes foot
Y. Semimembranosus	Tuberosity of ischium	Internal tuberosity	Extends thigh, flexes lower leg
Z. Achilles tendon	Common tendon of soleus and gastrocnemius	Calcaneus (heel)	Extends foot and helps keep body erect in standing position
A1. Long flexor of big toe	Back surface of fibula	Base of second phalanx of big toe (underside)	Flexes big toe and adducts foot
B1. Semitendinosus	Tuberosity of ischium	Internal tuberosity of tibia	Extends thigh, adducts it, rotates it inward; flexes leg, rotates it inward
C1. Gluteus maximus	Lateral surface of ilium, sacrum, and coccyx bones	Below trochanters of femur into iliotibial band and tensor faciae latae	Extends thigh backward, adducts it, rotates it outward

D1. Patella
E1. Head of fibula
F1. Iliac crest
G1. Pubis } Bones visible on surface, not covered by muscle
H1. Internal malleolus
I1. External malleolus
J1. Great trochanter

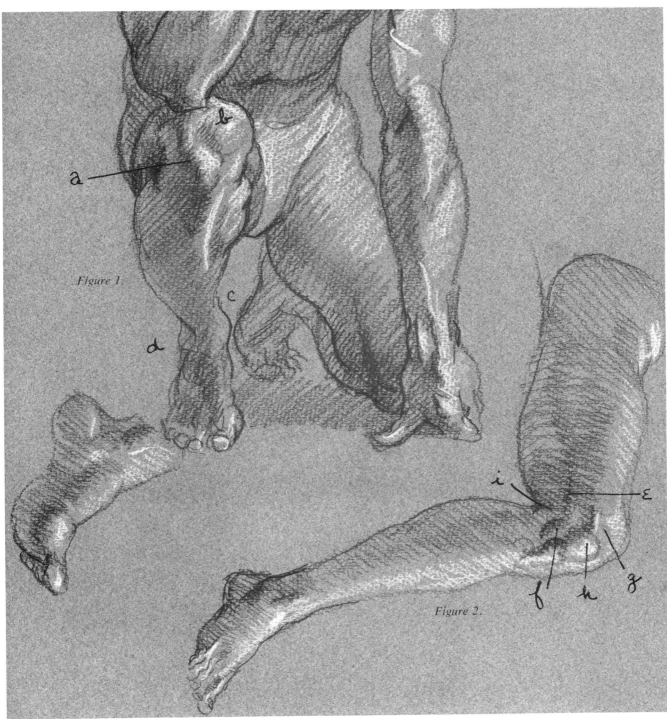

Figure 1.

Figure 2.

Figure 1. The patella (a) stays in place as the knee is bent back, and the vastus medialis (b) covers the internal condyle of the femur making the inside of the bent knee higher than the outside. The internal malleolus (c) is larger and higher than the external malleolus (d).

Figure 2. The iliotibial band (e) attaches to the external tuberosity of the femur (f). Above it can be seen the tendon of the rectus femoris (g) attaching to the patella (h), and below it the head of the fibula (i) protrudes.

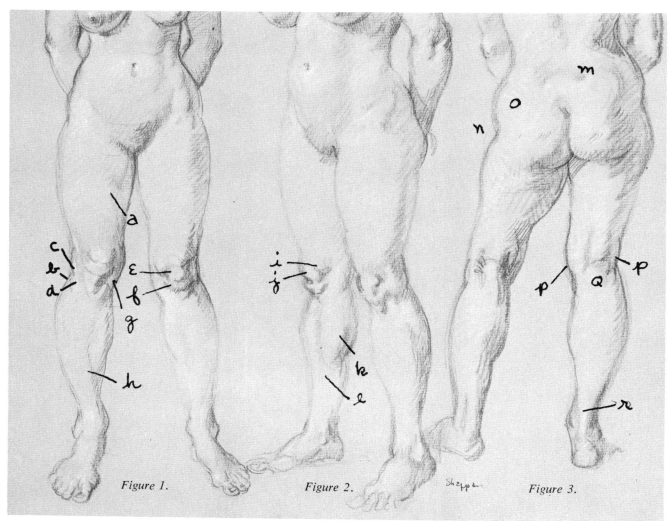

Figure 1. Figure 2. Figure 3.

Figure 1. The sartorius (a) runs obliquely down the front of the thigh. The tendons of the biceps femoris (b) and the iliotibial band (c) come from the back and side into the front of the external tuberosity of the tibia (d). Under the patella (e) a small ball of fat (f) covers the patella ligament. The tendons on the inside of the leg follow the same angle of the internal tuberosity of the tibia (g) and create a continuous spiraling line down the crest of the tibia (h) to the inside of the ankle.

Figure 2. The vastus medialis (i) attaches to the top and side of the patella (j). The gastrocnemius (k) and soleus (l) cover most of the inside of the calf.

Figure 3. The female buttocks are heavier than the male. The two dimples in the back are caused by the iliac tuberosities (m). The great trochanter (n) becomes an indentation instead of a protuberance. The gluteus maximus (o) forms the shape of butterfly wings. The tendons on the back of the thigh (p) wrap around the inserting gastrocnemius (q) and forms an H shape. The Achilles tendon (r) attaches to the heel, and the inside of the ankle is higher than the outside.

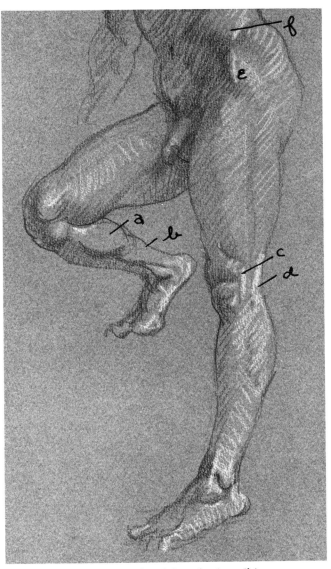

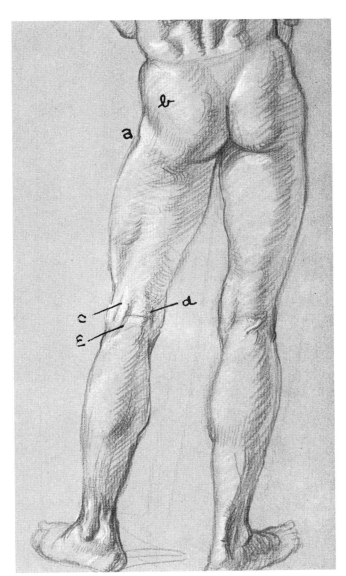

(Above) The gastrocnemius (a) and soleus (b) are very pronounced on the inside of the calf. The iliotibial band (c) and biceps femoris (d) create two straps on the outside of the knee. The tensor fasciae latae (e) angles back from the iliac crest (f) to the outside of the leg.

(Above right) The great trochanter (a) protrudes on the male, and the gluteus maximus (b) forms the shape of butterfly wings from the back. The tendons of the biceps femoris (c), semitendinosus (d), and gastrocnemius (e) form an H shape on the back of the knee.

The tendon of the biceps femoris (a) is very prominent on the outside of the knee. The patella (b) stays in place on the bent knee and is attached by a ligament to the tubercle of the tibia (c). The tibialis anterior (d) crosses over to the big toe side at the ankle.

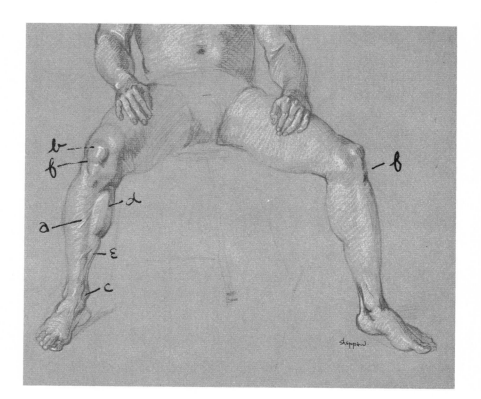

The crest of the tibia (a) curves from the patella (b) down to the internal malleolus (c), the gastrocnemius (d) and soleus (e) attach behind it. The tubercle of the tibia (f) is obvious on both knees.

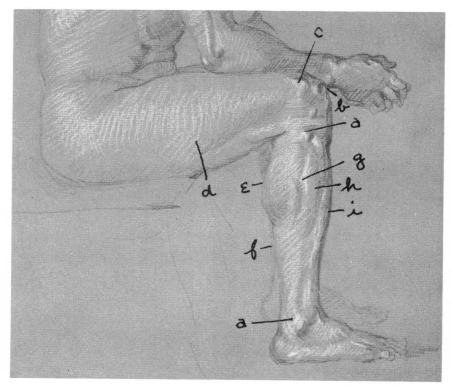

The fibula can be seen at both extremities (a) and the patella (b) is visible sitting in front of the sharp external condyle of the femur (c). The large vastus lateralis is marked on the thigh (d). The gastrocnemius (e), soleus (f), long peroneus (g), long extensor of the toes (h), and the tibialis anterior (i) form the outside of the lower leg. The tendons of the tibialis anterior and the long extensor of the toes pull out at the ankle and enter the top of the foot.

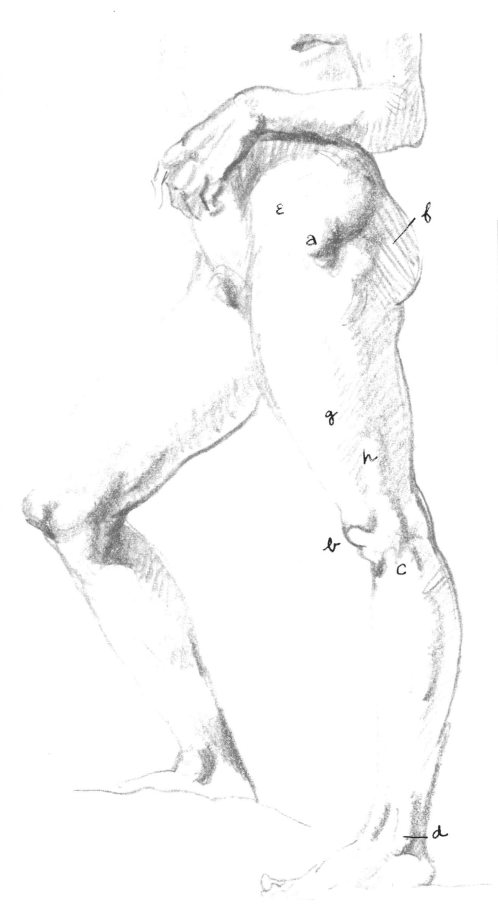

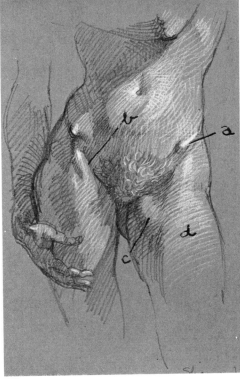

(Above) The anterior superior iliac spine (a) pushes out and holds the stomach. The origin of the satorius (b) is visible on the right leg, and on the left leg it can be seen dividing the groin muscles (c) from the rectus femoris (d)

The left leg is in its locked position. The bones, great trochanter (a), patella (b), head of fibula (c), and the distal end of the fibula (d) can be seen. The gluteus medius (e) and gluteus maximus (f) attach around the great trochanter and into the iliotibial band (g). The vastus lateralis (h) makes a deep groove on the outside of the thigh.

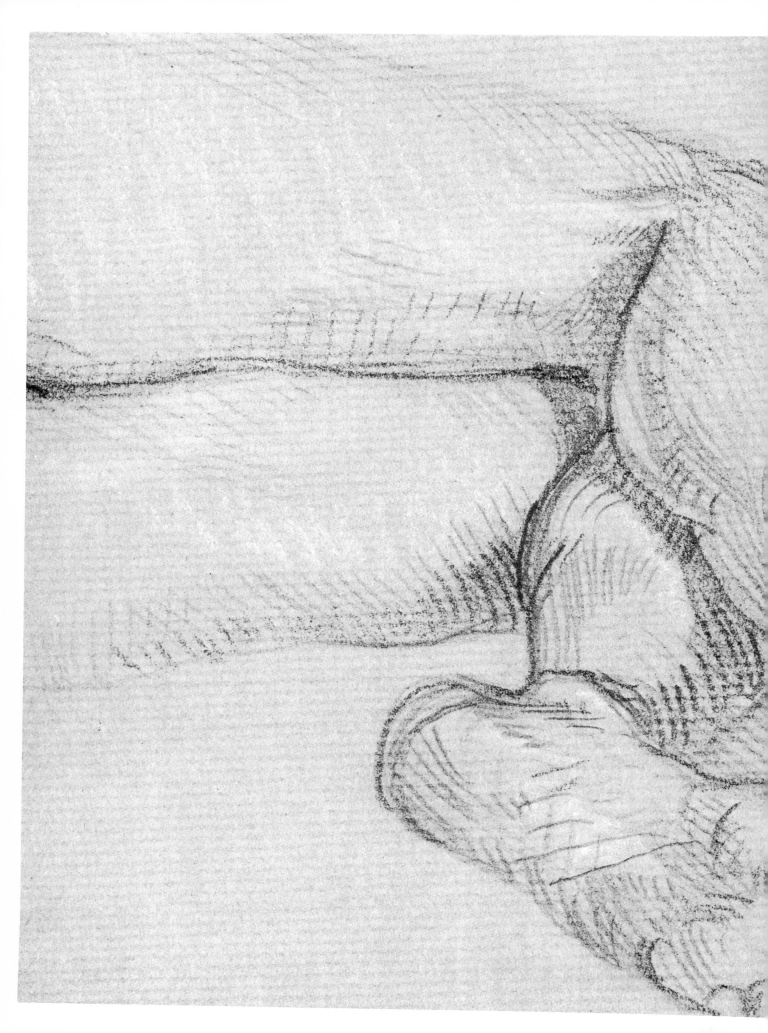

5. THE FOOT

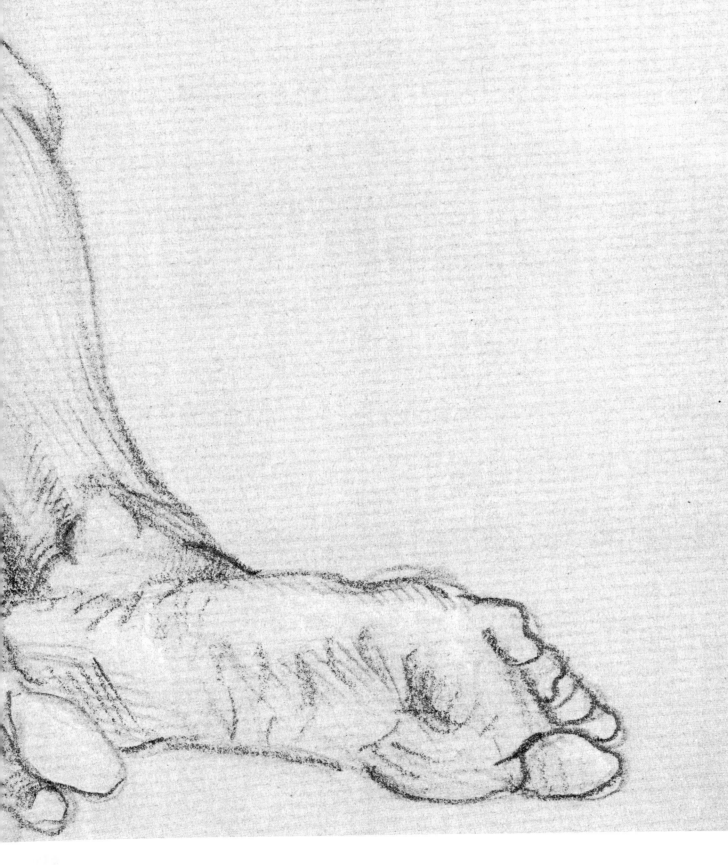

SCHEMATIC DRAWINGS

Outside

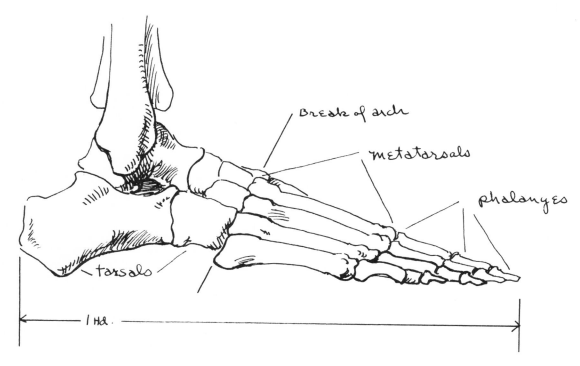

Break of arch

metatarsals

phalanges

tarsals

1 Hd.

The foot is one head in length and it arches from the heel to the metatarsals. The arch breaks at the bases of the first and fifth metatarsals, which divide the foot in half. There are seven *tarsals* and five *metatarsals*. There are three *phalanges* for each toe, except the big toe which has only two.

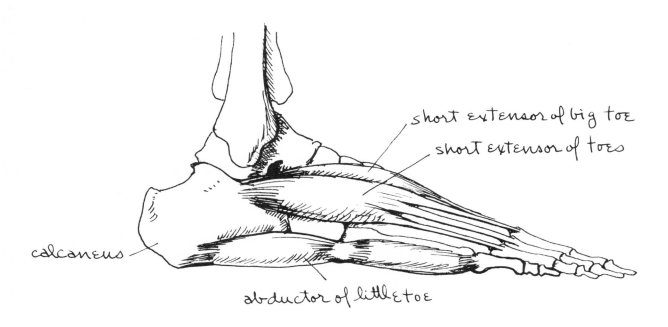

short extensor of big toe

short extensor of toes

calcaneus

abductor of little toe

The *abductor of the little toe* attaches from the heel and inserts into the fifth metatarsal and the first phalanx of the little toe. It flattens out the outside edge of the foot. The *short extensor of the toes* (two–five) *and the short extensor of the big toe* attach to the *calcaneus* (heel bone) and cross obliquely over the top of the foot.

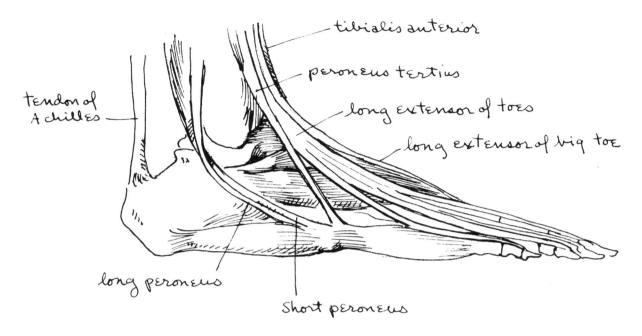

Most of the muscles for the foot and toes are actually in the calf; only their tendons enter the foot. The *Achilles tendon* attaches to the heel. The *long and short peroneus muscles* turn behind the fibula and down toward the base of the fifth metatarsal. The *peroneus tertius* along with the *long extensor of the toes* comes down the front of the ankle. The *long extensor of the big toe* and the *tibialis anterior* cross over the ankle to the inside

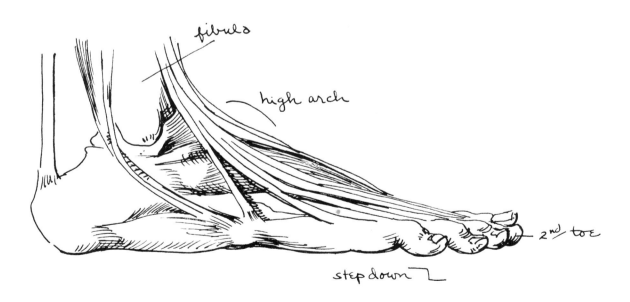

There is a stepdown on the toes to the toenails. The second toe is longer than the big toe. The outside of the sole of the foot is flat. The big toe side has a high arch, and the fibula is in the center of the ankle.

Inside

The big toe side of the foot has a high arch that acts as a spring. The *navicular* and the *first metatarsal* are prominent. The big toe has one phalanx fewer than the other toes and is slightly shorter than the second toe.

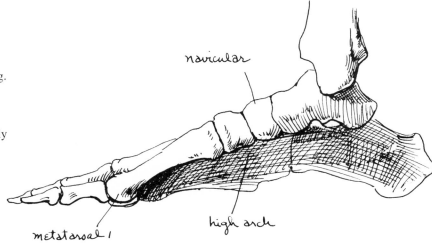

The *abductor of the big toe* and the *short flexor of the big toe* pass forward along the inner border of the arch of the foot. They cover the sesamoid bones and attach to the first phalanx of the big toe, helping to form the ball of the foot. The *tibialis anterior* and *long extensor of the big toe* form a bridge on the front of the ankle. In the back, the *Achilles tendon* attaches to the calcaneus.

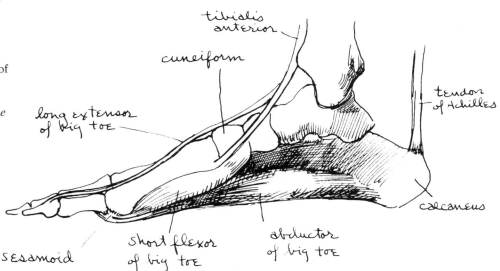

The *flexors of the foot and toes* come down behind the tibia and under the arch of the foot. The arch protects them from the weight of the body.

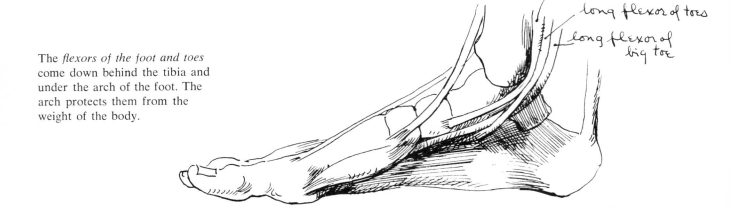

Front

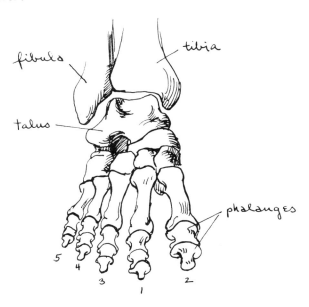

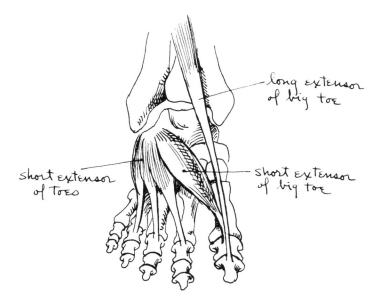

The *talus* rides like a hinge in the joint formed by the tibia and fibula. The inside of the ankle is higher than the outside. The big toe has only two phalanges, while the other toes have three. In this illustration the toes are numbered in order of their length, although they are normally numbered from one through five, starting with the big toe.

The *short extensor of the big toe* and the *short extensor of the toes* (two–five) attach to the outside of the calcaneus and cross obliquely over the foot, hiding the form of the bones. The *long extensor of the big toe,* starting up in the lower leg, also cuts obliquely across the ankle. It makes a high silhouette on the front of the ankle.

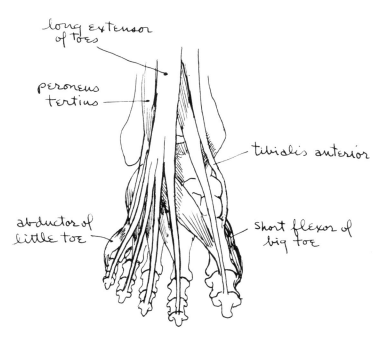

The *long extensor of the toes* and the *peroneus tertius* come down the front of the ankle and are obvious when they are tensed. The *tibialis anterior* lies beside the long extensor of the big toe and wraps around the inside of the foot. The *abductor of the little toe* and the *short flexor of the big toe* emphasize the shapes of the under-lying bones.

The ends of the toes are heavily padded, as is the ball of the foot. The toenails follow the contour of the tops of the toes and help explain the shape of the ends of the toes.

Back

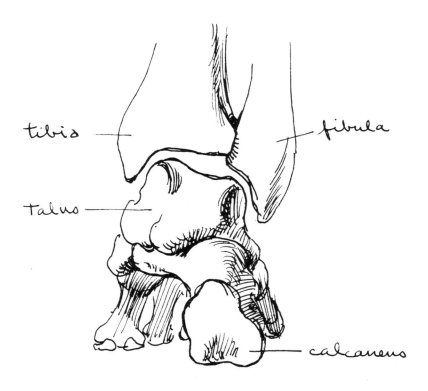

The heel, or *calcaneus*, is on the
outer border of the foot and
acts as a lever to point the toes.
The *talus* rides in the tibia/fibula
socket, and the inside of the
ankle is higher than the outside.

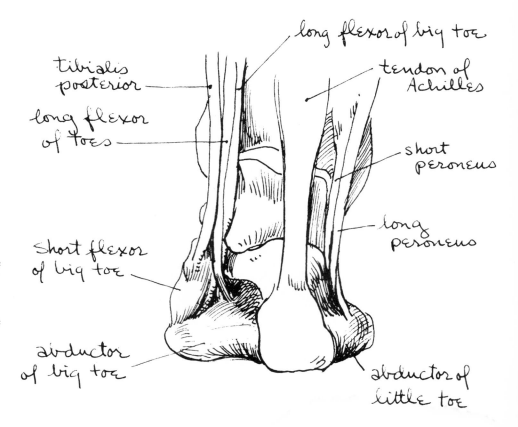

The two *long flexors* and the
tibialis posterior come down
behind the ankle on the tibia
side and tuck under the arch. The
long and short peroneus muscles
come down behind the fibula
and insert into the head of the
fifth, or little toe, metatarsal. The
*abductors of the little toe and
the big toe* flatten out the sole of
the foot. The *Achilles tendon*
attaches to the end of the
calcaneus.

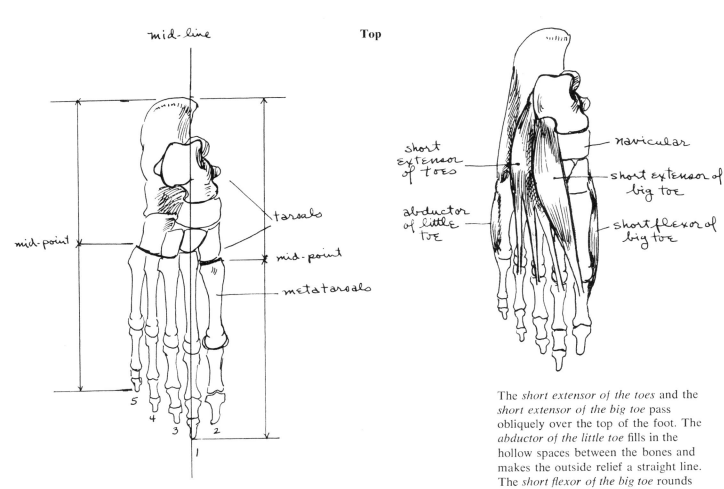

mid-line

Top

tarsals

mid-point

mid-point

metatarsals

5
4
3
2
1

navicular

short
extensor
of toes

short extensor of
big toe

abductor
of little
toe

short flexor of
big toe

The second toe is the longest and straightest and is on the midline. The *calcaneus* (heel bone) is on the outer side of the foot. The division between the tarsals and the metatarsals marks the midpoint of the length of the foot. In this illustration the toes are numbered in order of their length.

The *short extensor of the toes* and the *short extensor of the big toe* pass obliquely over the top of the foot. The *abductor of the little toe* fills in the hollow spaces between the bones and makes the outside relief a straight line. The *short flexor of the big toe* rounds the form behind the ball of the foot to the navicular, which protrudes.

1.
2.
3.
4.

There are four sets, or groups, of tendons that come from the calf down into the foot. They can be remembered by the numbers 1, 2, 3, and 4. The first set consists of one tendon: the *Achilles tendon*. The second set consists of two tendons: the *short peroneus* and the *long peroneus*. The third set consists of three tendons: the *long flexor of the toes*, *long flexor of the big toe*, and the *tibialis posterior*. The fourth set has four tendons: the *peroneus tertius*, the *long extensor of the toes*, the *long extensor of the big toe*, and the *tibialis anterior*.

Bottom

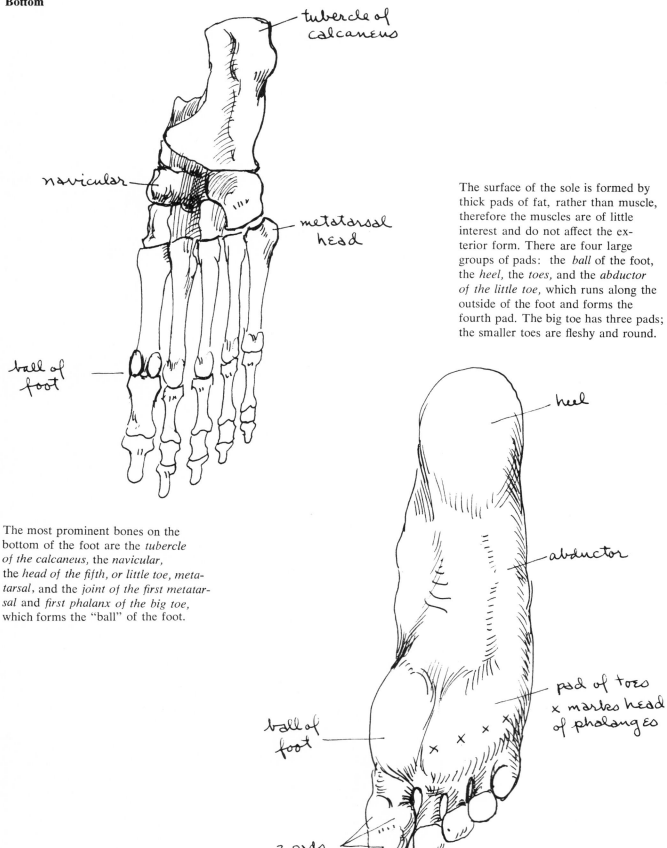

tubercle of calcaneus

navicular

metatarsal head

ball of foot

heel

abductor

pad of toes
x marks head of phalanges

ball of foot

3 pads

The surface of the sole is formed by thick pads of fat, rather than muscle, therefore the muscles are of little interest and do not affect the exterior form. There are four large groups of pads: the *ball* of the foot, the *heel*, the *toes*, and the *abductor of the little toe,* which runs along the outside of the foot and forms the fourth pad. The big toe has three pads; the smaller toes are fleshy and round.

The most prominent bones on the bottom of the foot are the *tubercle of the calcaneus*, the *navicular,* the *head of the fifth, or little toe, meta-tarsal*, and the *joint of the first metatarsal* and *first phalanx of the big toe,* which forms the "ball" of the foot.

MUSCLES

Note: For the bones of the foot and ankle, see pages 113–117.

Key

A. Abductor of little toe
B. Short extensor of big toe
C. Short extensor of toes
D. Achilles tendon
E. Tibialis anterior
F. Peroneus tertius
G. Long extensor of toes
H. Long extensor of big toe
I. Long peroneus
J. Short peroneus
K. Abductor of big toe
L. Short flexor of big toe
M. Tibialis posterior
N. Long flexor of toes
O. Long flexor of big toe
P. Internal malleolus ⎫ Bones
Q. External malleolus ⎪ visible
R. Navicular ⎬ on surface,
S. Tuberosity of fifth ⎪ not covered
 (little toe) metatarsal ⎭ by muscle

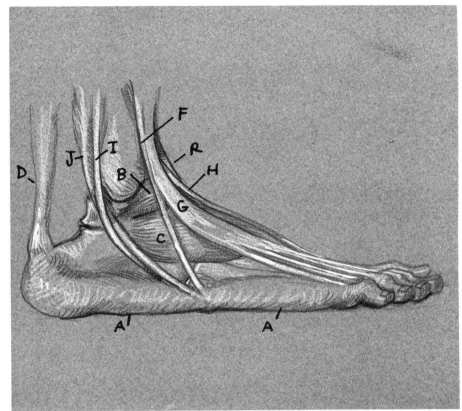

Outside of the foot.

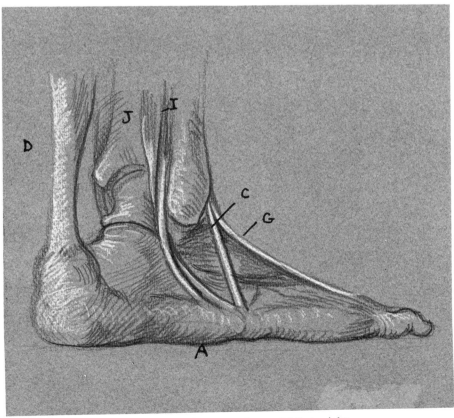

Outside of the foot turned one-eighth to right.

Key

A. Abductor of little toe
B. Short extensor of big toe
C. Short extensor of toes
D. Achilles tendon
E. Tibialis anterior
F. Peroneus tertius
G. Long extensor of toes
H. Long extensor of big toe
 I. Long peroneus
 J. Short peroneus
K. Abductor of big toe
L. Short flexor of big toe
M. Tibialis posterior
N. Long flexor of toes
O. Long flexor of big toe
P. Internal malleolus ⎫ Bones
Q. External malleolus ⎪ visible
R. Navicular ⎬ on surface,
S. Tuberosity of fifth ⎪ not covered
 (little toe) metatarsal ⎭ by muscle

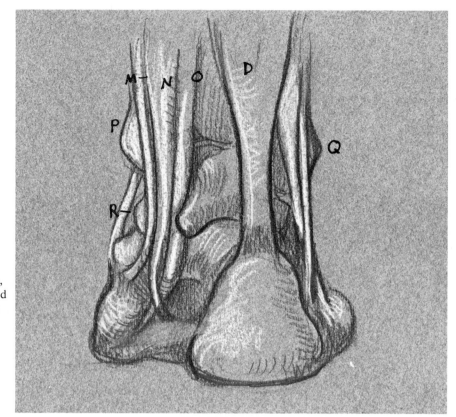

Back of the foot.

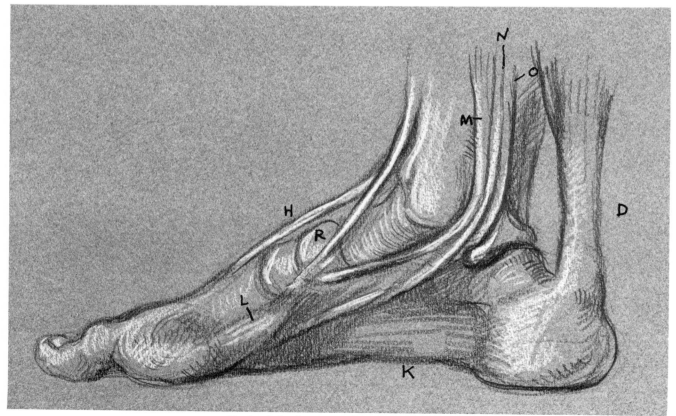

Back of the foot turned one-eighth turn more.

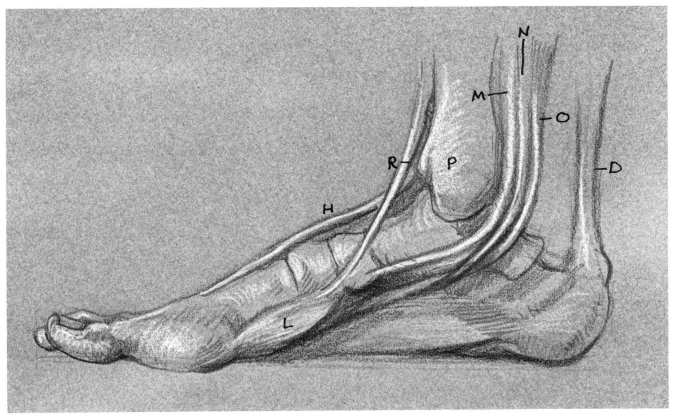

Inside of the foot.

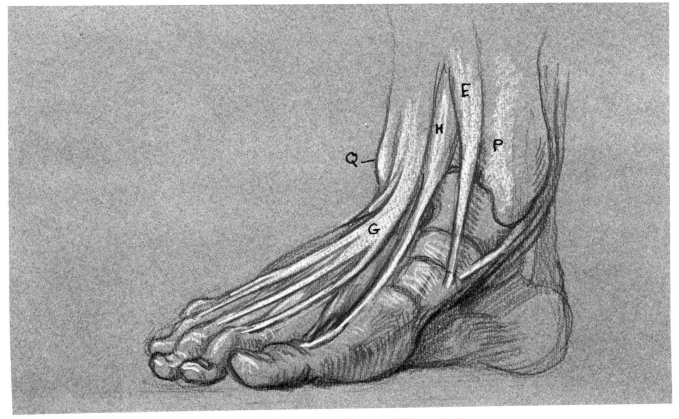

Inside of the foot turned one-eighth turn more.

Key

A. Abductor of little toe
B. Short extensor of big toe
C. Short extensor of toes
D. Achilles tendon
E. Tibialis anterior
F. Peroneus tertius
G. Long extensor of toes
H. Long extensor of big toe
I. Long peroneus
J. Short peroneus
K. Abductor of big toe
L. Short flexor of big toe
M. Tibialis posterior
N. Long flexor of toes
O. Long flexor of big toe
P. Internal malleolus ⎫ Bones
Q. External malleolus ⎪ visible
R. Navicular ⎬ on surface,
S. Tuberosity of fifth ⎪ not covered
 (little toe) metatarsal ⎭ by muscle

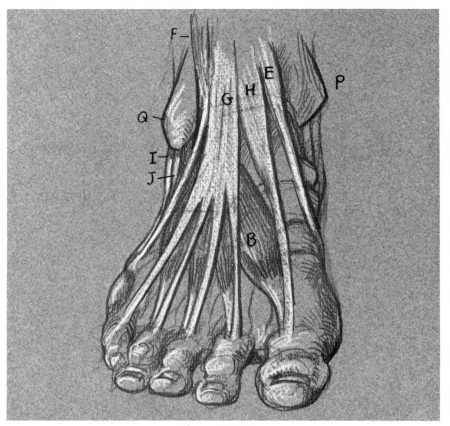

Front of the foot.

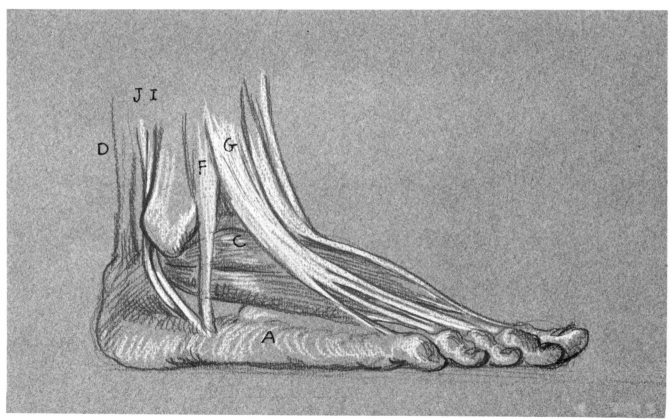

Front of the foot turned seven-eighths turn to the right.

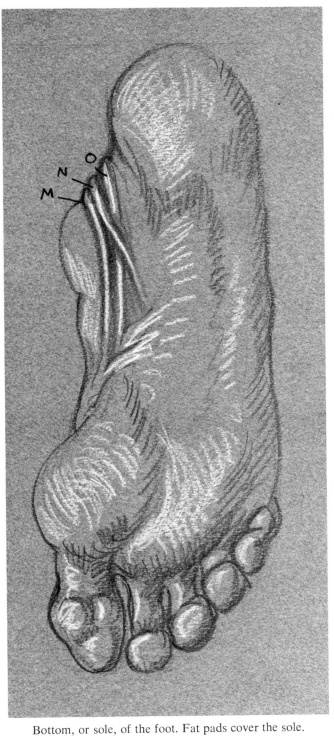

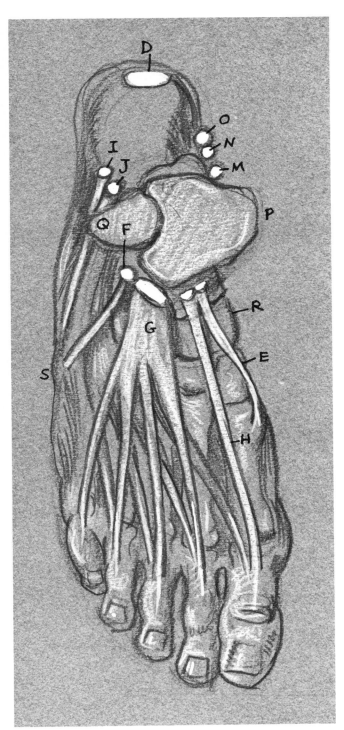

Bottom, or sole, of the foot. Fat pads cover the sole.

Top of the foot.

TABLE OF MUSCLE ORIGINS AND INSERTIONS

MUSCLE	ORIGIN	INSERTION	ACTION
A. Abductor of little toe	Underside of calcaneus	Tuberosity of fifth metatarsal, base of first phalanx of little toe	Abducts little toe, curls first phalanx downward
B. Short extensor of big toe	Top and outside of calcaneus	Base of first phalanx of big toe	Draws big toe up and in toward other toes
C. Short extensor of toes	Top and outside of calcaneus	By tendons to third phalanges of toes two–five	Draws up toes two–five
D. Achilles tendon E. Tibialis anterior F. Peroneus tertius G. Long extensor of toes H. Long extensor of big toe I. Long peroneus J. Short peroneus	See *Table of Muscle Origins and Insertions* for the leg in Chapter 4		
K. Abductor of big toe	Calcaneus	First phalanx of big toe	Abducts the big toe
L. Short flexor of big toe	Third cuneiform and cuboid bone (origin can vary)	Base of first phalanx of big toe	Helps flex big toe
M. Tibialis posterior N. Long flexor of toes O. Long flexor of big toe	See *Table of Muscle Origins and Insertions* for the leg in Chapter 4		
P. Internal malleolus Q. External malleolus R. Navicular S. Tuberosity of fifth metatarsal	Bones visible on surface, not covered by muscle		

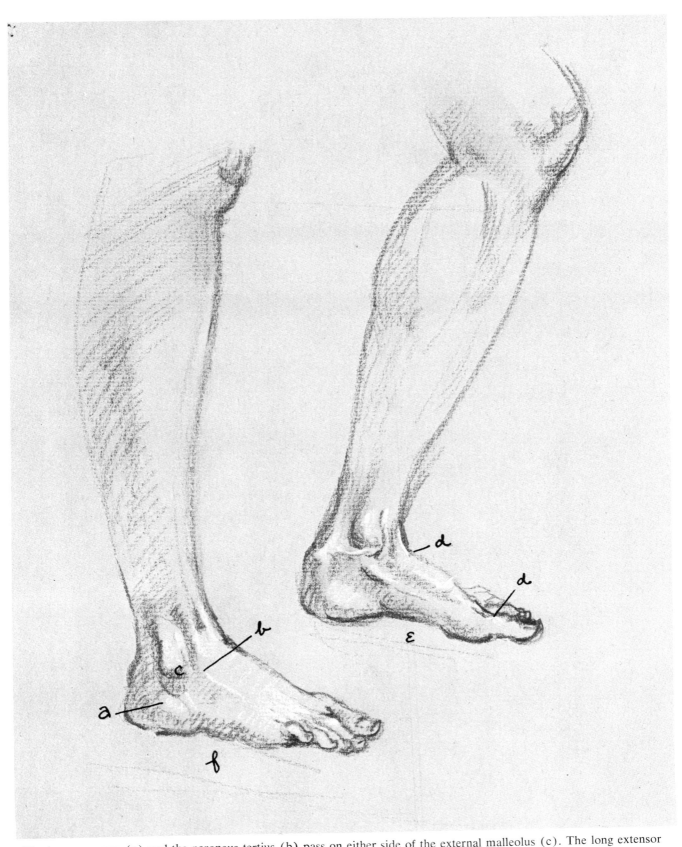

The long peroneus (a) and the peroneus tertius (b) pass on either side of the external malleolus (c). The long extensor of the big toe (d) shows at the ankle and the beginning of the big toe. The inside of the foot has a high arch (e) and the outside (f) is flat.

(Above) The underside of the foot is covered by fleshy pads. The abductor of the little toe (a) forms the outside pad.

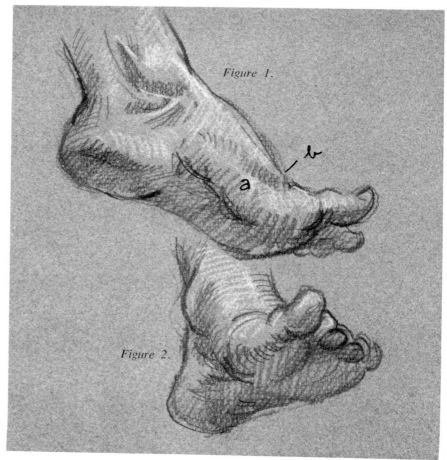

Figure 1.

Figure 2.

Figure 1. The short flexor of the big toe (a) and the long extensor of the big toe (b) are set against each other.

Figure 2. A foreshortened view of the foot showing the big toe slightly extended and the other toes flexed.

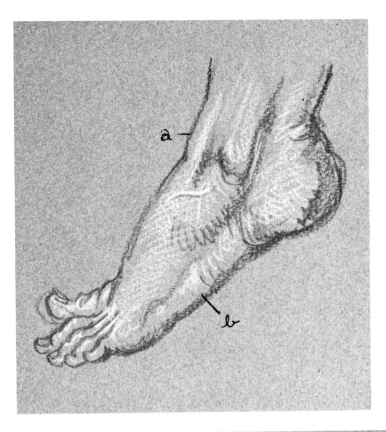

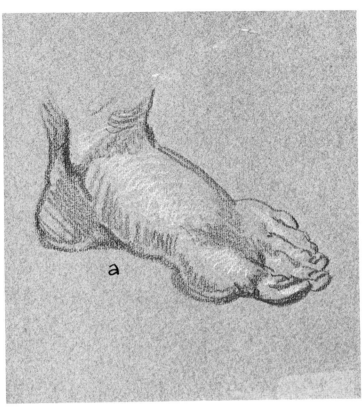

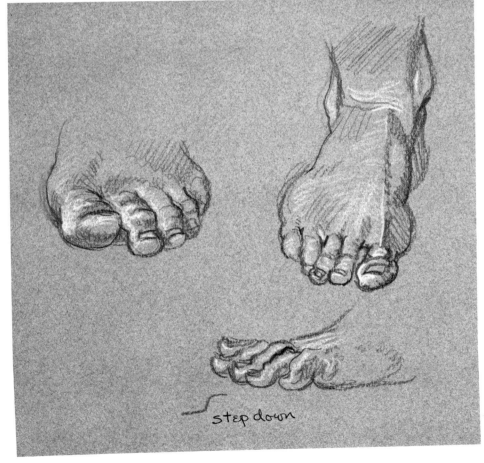

step down

(Above left) The toes pushing against the floor bring the tendons of the long extensor of the toes (a) into view. The abductor of the little toe (b) forms a wall along the outside of the foot.

(Above right) The high arch (a) of the instep is obvious on the fleshy foot but most of the tendons are not visible.

Several views of the toes showing the second toe longer than the big toe and the stepdown of the four toes.

6. THE TORSO

SCHEMATIC DRAWINGS

Front View

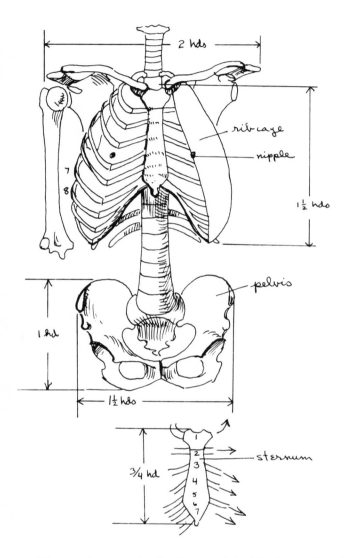

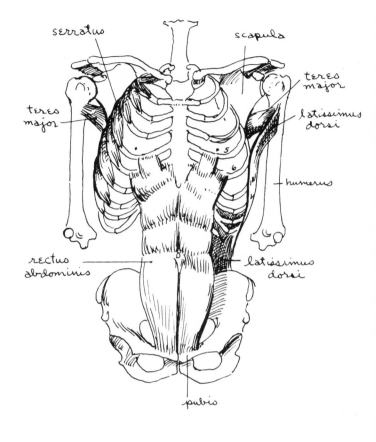

The area between the shoulders and the hips is considered the torso. The male torso is two heads wide at the shoulders and one-and-a-half heads wide at the hips. The female torso is just the opposite: one-and-a-half at the shoulders and two at the hips. The nipple is between the fourth and fifth ribs and is the second head measurement on the front view of the body. The sternum is shaped like a necktie and is three-quarters of a head high. The first rib attaches to it and is directed upward toward the back. The second rib attaches straight across, and the third starts in a downward direction, as do the following four ribs. The widest point on the ribcage is between the seventh and eighth ribs.

The *serratus* attaches on the first nine ribs and inserts on the underside of the scapula. It wraps around the ribs like a series of fingers. The *teres major* muscle comes from the back of the scapula and inserts into the front of the humerus. The *latissimus dorsi,* also coming from the back, inserts into the humerus just in front of the teres major. The *rectus abdominis* starts on the fifth and sixth ribs and attaches into the pubis. When contracted, it flexes the trunk.

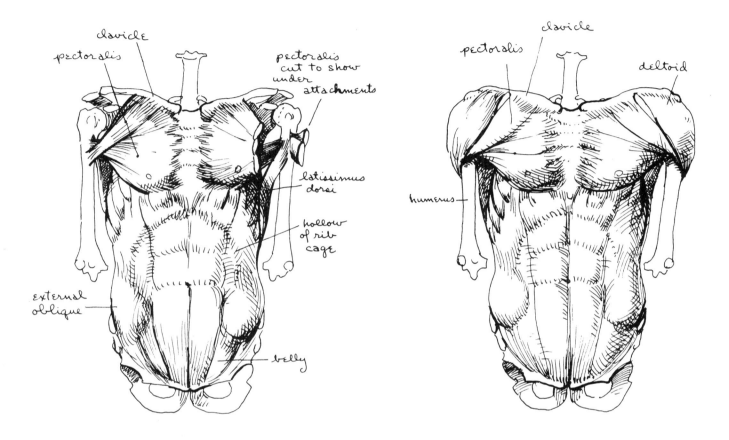

The *pectoralis* (major and minor) is the large chest muscle and attaches to the inner two-thirds of the clavicle, the sternum, and the fifth rib. Its parts cross and insert into the humerus, overlapping the teres major and latissimus dorsi. In this illustration, the left pectorial is cut to show the underattachments. The *external oblique* helps turn the torso from side to side. Its upper part interweaves with the "fingers" of the serratus. The fullness of this muscle gives the front of the torso a violin shape.

The *deltoid* attaches on the external third of the clavicle next to the pectoralis, leaving a small triangular space in between, and inserts down into the outside of the humerus.

Back View

The spinal column is divided into three parts (from top to bottom): the *cervical*, with seven vertebrae; the *thoracic*, with twelve vertebrae; and the *lumbar*, with five *vertebrae*. The spines of the seventh cervical and the first thoracic vertebrae are long and show on the surface. There are twelve ribs that attach to the twelve thoracic vertebrae in the back and they proceed in a downward direction toward the front. The first ten ribs attach to the sternum in front; the remaining two have no sternal attachment and are called "floating" ribs. In a relaxed position, the end of the scapula is between the sixth and seventh ribs, which is the second head measurement on the back view of the body.

The *infraspinatus* and *teres major* attach from the scapula to the humerus. The *rhomboid* fixes the scapula and originates from the fourth cervical vertebra to the fifth thoracic vertebra. The *sacrospinalis* originates in the pelvic area in a cylinder shape and inserts up and into the spinal column and ribcage, where it divides into three underlying muscles that rarely show on the surface. The *serratus* muscle comes out from beneath the scapula and attaches obliquely across the ribs.

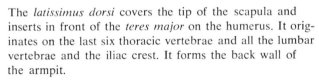

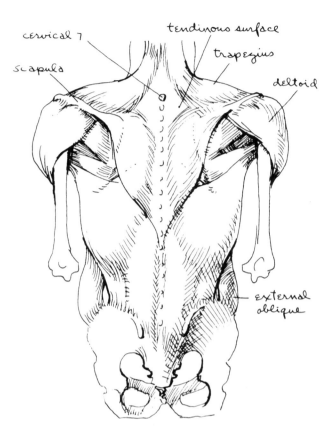

The *latissimus dorsi* covers the tip of the scapula and inserts in front of the *teres major* on the humerus. It originates on the last six thoracic vertebrae and all the lumbar vertebrae and the iliac crest. It forms the back wall of the armpit.

The *trapezius* is the large kite-shaped muscle on the upper back. There is a flat, diamond-shaped tendinous surface in the center of the muscle that exposes the spines of the vertebrae, especially the cervical seventh. The upper part of the trapezius attaches to the base of the skull and into the spine of the scapula. The *deltoid* covers the scapula muscles and inserts into the outside of the arm. The *external oblique* can be seen on the sides.

Side View

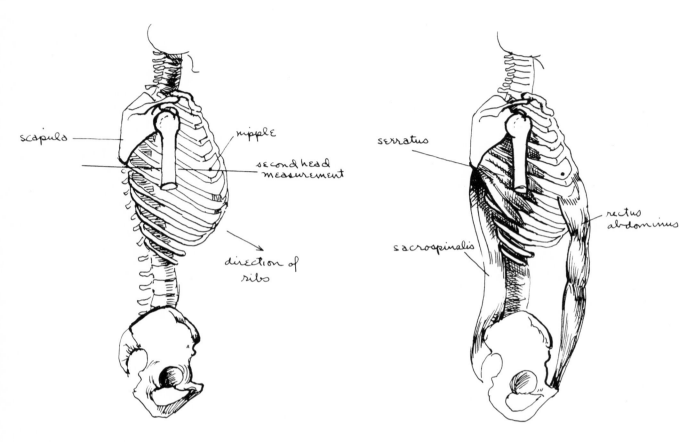

The second head measurement is taken in front, by the nipple, between the fourth and fifth ribs and in back by the bottom tip of the scapula. The ribs are high in back and proceed downward toward the front.

The *serratus* fans out from under the scapula to the first nine ribs. The *rectus abdominus* and *sacrospinalis* counter each other in flexing and extending the torso.

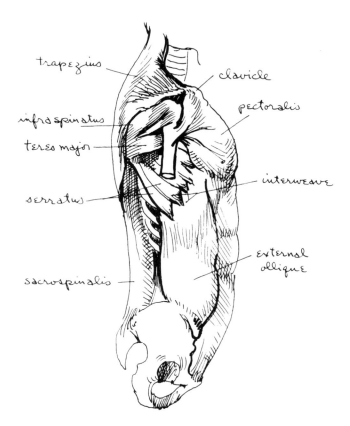

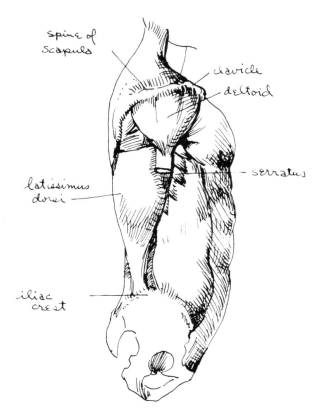

The *trapezius* attaches not only along the spine of the scapula but also to the external end of the clavicle. Its lower part overlaps the scapula muscles, infraspinatus and teres major. The *pectoralis* covers the chest and inserts into the outside of the arm, forming the front wall of the armpit. The *external oblique* originates from the fifth to the twelfth ribs and interweaves with the serratus.

The *deltoid* attaches to the spine of the scapula and to the clavicle. It overlaps the pectoralis and the scapula muscles and inserts into the outside of the arm. The *latissimus dorsi* rises up from the iliac crest and overlaps the serratus, revealing only the lower attachments.

Back View with Torso Bent and Arm Raised

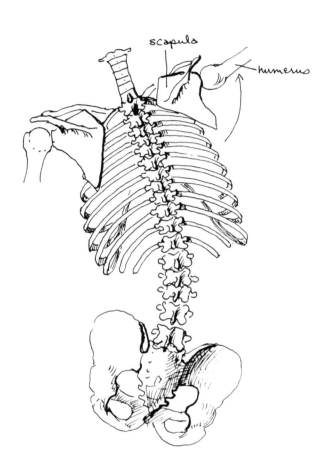

Scapula follows humerus when arm is raised.

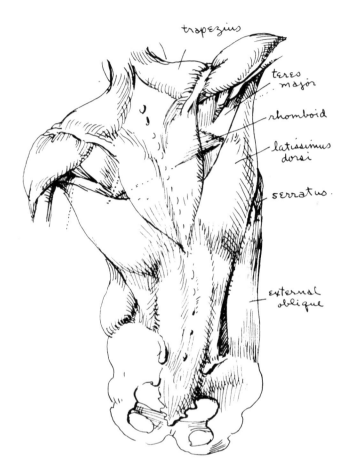

The teres major and latissimus dorsi stretch out into the arm as it is raised. The right side of the trapezius flexes as it helps raise the shoulder. The external oblique on the left side bulges as it pulls the ribcage down and the right side is stretched flat.

Side View with Arm Raised Forward

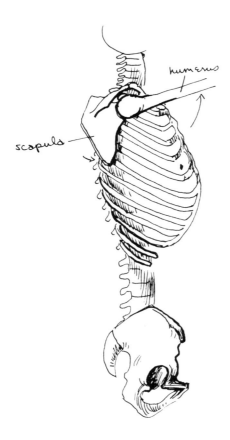

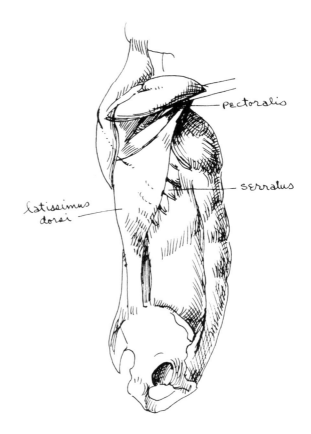

Scapula is brought forward as humerus is raised.

The scapula muscles follow the arm forward and the latissimus dorsi covers most of the serratus, only showing the tip ends of the last five "fingers." The front wall of the armpit, the pectoralis, is also pulled forward.

Side View with Arm Pulled Back

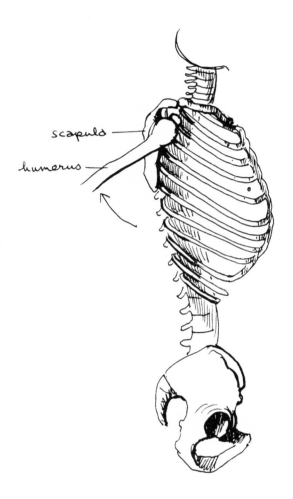

Scapula follows humerus back.

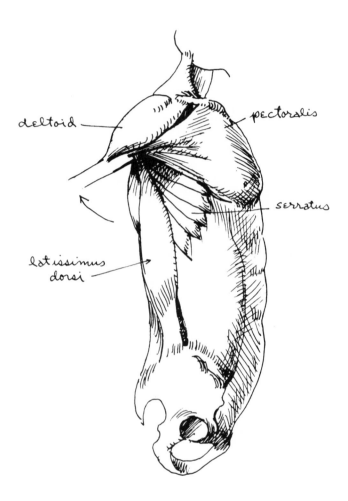

The latissimus dorsi and the pectoralis stretch back with the arm, revealing more of the serratus.

Front View with Arms Raised

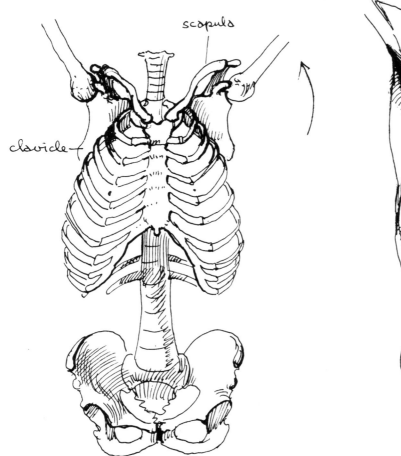

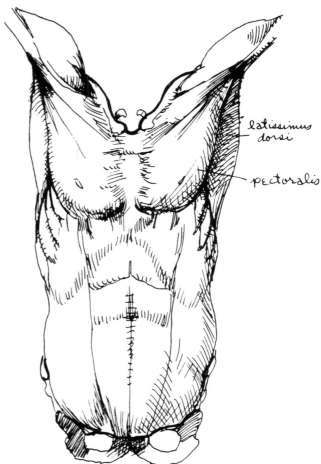

The arms raise, causing the clavicles in front and the scapulas in back to follow.

The front of the armpit, the pectoralis, and the back of the armpit, the latissimus dorsi, both stretch out into the arm.

BONES

The Spinal Column

The spinal column is made up of twenty-four vertebrae that are divided into three groups: the seven *cervical* vertebrae, which support the skull and are the most flexible; the twelve *thoracic* vertebrae, which give support to twelve pairs of ribs; and the five *lumbar* vertebrae, which are the largest.

Key

1. Cervical vertebrae,
 seven in number (one–seven)
2. Thoracic vertebrae,
 twelve in number (eight–nineteen)
3. Lumbar vertebrae,
 five in number (twenty–twenty-four)
4. Sacrum
5. Coccyx

Side view.

Back view.

The Vertebrae

The articular processes above and below unite with other vertebrae or ribs to form flat joints. The transverse processes serve as muscular attachments, and only the spinous processes are seen on the surface.

Key

1. Superior articular process
2. Spinous process
3. Body
4. Transverse process

First cervical vertebra, or *atlas,* is shaped to enable the head to rock forward and backward. The second cervical is the *axis*; it lets the head swivel from side to side.

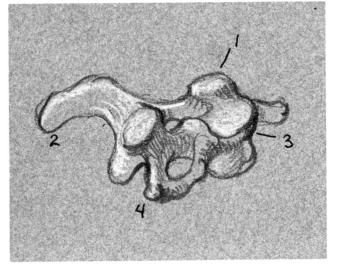

Fourth cervical vertebra.

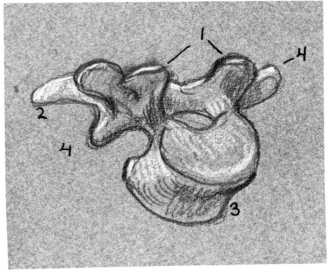

Sixth thoracic vertebra.

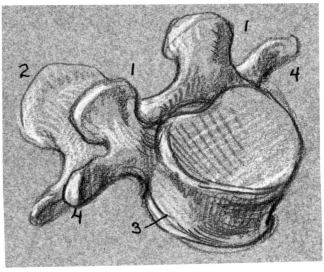

Third lumbar vertebra.

The Ribcage

There are twelve pairs of ribs that attach to the twelve thoracic vertebrae in the back. They swing obliquely downward to the front. The first seven ribs attach by cartilage directly to the sternum, in the front. Each of the next three ribs attaches by cartilage to the rib above it. The eleventh and twelfth ribs have no sternal attachment and are called "floating" ribs.

Key

1. Ribs, twelve in number
2. Sternum

 a. Manubrium
 b. Body
 c. Xiphoid process

3. Clavicle

 d. Sternal end
 e. Acromion end
 f. Shaft

4. Scapula

 g. Acromion process
 h. Coracoid process
 i. Glenoid fossa
 j. Spine
 k. Superior angle
 l. Inferior angle
 m. Exterior border
 n. Interior border
 o. Superior border
 p. Supraspinous fossa
 q. Infraspinous fossa
 r. Anterior surface

5. Pelvis

 s. Iliac crest
 t. Anterior superior iliac spine
 u. Pubis
 v. Sacrum
 w. Iliac tuberosity

6. Cervical vertebrae of the spine
7. Thoracic vertebrae of the spine
8. Lumbar vertebrae of the spine

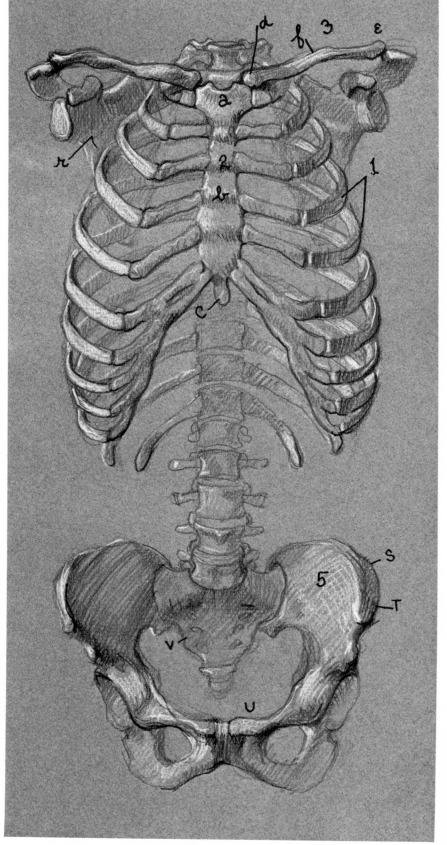

Front view.

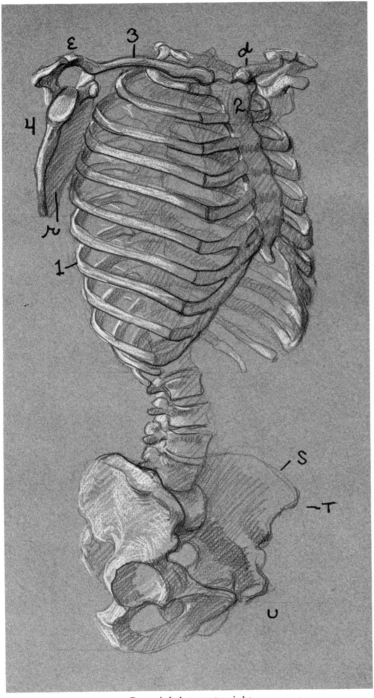

One-eighth turn to right.

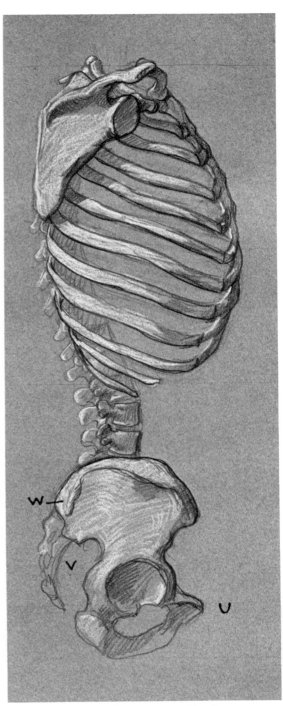

One-eighth turn more, side view.

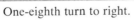

One-eighth turn more to right.

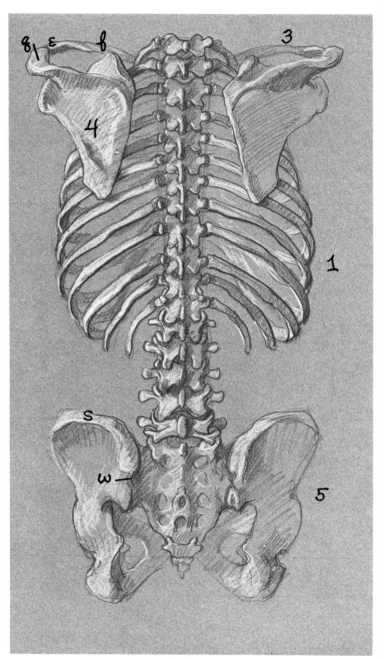

Back view.

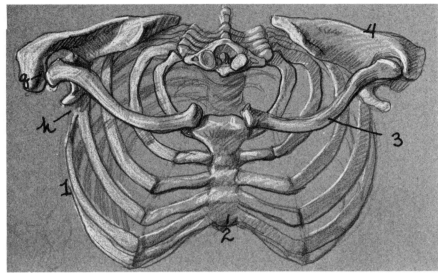

Top view tilted slightly
with the cervical vertebrae attached.

The Ribcage

Key

1. Ribs, twelve in number
2. Sternum

 a. Manubrium
 b. Body
 c. Xiphoid process

3. Clavicle

 d. Sternal end
 e. Acromion end
 f. Shaft

4. Scapula

 g. Acromion process
 h. Coracoid process
 i. Glenoid fossa
 j. Spine
 k. Superior angle
 l. Inferior angle
 m. Exterior border
 n. Interior border
 o. Superior border
 p. Supraspinous fossa
 q. Infraspinous fossa
 r. Anterior surface

5. Pelvis

 s. Iliac crest
 t. Anterior superior iliac spine
 u. Pubis
 v. Sacrum
 w. Iliac tuberosity

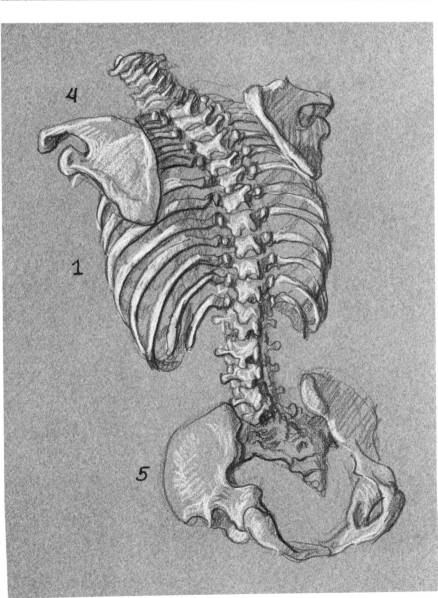

Viewed at an angle from below.

MUSCLES

The Torso

The muscles between the pelvis and ribcage control motion at the waist; they perform the bending and twisting of the torso. The muscles of the upper part of the trunk control the shoulders and upper arms.

Key

A. Pectoralis major (minor not shown)
B. Serratus anterior
C. External oblique
D. Rectus abdominus
E. Sacrospinalis
F. Rhomboid (major and minor, treated as one muscle)
G. Infraspinatus and teres minor, treated as one muscle
H. Teres major
I. Trapezius
J. Latissimus dorsi
K. Sheath of rectus abdominus
L. Clavicle
M. Sternum
N. Scapula
O. Seventh cervical vertebra
P. First–twelfth thoracic vertebrae
Q. First–twelfth ribs
R. Pubis
S. Iliac crest
T. Iliac tuberosity
U. Anterior superior iliac spine

} Bones visible on surface, not covered by muscle

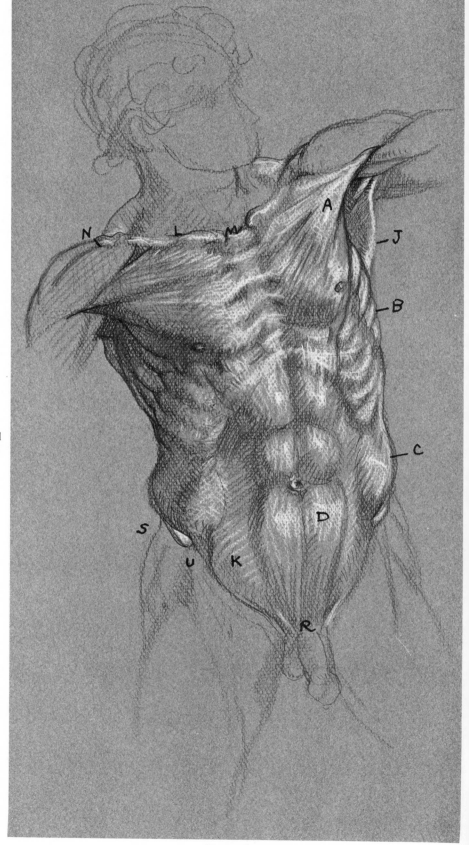

Front view.

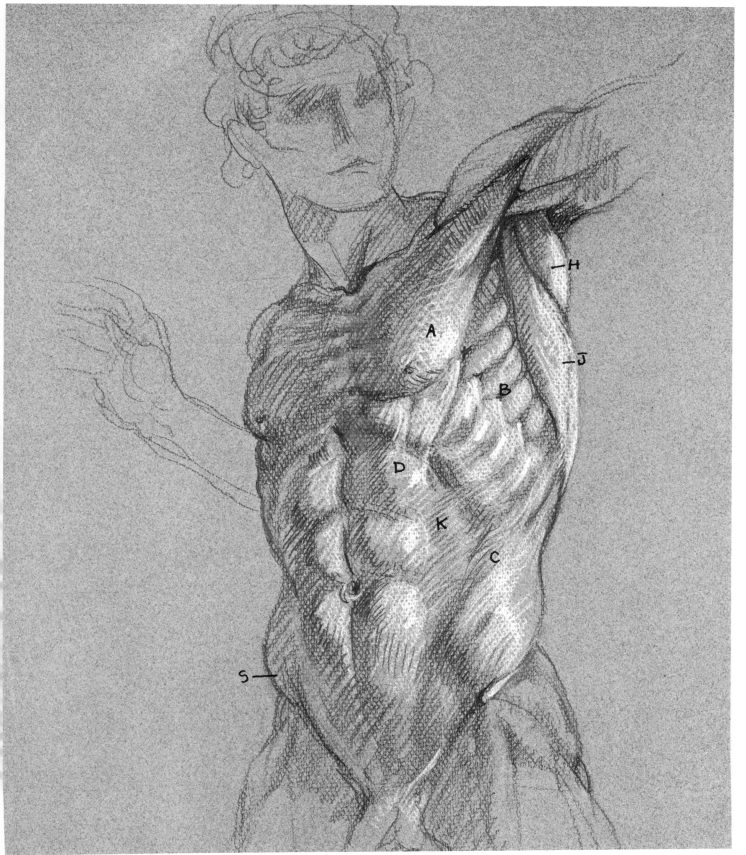

One-eighth turn to the left.

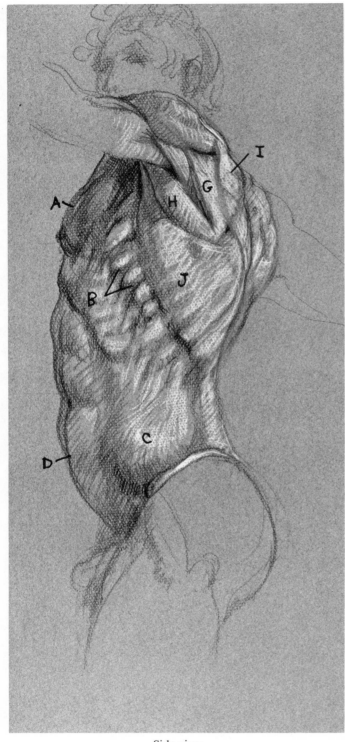

Side view.

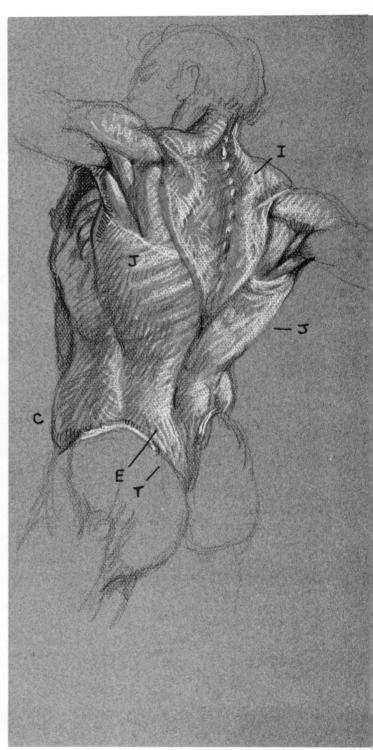

One-eighth turn more to the left.

For key to figures see page 162.

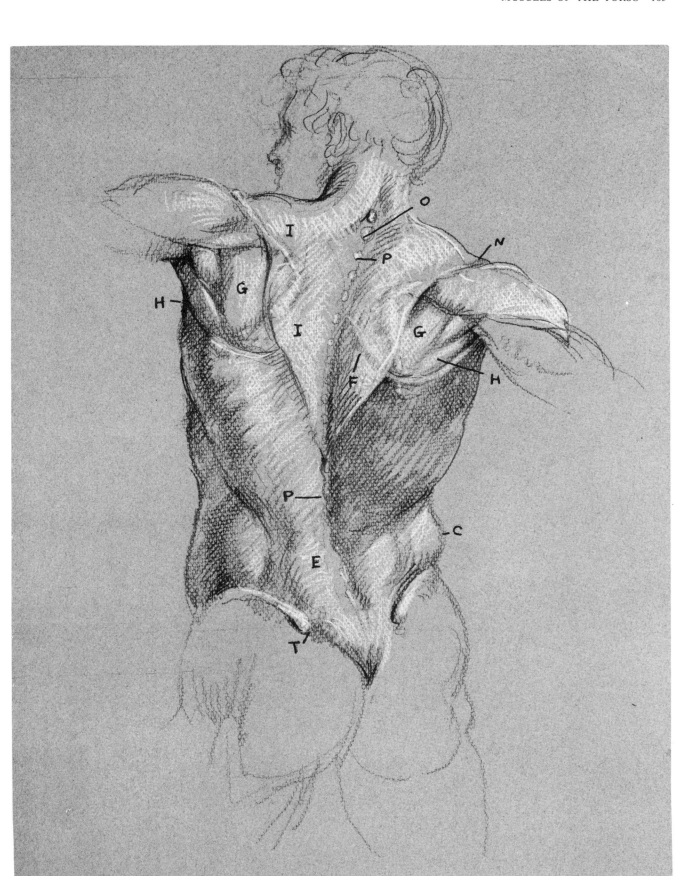

Back view.

The Armpit

The hollow of the arm is formed by two walls: the *latissimus dorsi* and *teres major* form the deeper, rounder, back wall; the *pectoralis major* attaches farther down the humerus and creates the longer front wall. Into the base of the armpit, the biceps, coracobrachialis, and triceps attach. (For action of bones, refer to the muscles of the shoulder socket in Chapter 2.)

Key

A. Pectoralis major
B. Serratus
G. Infraspinatus
H. Teres major
J. Latissimus dorsi
L. Clavicle
V. Humerus
W. Scapula

 1. Coracoid process
 2. Glenoid fossa
 3. Spine
 4. Acromion process

X. Coracobrachialis

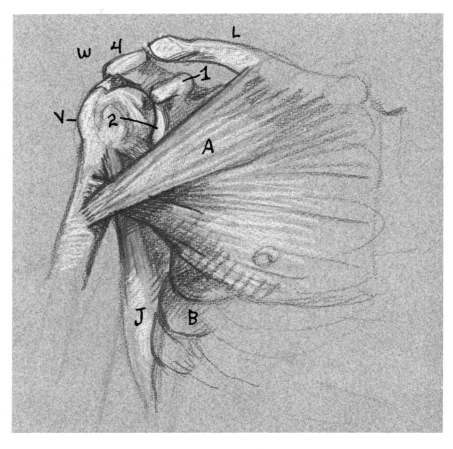

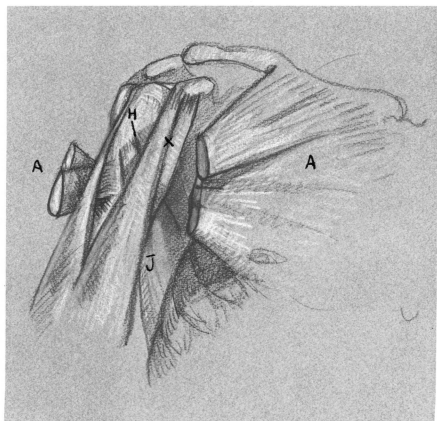

(Above) Front view. Pectoralis crosses and forms front wall of armpit, overlapping insertion of latissimus dorsi and teres major.

Front view. Pectoralis tendons are cut here to show teres major and latissimus dorsi attaching high on the humerus between short and long heads of biceps. Pectoralis wraps around and attaches behind biceps. The coracobrachialis can also be seen.

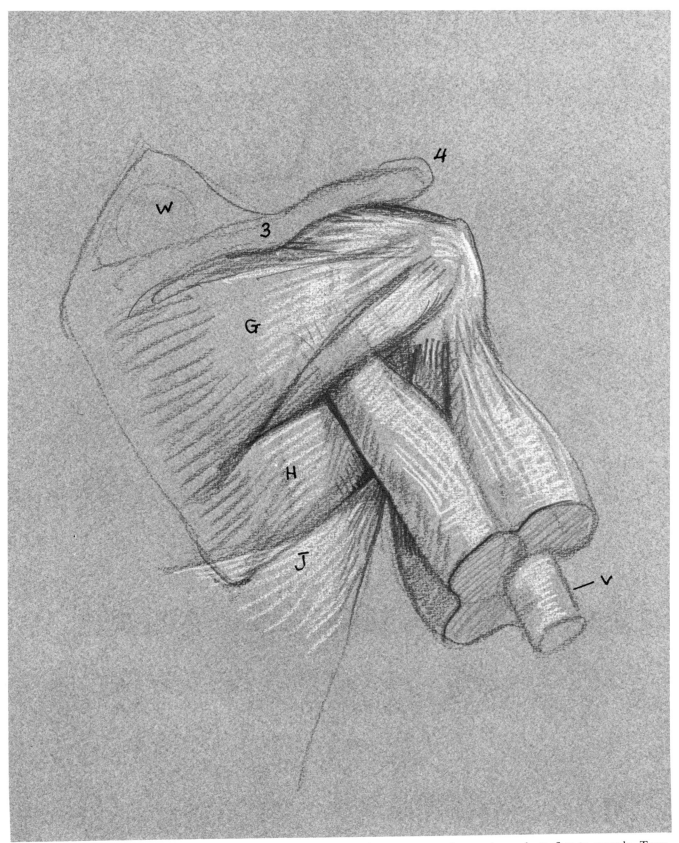

Back view, with the triceps and humerus cut. Long head of triceps intersects scapula muscles and attaches to scapula. Teres major and latissimus dorsi go under long head of triceps and insert high on the front of humerus.

TABLE OF MUSCLE ORIGINS AND INSERTIONS

MUSCLE	ORIGIN	INSERTION	ACTION
A. Pectoralis major (minor not shown)	Medial two-thirds of clavicle, anterior surface of sternum, and fourth and fifth ribs	Upper front surface of humerus	Draws arm forward, rotates it inward; lowers the arm
B. Serratus anterior	First nine ribs	Underside of scapula	Draws scapula forward and laterally
C. External oblique	Fifth–twelfth ribs; upper five interweave with serratus anterior	Sheath of rectus abdominis and anterior half of iliac crest	Flexes the trunk: isolated action of one side turns anterior surface of trunk to that side; bends spinal column laterally
D. Rectus abdominis	Fifth–seventh ribs and xiphoid process of sternum	Pubic symphysis of pubis	Flexes trunk
E. Sacrospinalis	Dorsal surface of sacrum, process of lumbar and thoracic vertebrae, and iliac crest	Spine and ribs; deep insertions, do not show on surface	Straightens spine, draws pelvis backward and upward
F. Rhomboid major and minor, treated as one muscle	Spinous process of fourth–seventh cervical vertebrae and first–fifth thoracic vertebrae	Spinal boarder of scapula	Elevates, rotates scapula; draws it toward median line
G. Infraspinatus and teres minor, treated as one muscle	See *Table of Muscle Origins and Insertions* for the arm in Chapter 2		
H. Teres major			
I. Trapezius	Occipital protruberance, by a ligament to the seven cervical vertebrae, and to the twelve thoracic vertebrae	Lateral third of clavicle and acromion process and spine of scapula	Extends the head, inclines it to one side, and turns the head in opposite direction; middle part lifts scapula; inferior part lowers scapula
J. Latissimus dorsi	Spinous processes of last six thoracic vertebrae and all lumbar vertebrae, iliac tuberosity, and posterior third of iliac crest	Groove on upper interior surface of humerus, in front of insertion of teres major	Throws back shoulders; draws arm backward and, medially, rotates it inward, and lowers it
K. Sheath of rectus abdominis	A broad expanded tendon that joins the external oblique and rectus abdominis		
L. Clavicle	Bones visible on the surface, not covered by muscle		
M. Sternum			
N. Scapula			
O. Seventh cervical vertebra			
P. First–twelfth thoracic vertebrae			
Q. First–twelfth ribs			
R. Pubis			
S. Iliac crest			
T. Iliac tuberosity			
U. Anterior superior iliac spine			

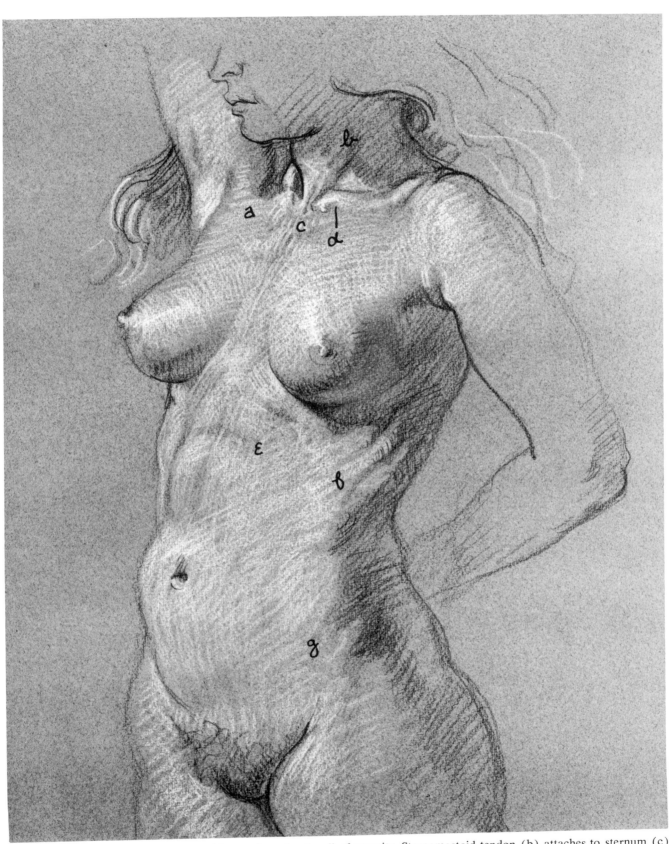

Pectoralis muscles (a) enter into shoulders to form front wall of armpits. Sternomastoid tendon (b) attaches to sternum (c) between the two clavicle bones (d). Divisions of rectus abdominis (e) can be seen. Ribs (f) slant downward from front to back, and anterior superior iliac spine of pelvis (g) thrusts forward.

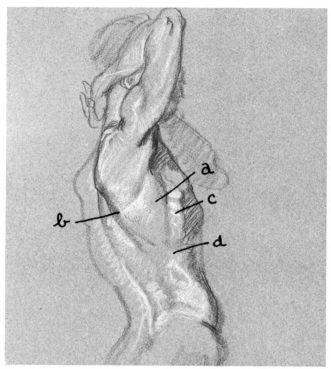

Latissimus dorsi (a) covers tip of scapula (b). Serratus (c) appears beneath latissimus dorsi. Attachments of external oblique (d) into lower ribs show as arm is raised.

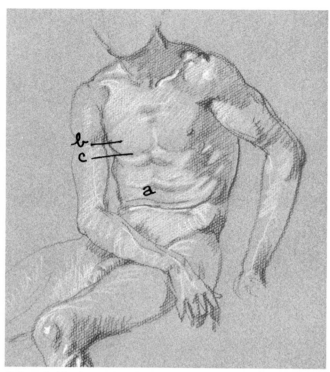

Relaxed thin figure. Folds (a) at belly when torso leans forward. Bottom of pectoralis (b) attaches to fifth rib, exposing sixth and seventh ribs (c).

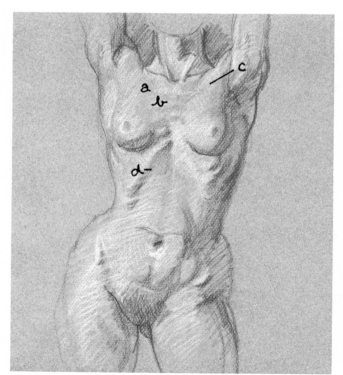

Clavicle (a) and beginning of ribs on sternum (b) show on chest. Pectoralis (c) is pulled up into arm. Ribcage cavity (d) is prominent.

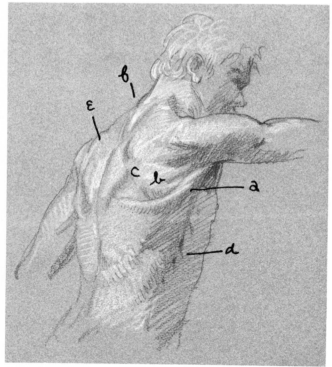

Latissimus dorsi (a) winds around teres major (b). Scapula (c) drawn forward with arm. Serratus (d) and trapezius (e) are marked, as is seventh cervical vertebra (f).

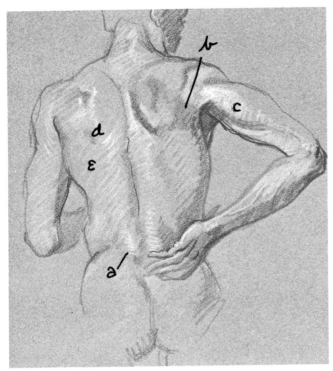

Sacrospinalis (a) forms two cylinders at base of back. Teres major (b) and long head of triceps (c) intersect each other. Rhomboid (d) forms flat plane down to edge of scapula (e).

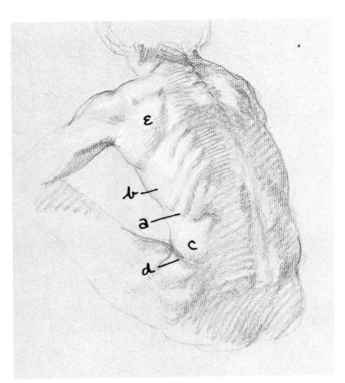

Downward slant of ribs (a) toward front of body can be seen through latissimus dorsi (b). External oblique (c) bulges over iliac crest (d). Teres major (e) and latissimus dorsi (b) enter arm, forming back wall of armpit.

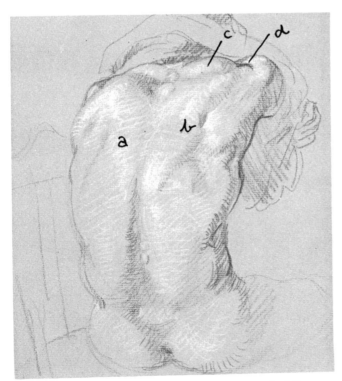

Trapezius (a) prominent and scapula (b) at angle following forward position of arm. Spine of scapula (c) and acromion process (d) can be seen.

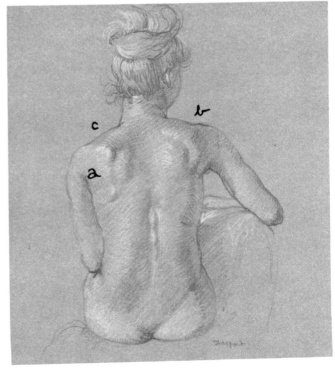

Muscles are less prominent on female back. Edge of scapula (a) and acromion process (b) are noticeable. Trapezius (c) forms shoulder silhouette.

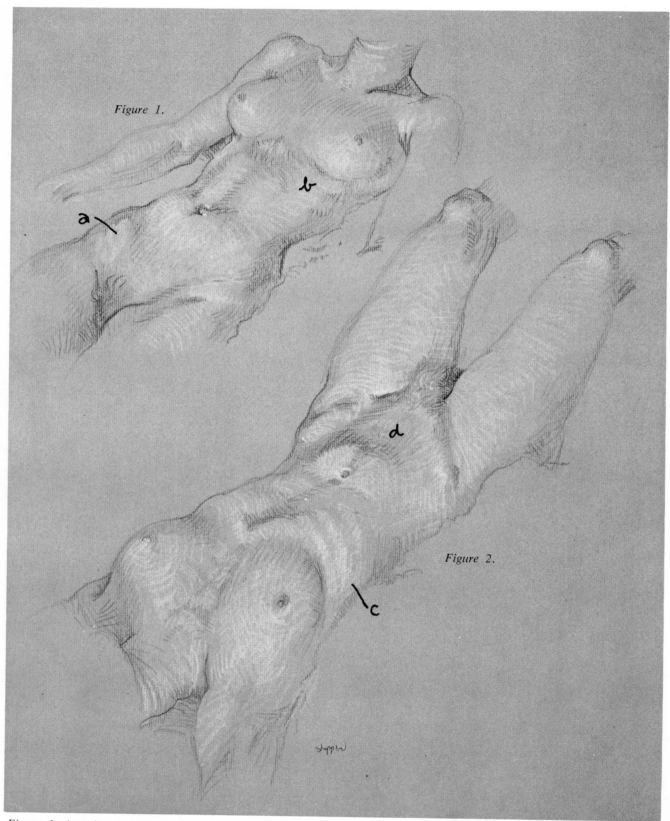

Figure 1. Anterior superior iliac spine (a) always prominent and next to skin. Sixth and seventh ribs (b) show under breast and pectoralis.

Figure 2. Ribcage (c) prominent when figure lies on back and rectus abdominus (d) is relaxed.

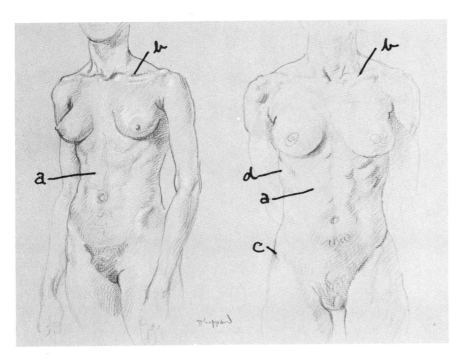

Lean figure shows rectus abdominis (a) clearly. Bones—clavicle (b), pelvis (c), and ribs (d)—are visible.

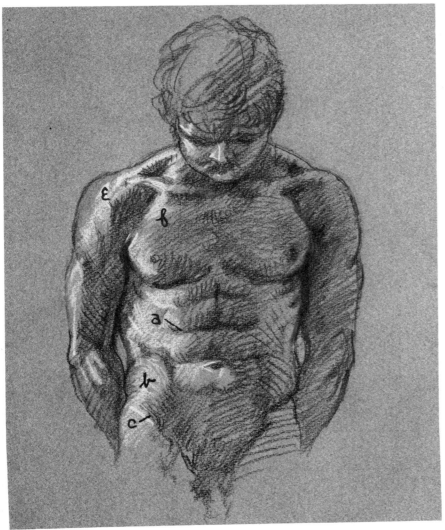

Intersections (a) of rectus abdominis show when muscles are tensed. External oblique (b) bulges over the iliac spine (c). Division between deltoid (e) and pectoralis (f) is clear.

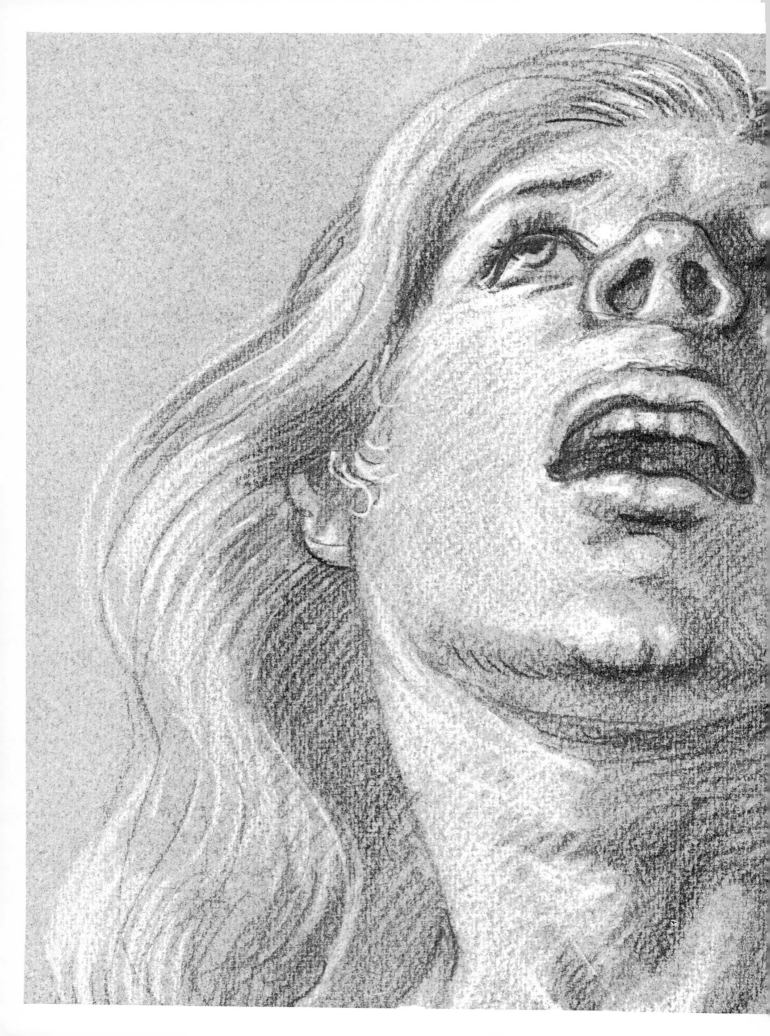

7. THE HEAD AND NECK

SCHEMATIC DRAWINGS

Front View

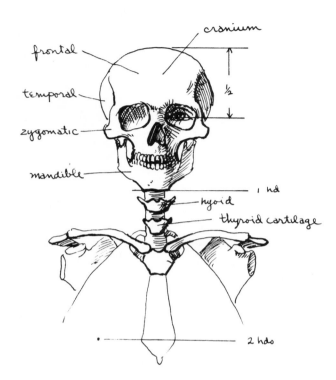

There are two separate parts to the skull: the *cranium* and the *mandible* (jaw). The eye sockets are shaped like television screens, that is, rectangular with rounded edges. The eye sits inside this socket and serves as the one-half measurement of the head. The cavity for the nose is like an upside-down heart. The *hyoid bone* and *thyroid cartilage* form the "Adam's apple." The front of the cranium is called the *frontal bone* and it is slightly rounded. The *temporal* is on the side of the cranium and is flat. The *zygomatic* is the cheekbone and is always prominent.

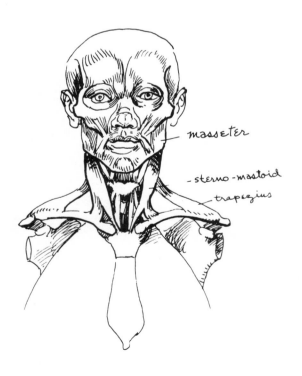

Most of the muscles of the head are facial muscles and deal with expression. (See pages 205–209 for expressions of the face.) They do not change the contour very much. The *masseter* is the strongest muscle and helps hold the mandible in place. From the front, the *sternomastoid* muscle forms the letter M. The sternomastoid and the trapezius, which comes in from the back, are the most important muscles of the neck.

Side View

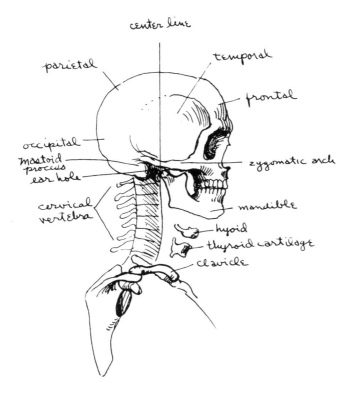

The *skull* sits on the seven cervical vertebrae. The center line of the profile of the skull is in back of the mandible and in front of the earhole. The *zygomatic arch* protrudes over the mandible. The back part of the skull is the *occipital bone* and the top is the *parietal bone*. These bones are fixed together by cranial sutures and do not move on each other.

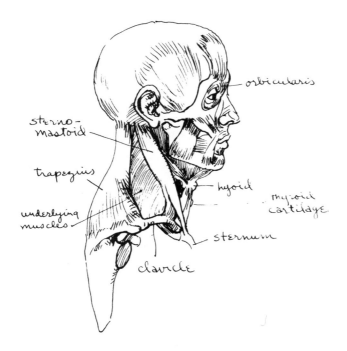

The *ear* fits behind the zygomatic arch and mandible. The *eye* fits into the eye socket and is encircled by the eye muscle, the *orbicularis*. The *sterno-mastoid* muscle inserts into the mastoid process and originates in two places, the clavicle and the sternum. The *hyoid bone* and *thyroid cartilage* are held in place by small muscles. The *trapezius* forms the back of the neck and outline of the shoulders. There are several deep underlying muscles that have little effect on the surface.

Front View with Head and Neck Turned

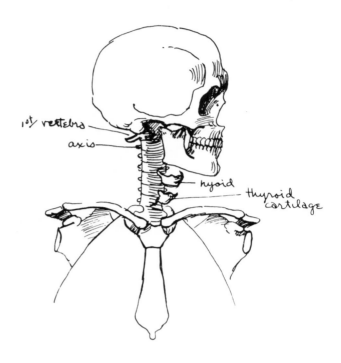

The first vertebra turns with the skull on the second vertebra, called the *axis*. The *hyoid bone* and *thyroid cartilage* follow slightly.

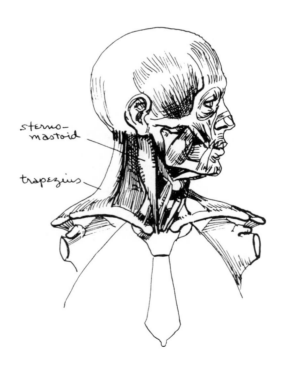

The *sternomastoid* and *trapezius* are used in the rotation of the head. When the head is turned to one side, the sternomastoid makes a perpendicular line from behind the ear to the base of the neck.

Side View with Head Down

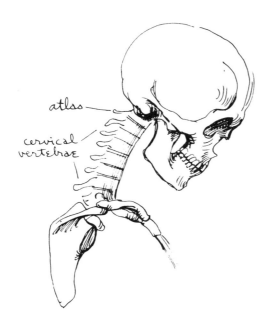

The head tips forward on the first vertebra, called the *atlas*. The other six cervical vertebrae are able to bend.

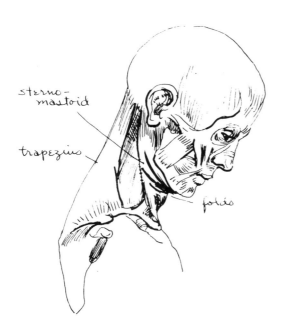

Folds develop between the chin and neck when the head is in a down position. The head is pulled down by a deep muscle, *longus capitis* (not shown here).

Side View with Head Back

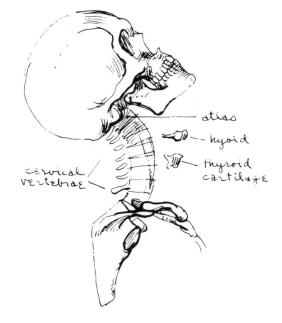

The skull tips back on the atlas. The cervical vertebrae also bend backward.

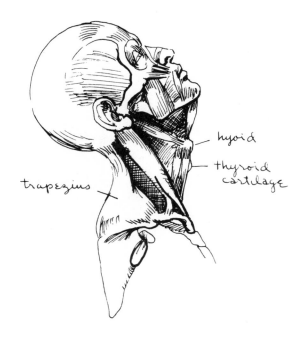

The trapezius pulls the back of the skull down, raising the chin. The hyoid bone and thyroid cartilage protrude.

The Skull

The skull is in two distinct pieces: the *cranium* and upper part of the face and the *mandible,* or lower jaw. Eight tightly joined bones form the cranium and fourteen form the face.

Key

1. Frontal bone
2. Temporal bone
3. Temporal line
4. Nasal eminence
5. Zygomatic bone
6. Zygomatic process
7. Zygomatic arch
8. Supraorbital eminence
9. Orbit
10. Maxilla
11. Dental arch (upper)
12. Ramus
13. Angle of mandible
14. Mental protruberance
15. Mental tubercle
16. Dental arch (lower)
17. Parietal bone
18. Occipital bone
19. Mastoid process
20. Occipital protruberance
21. Nuchal line
22. Cranial sutures
23. Earhole
24. Condyloid process
25. Coronoid process
26. Nasal spine
27. Sphenoid bone
28. Foramen magnum
29. Nasal bone
30. Occipital condyle

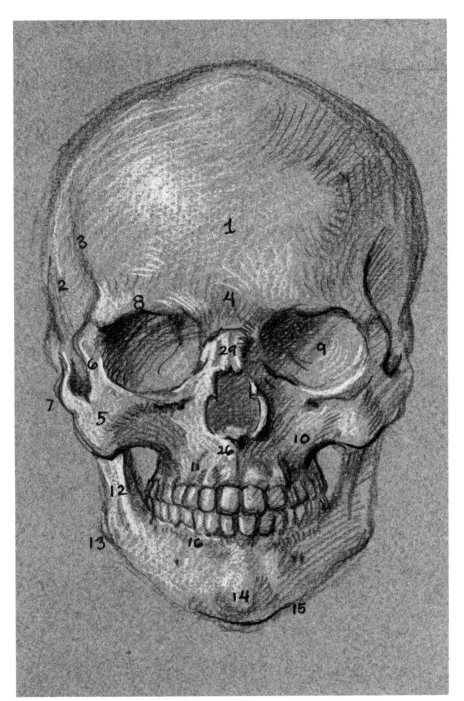

Front view.

For key to figures see page 181.

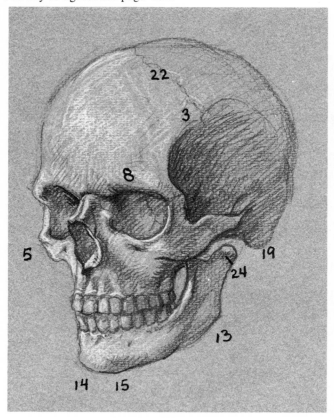

One-eighth turn to the left.

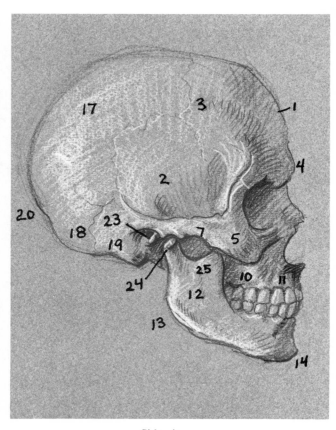

Side view.

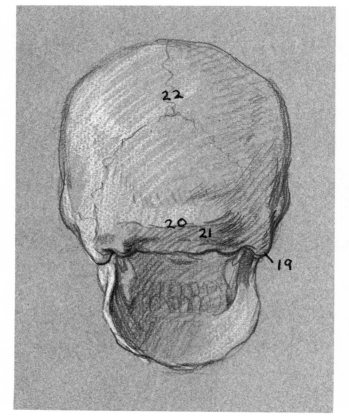

Back view.

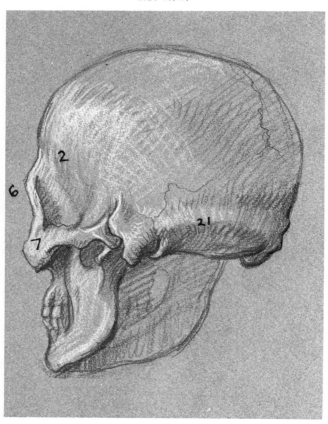

Back view, one-eighth turn to the right.

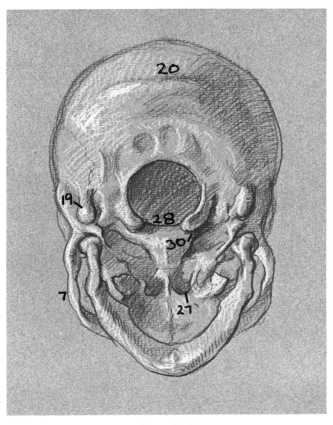

Seen from the bottom.

Top view.

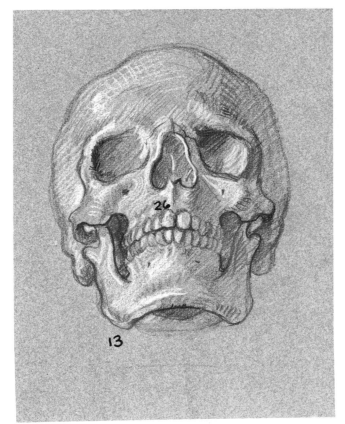

Front view seen from below.

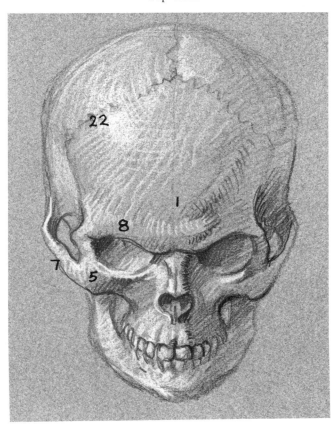

Front view seen from above.

Neck Joint

The atlas, or first vertebra of the cervical vertebrae, has two concave surfaces that articulate with the occipital condyles of the skull, enabling the skull to tip forward or backward. When the head rotates from side to side, the atlas bone rotates with it upon the second vertebra, the axis. The hyoid bone and thyroid cartilage are suspended and held in place by muscle. The lower six cervical vertebrae can bend forward, backward, and laterally.

Key

1. Atlas
2. Axis
3. Cervical vertebrae (three and four)
4. Hyoid bone
5. Thyroid cartilage
6. Scapula
7. Clavicle
8. Sternum
9. First rib

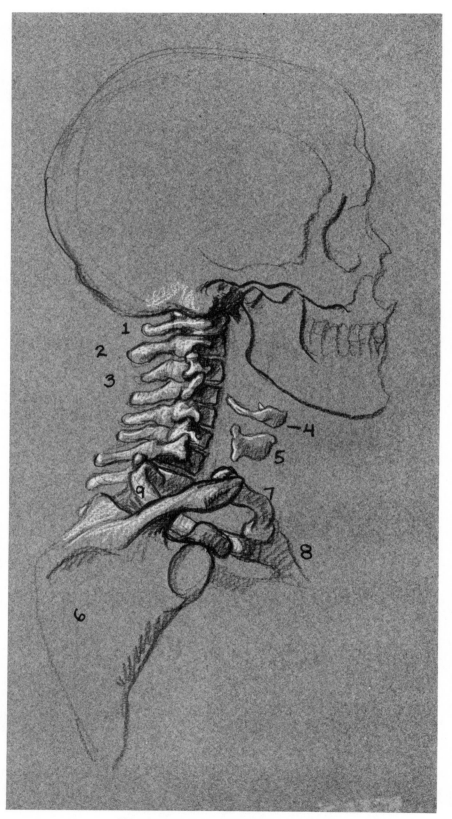

Side view of the neck in normal position.

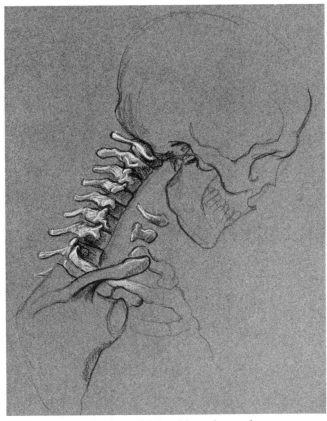

Side view with head bent forward.

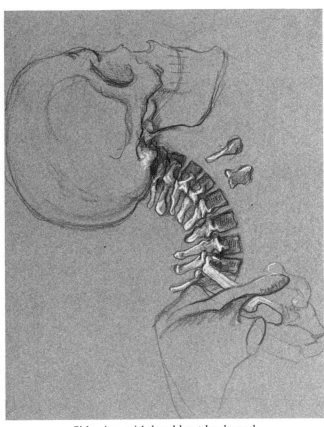

Side view with head bent backward.

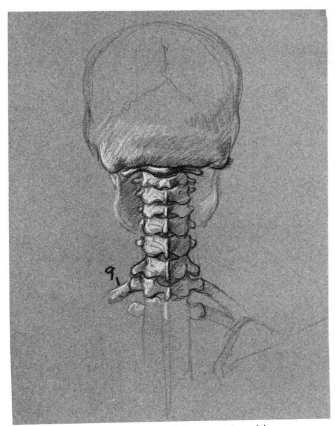

Back view of the neck in normal position.

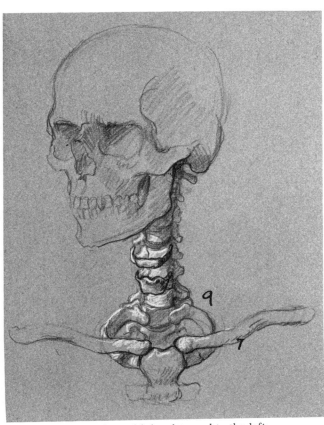

Front view with head turned to the left.

MUSCLES

There are three groups of muscles on the head: the muscles of the scalp, the facial muscles, and the muscles used for mastication. There are several underlying muscles in the neck that are not prominent. The two most important and obvious are the sternomastoid and the upper part of the trapezius.

Key

A. Occipitalis
B. Frontalis
C. Orbicularis of the eye
D. Corrugator
E. Nasalis
F. Orbicularis of the mouth
G. Quadratus of the lip

 1. Angular head
 2. Infraorbital head
 3. Zygomatic minor

H. Zygomatic major
I. Triangularis
J. Depressor of lower lip
K. Mentalis
L. Buccinator
M. Masseter
N. Temporalis
O. Trapezius
P. Digastric

 4. Anterior belly
 5. Posterior belly

Q. Sternomastoid

 6. Sternal head
 7. Clavicular head

R. Sternohyoid
S. Omohyoid
T. Underlying muscles
U. Zygomatic process ⎫
V. Zygomatic bone ⎪ Bones
W. Condyloid process ⎬ visible
X. Hyoid bone ⎪ on surface,
Y. Thyroid cartilage ⎪ not covered
Z. Nasal spine ⎭ by muscle

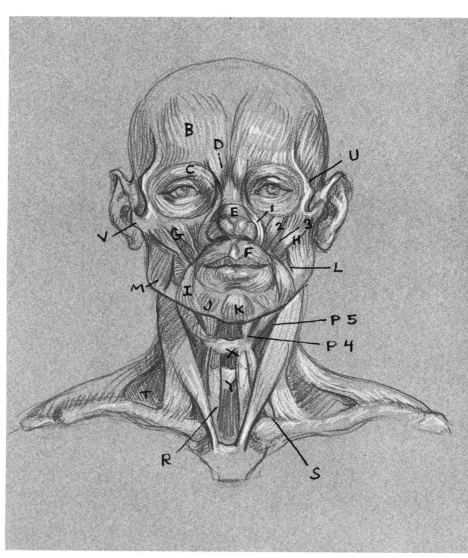

Front view.

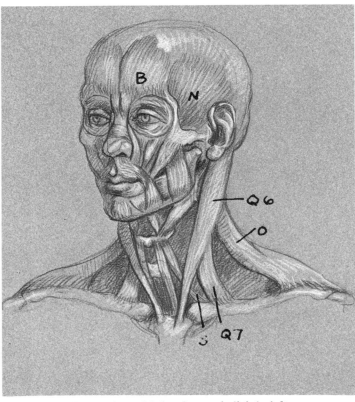

Front view with head turned slightly left.

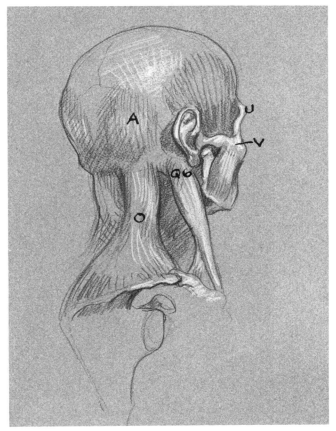

Side view with head turned away.

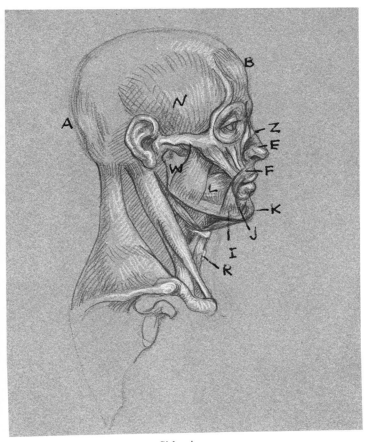

Side view.

TABLE OF MUSCLE ORIGINS AND INSERTIONS

MUSCLE	ORIGIN	INSERTION	ACTION
Muscles of the Scalp			
A. Occipitalis	Nuchal line of cranium	Into the aponeurosis (membrane-like tendon covering the top of the head)	Draws scalp backward
B. Frontalis	From aponeurosis	Skin of brow	Draws scalp forward, wrinkles brow horizontally, pulls eyebrows upward
Muscles of the Face			
C. Orbicularis of the eye	Medial rim of orbit	Surrounds orbit	Closes eyes
D. Corrugator	Nasal part of frontal bone	Skin of brow	Wrinkles brow vertically
E. Nasalis	Maxilla	Common tendon on crest of nose	Narrows nostrils
F. Orbicularis of the mouth	Maxilla and mandible; buccinator and other adjacent muscles	Encircles mouth	Closes mouth, purses lips
G. Quadratus of the lip			
1. *Angular head*	Wall of nasal cavity ⎫		
2. *Infraorbital head*	Below orbit ⎬	Upper lip and nose	Raises upper lip
3. *Zygomatic minor*	Zygomatic bone ⎭		
H. Zygomatic major	Zygomatic bone	Orbicularis oris	Draws corner of mouth upward
I. Triangularis	Lower margin of mandible	Corner of mouth	Draws corner of mouth downward, closes mouth
J. Depressor of lower lip	Base of mandible	Corner of mouth, lower lip	Draws lower lip downward
K. Mentalis	Below incisor teeth of mandible	Skin of chin	Raises skin of chin
L. Buccinator (deep)	Along outer border of roots for molar teeth	Interlaces with orbicular oris muscles	Closes mouth, compresses lips and cheeks
Muscles of Mastication			
M. Masseter	Zygomatic arch	Angle of mandible	Closes lower jaw
N. Temporalis	Temporal line and fossa of cranium	Coronoid process of mandible	Closes lower jaw
Muscles of the Neck			
O. Trapezius	See *Table of Muscle Origins and Insertions* for the torso in Chapter 6		
P. Digastric			
1. *Anterior belly*	Inside of lower mandible ⎫	Fibrous loop to hyoid bone	Draws hyoid bone upward, draws jaw downward
2. *Posterior belly*	Mastoid process ⎭		
Q. Sternomastoid			
1. *Sternal head*	Top of manubrium ⎫	Mastoid process	Turns head from side to side, lifts face and tilts head backward
2. *Clavicular head*	Sternal end of clavicle ⎭		
R. Sternohyoid	Back of manubrium	Hyoid bone	Draws hyoid bone downward
S. Omohyoid	Lower and outer border of hyoid bone	Under sternomastoid into upper border of scapula	Draws hyoid bone downward
T. Underlying muscles	Usually not seen on surface		
U. Zygomatic process	⎫		
V. Zygomatic bone			
W. Condyloid process	⎬ Bones visible on surface, not covered by muscle		
X. Hyoid bone			
Y. Thyroid cartilage			
Z. Nasal spine	⎭		

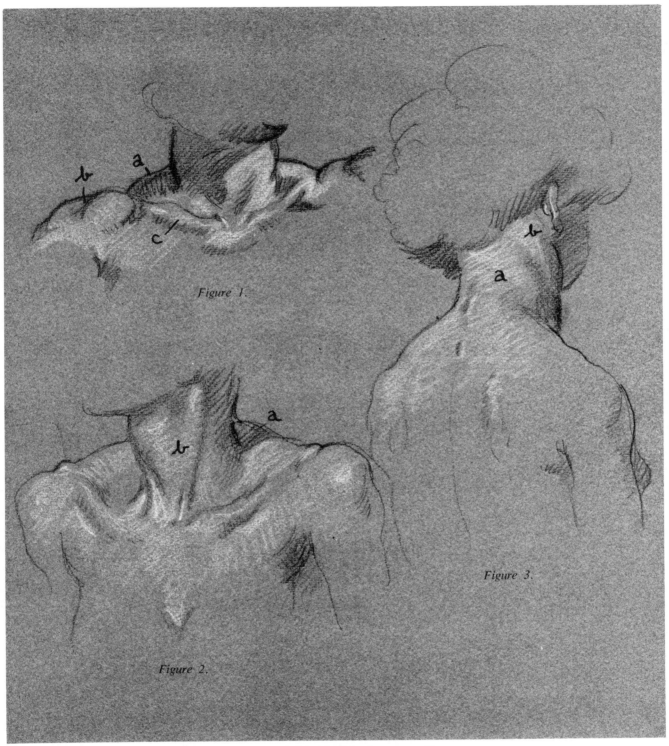

Figure 1. Strongly muscled neck. Trapezius (a) and deltoids (b) almost engulf the clavicle (c). Neck is full.

Figure 2. Shoulders hunched up. Trapezius (a) is pulled forward and into the center. Head is turned, causing tendons of sternomastoid (b) to be prominent.

Figure 3. Back of neck relaxed. Division between trapezius (a) and sternomastoid (b) can easily be seen.

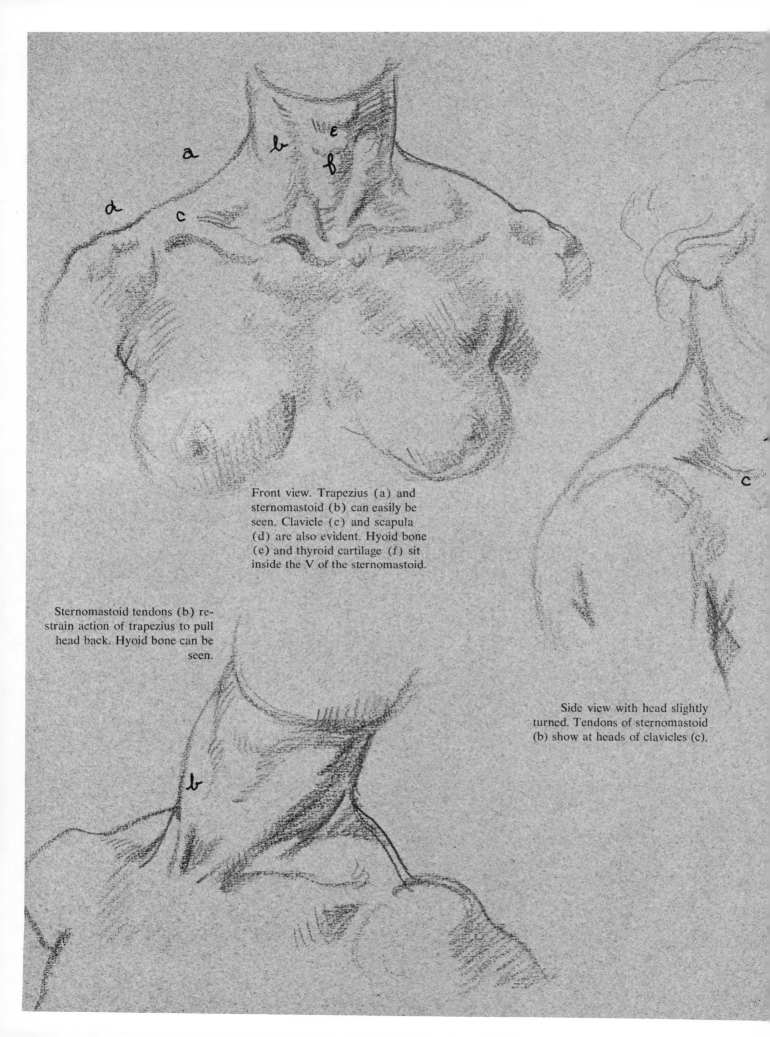

Front view. Trapezius (a) and sternomastoid (b) can easily be seen. Clavicle (c) and scapula (d) are also evident. Hyoid bone (e) and thyroid cartilage (f) sit inside the V of the sternomastoid.

Sternomastoid tendons (b) restrain action of trapezius to pull head back. Hyoid bone can be seen.

Side view with head slightly turned. Tendons of sternomastoid (b) show at heads of clavicles (c).

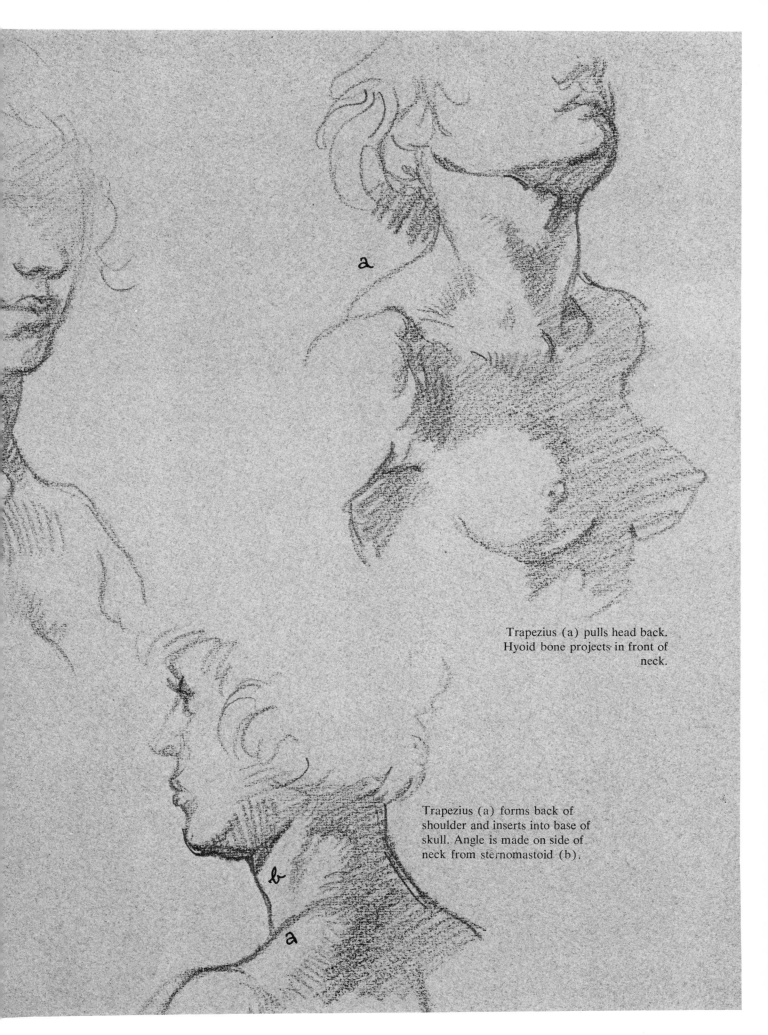

Trapezius (a) pulls head back.
Hyoid bone projects in front of
neck.

Trapezius (a) forms back of
shoulder and inserts into base of
skull. Angle is made on side of
neck from sternomastoid (b).

THE FEATURES

The Ear

The ear is vertically in line with the back of the mandible and lies horizontally between the lines of the eyebrow and the nasal spine.

(A) Side view. The *helix* is in the shape of a question mark. The right ear would have the question mark reversed, as in the diagram. The *antihelix* is in the shape of the letter Y, with a tail. It fits inside the helix and they both wrap around the earhole. The upper part of the antihelix has two legs: the upper leg is round and full, the lower leg is sharp and thin. The *tragus* guards the front of the earhole, and along with the helix forms the letter G.

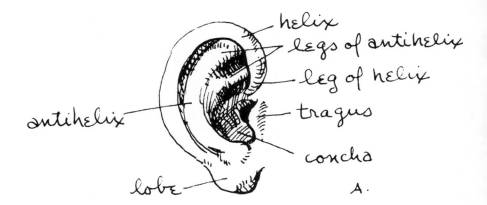

A.

(B) Front view with the tragus protruding in front of the earhole. It and the lobe are both fleshy and soft.

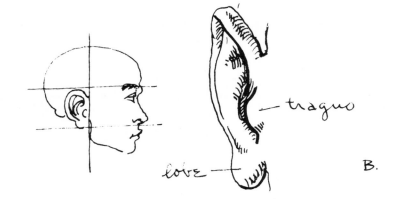

B.

(C) Back view showing the depth of the *concha* and the full roundness of the helix. Except for the lobe and the tragus, the ear is made up of cartilage.

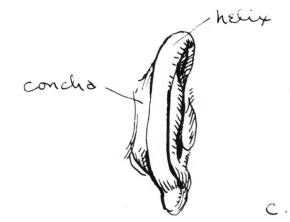

C.

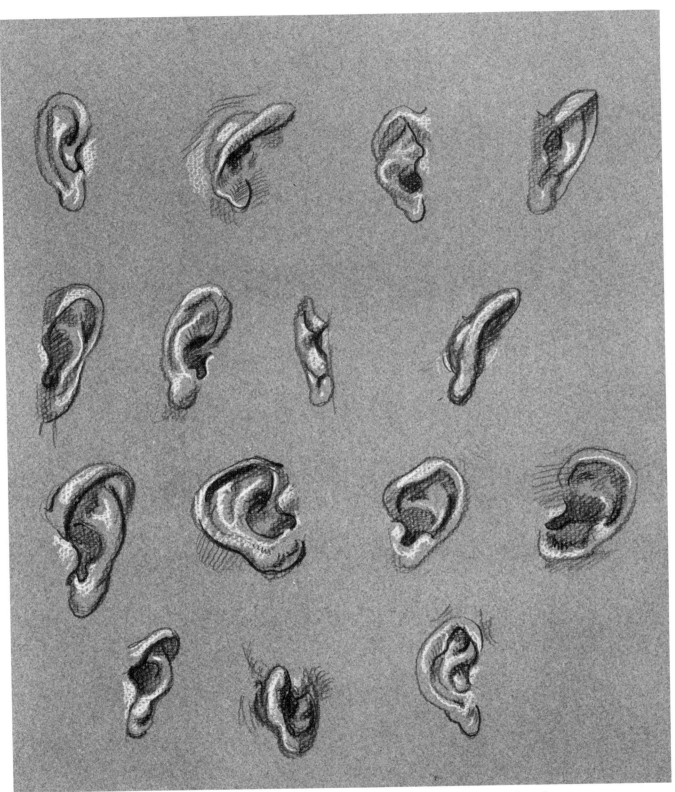

Ears vary in size: medium, small, or large. And in shape: round, oval, or triangular.

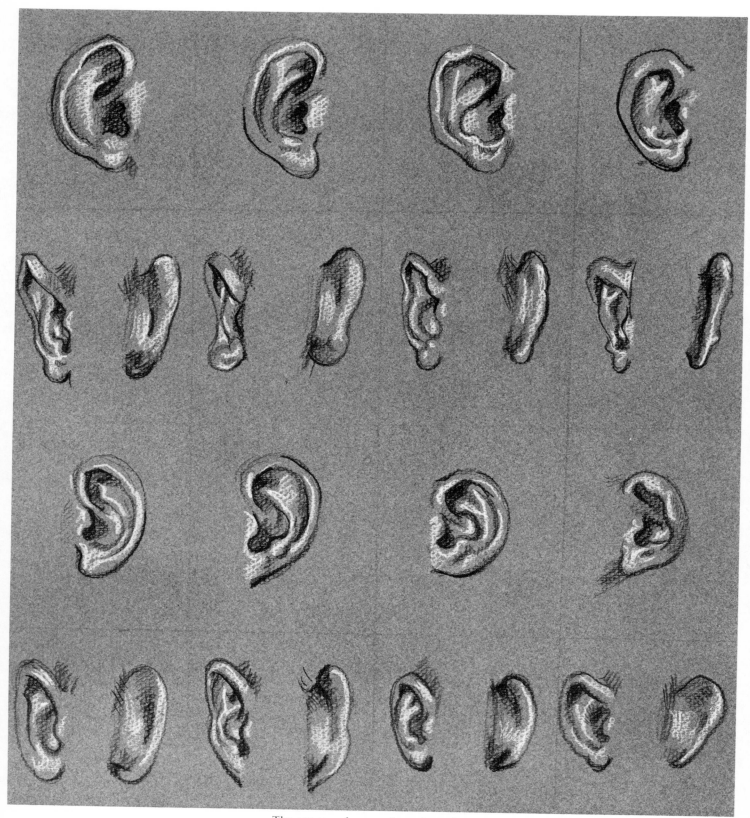

The ear seen from various viewpoints.

The Nose

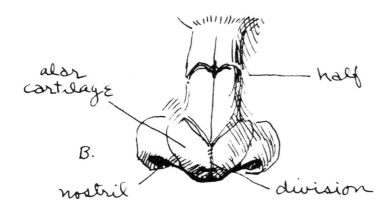

(A) The nose wedges out from the nasal eminence. The angle of the nasal bone has much to do with the shape of the nose. It determines whether a nose is "Roman," pug, hooked, or one of many other types. Except for the nasal bone and nasal spine, the rest of the nose is made up of cartilage.

(B) The two alar cartilages meet at the center of the apex and their division can often be seen. They circle back and form the outer edge of the nostrils. The nasal bone stops about halfway down the nose.

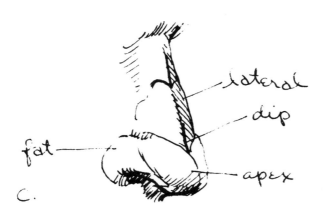

(C) The two lateral cartilages form the sides of the nose between the nasal bone and alar cartilages. They make the nose more narrow at, and their silhouette dips slightly toward, the apex. The outside part of the alar cartilage has a layer of fat that gives it a more rounded appearance.

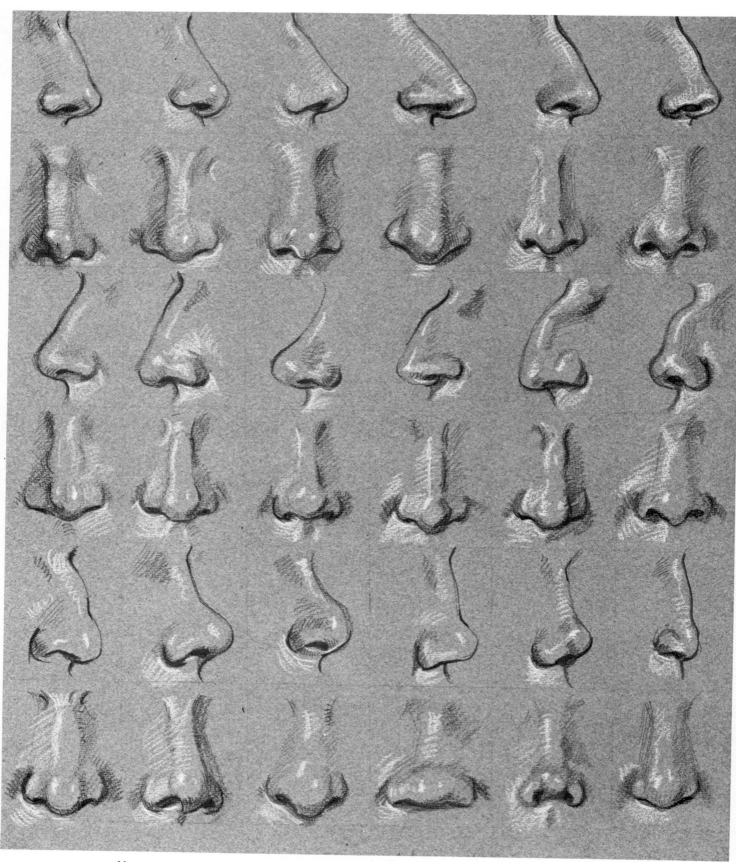

Noses vary, and may be small, medium, or large; concave, convex, or a number of other shapes.

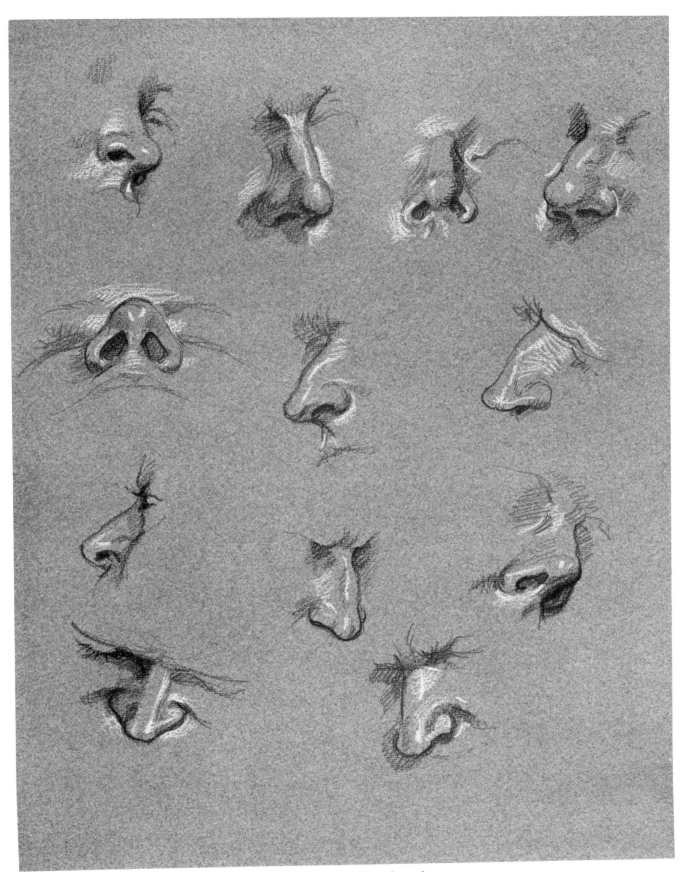

Noses seen from various viewpoints.

The Lips

(A) The lips are the most flexible feature of the face. The red margin of the upper lip consists of a central wedge shape and two curled wings that recede into dimples at the corners of the mouth. The lower lip has a center groove and two rounded lobes. It is not as long as the upper lip.

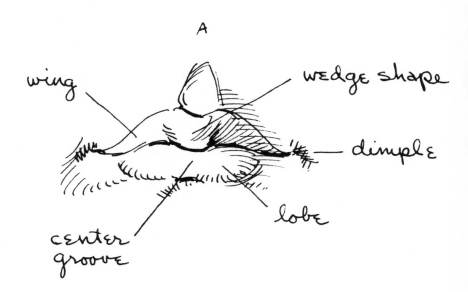

(B) The upper lip usually protrudes over the lower. This is not necessarily true of non-Caucasian facial types.

(C) There is an oblique groove, called the philtrum, starting at the nasal spine and broadening to the upper lip.

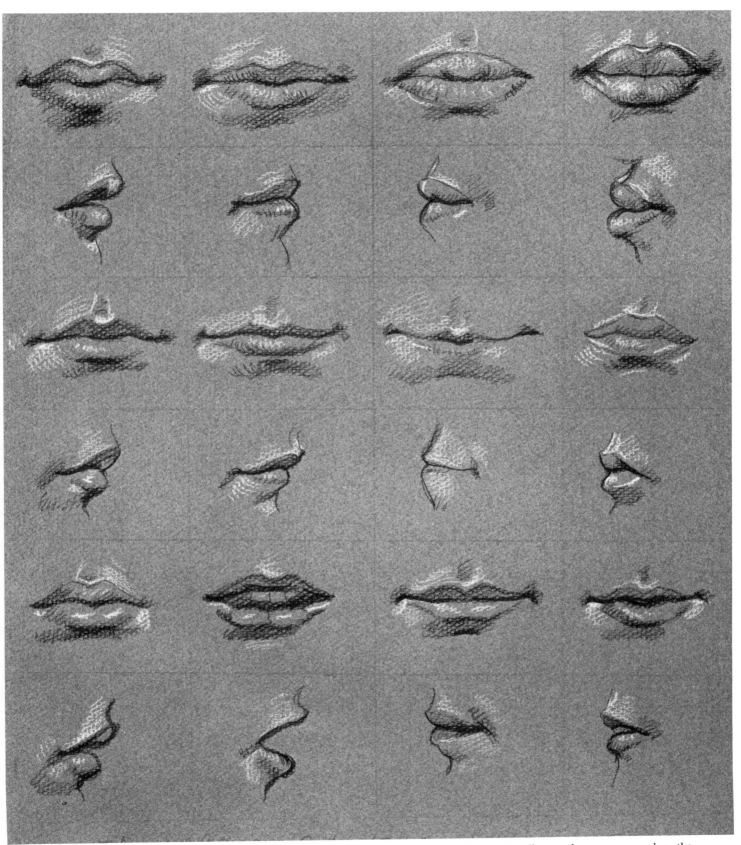

There are many variations in lips, from thick to thin, wide to narrow, protruding to receding, and many more; also, the same lips change constantly as they take on different expressions.

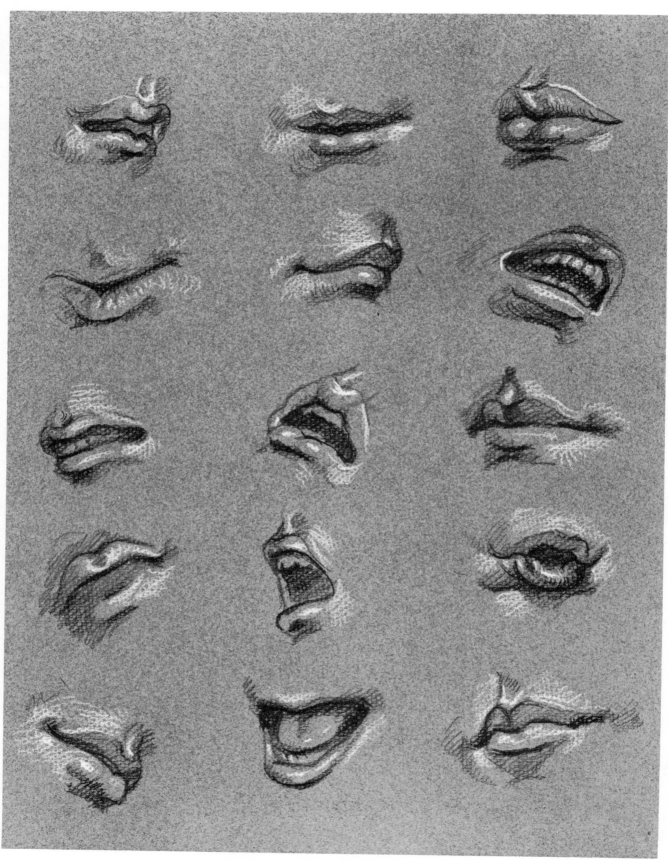

Lips seen from various viewpoints and in different positions.

The Eye

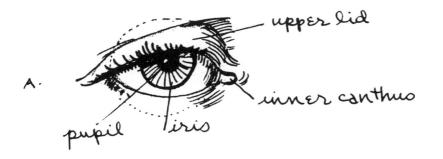

(A) The eyeball is round, like an egg, and the two lids cover it. It sits into the eye socket of the skull. The upper lid is larger and more mobile than the lower. The *inner canthus* is pink and moist, and the eyeball is constantly wet, which gives it a strong highlight.

(B) When the upper lid closes, the form of the eyeball can be seen beneath it.

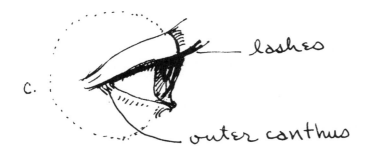

(C) The *outer canthus* ends in a crease where the upper lid overlaps the lower lid. The lashes serve as shades and feelers for protection.

(D) The lower lid is stable when the eye shuts.

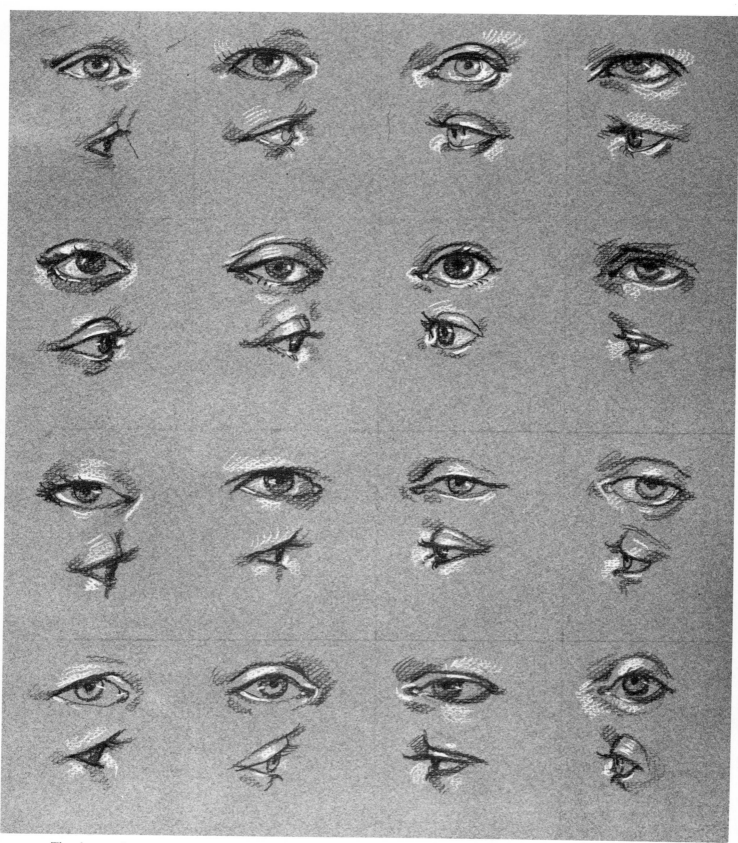

The shapes of eyelids may be thin or thick and the eyes may be close or far apart. The eye slit can be long or short. The iris can be blue, brown, yellow or a green color, but the pupil is always black.

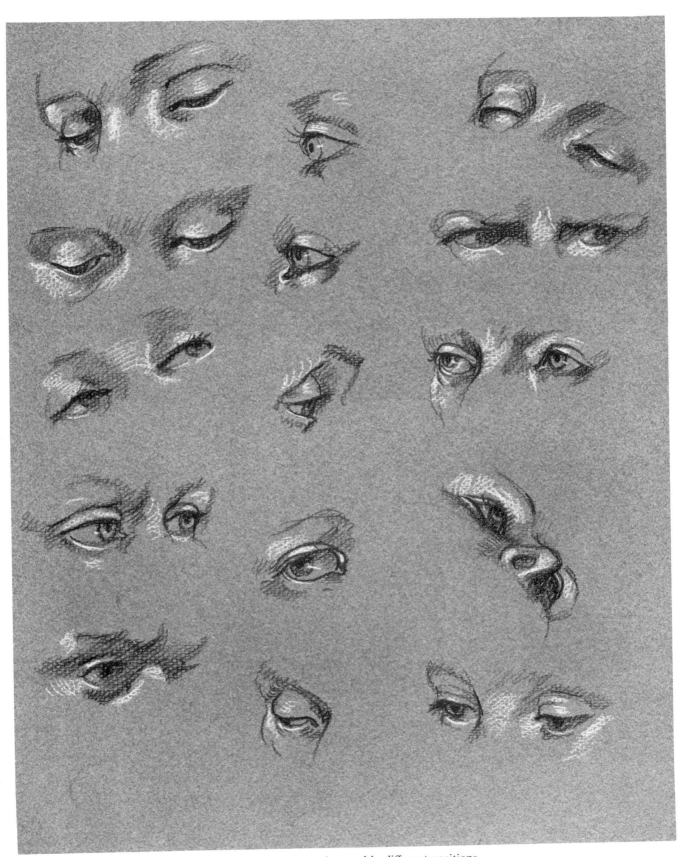

Eyes seen from various viewpoints and in different positions.

The Teeth

There are sixteen teeth in the upper
jaw. The lower jaw has sixteen or
fourteen (the third molar is sometimes
missing in Caucasians). The first two
teeth from the center are *incisors* and
are chisel-shaped. The third tooth
from the center is the *canine,* or cuspid,
and it is sharply pointed. The next
two teeth are *bicuspid*; they are small
and slightly pointed. The next three
teeth are *molars*; they are large but
decrease in size toward the back. The
row of upper teeth overlaps the lower
and is generally more exposed.

There are three areas of the face that control expression: the upper part—forehead, eyebrows, and eyes; the middle part—nose, cheeks, and ears; the lower part—mouth, jaw, and chin. Combinations of muscle actions form the different expressions. The same muscle action in the forehead combined with a different action in the mouth can produce two totally different expressions; for instance, laughing and crying. There is an unlimited number of possible combinations.

Tears can be seen in any number of violent emotions, including coughing, sneezing, yawning, laughing, retching, crying, screaming, and others.

The circulation of blood to the face (blushing) is caused by emotion and accompanies such expressions as love, hate, rage, shame, and embarrassment. Lack of color (pallor) happens when the blood of the face is withdrawn, such as in fear or horror.

Illustrated are some of the more common and obvious expressions.

Severe pain.

Sharp pain.

Anxiety.

Yawning.

Fear.

Scorn.

Contentment.

Remorse.

Happiness.

Crying.

Flirtation.

Ecstasy.

Anger.

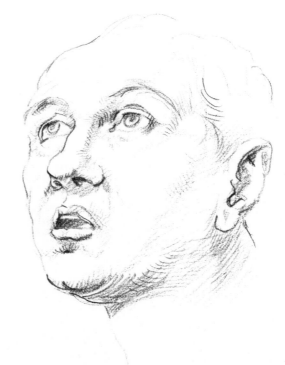

Devotion.

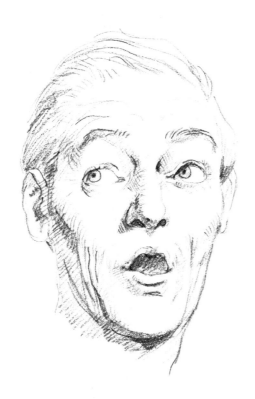

Surprise.

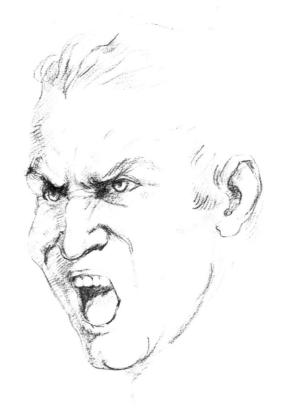

Rage.

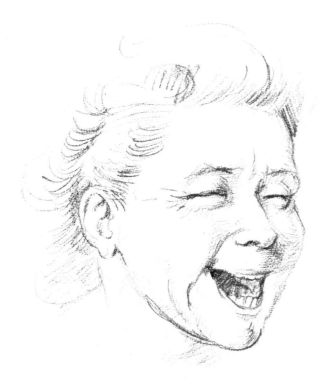

Laughter.

Loneliness.

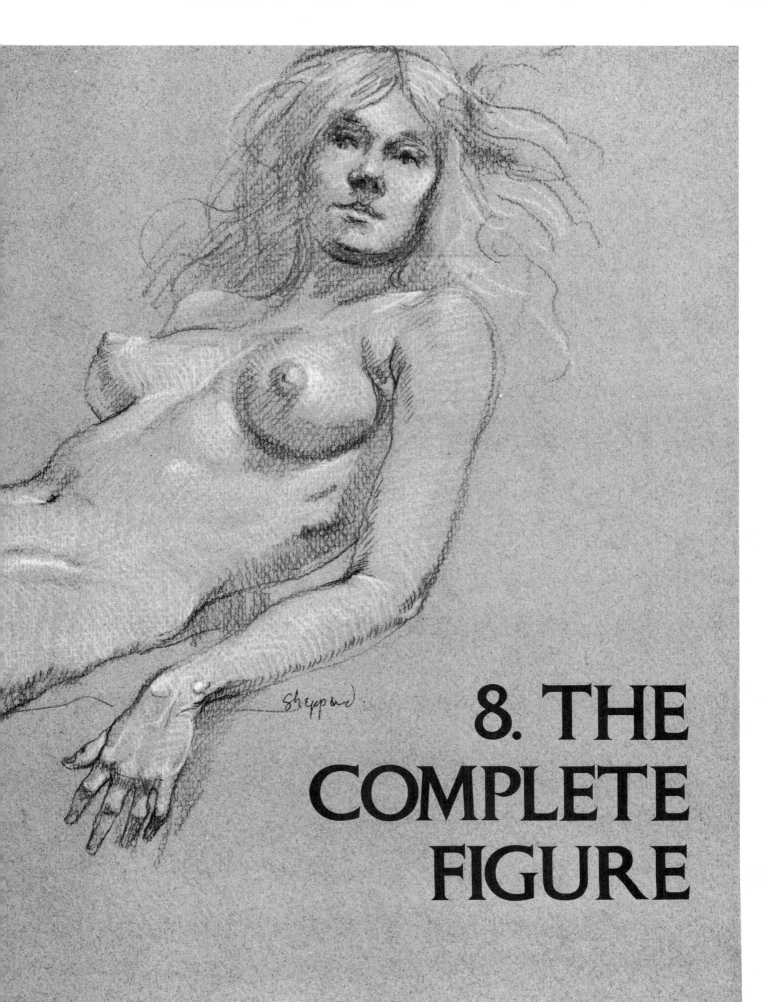

8. THE COMPLETE FIGURE

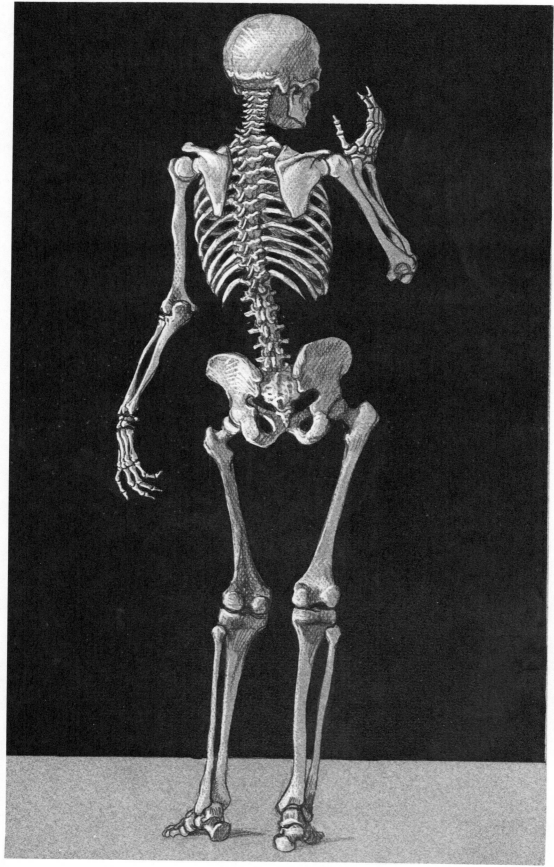

Skeleton, back view.

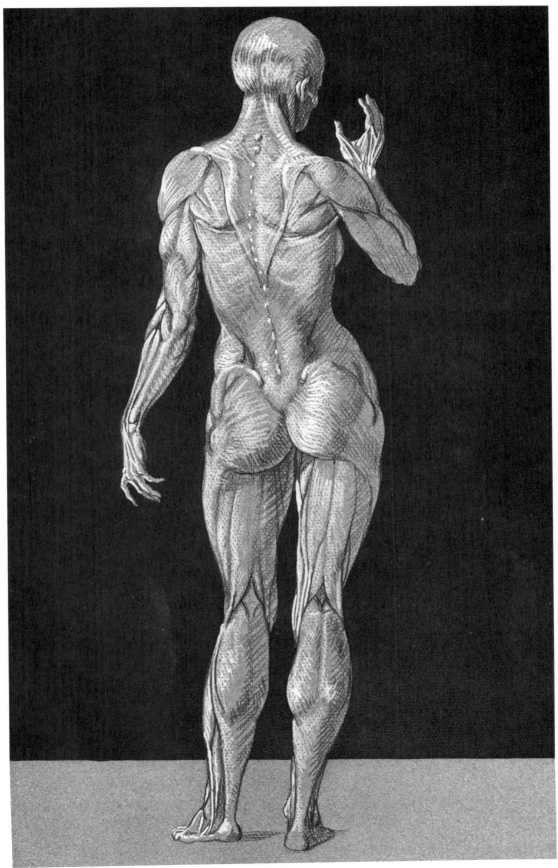

Muscles, back view.

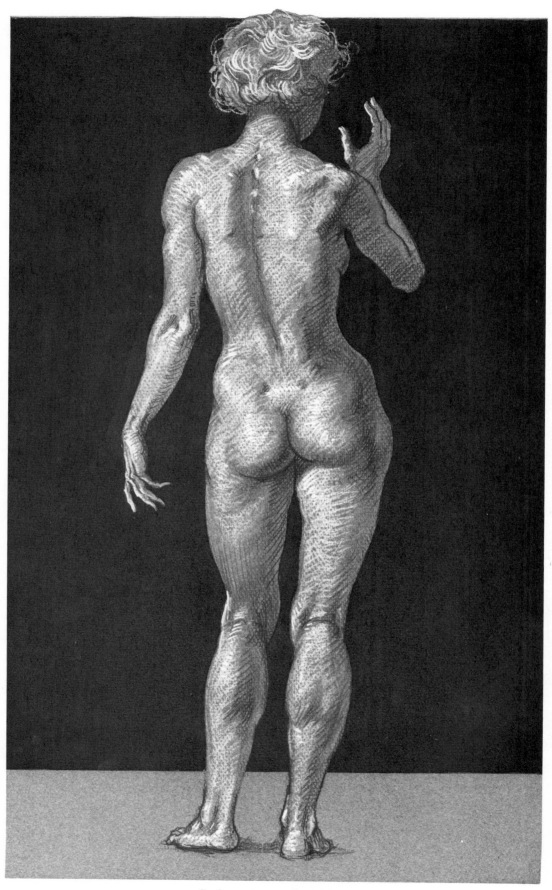

Surface anatomy, back view.

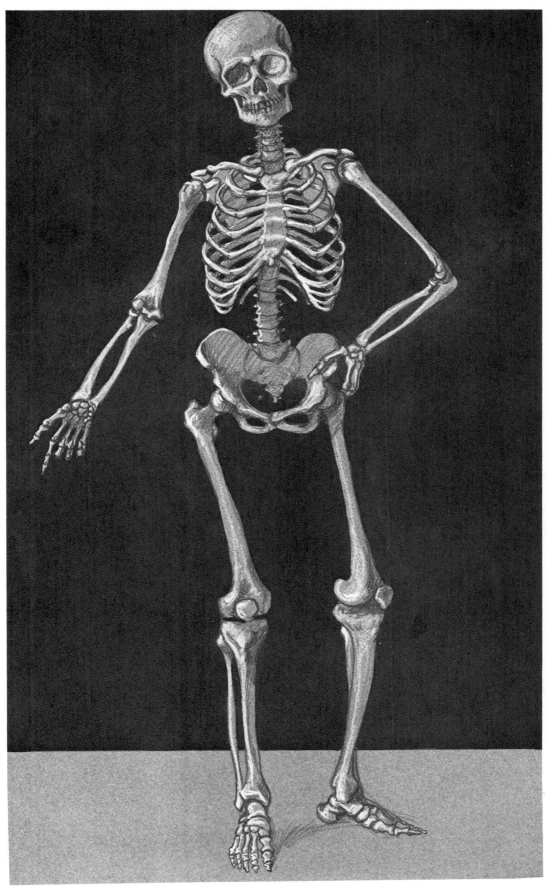

Skeleton, front view.

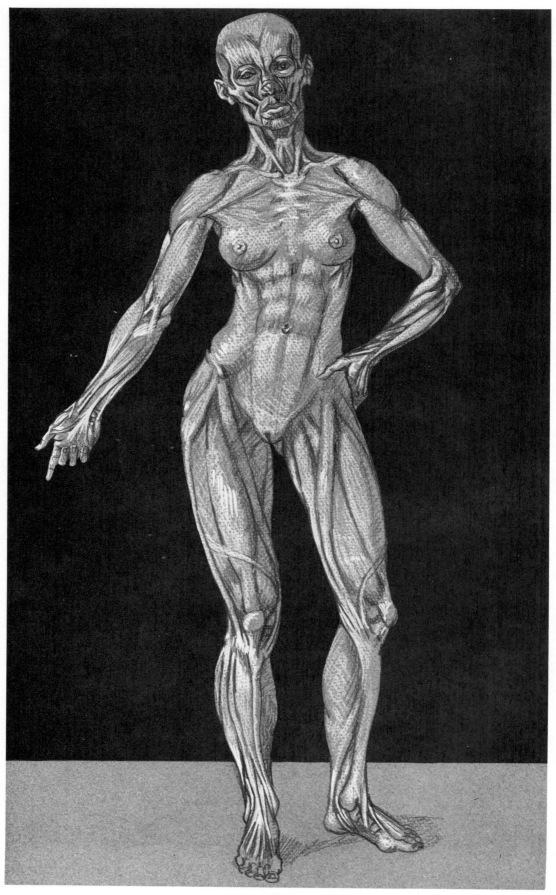

Muscles, front view.

Surface anatomy, front view.

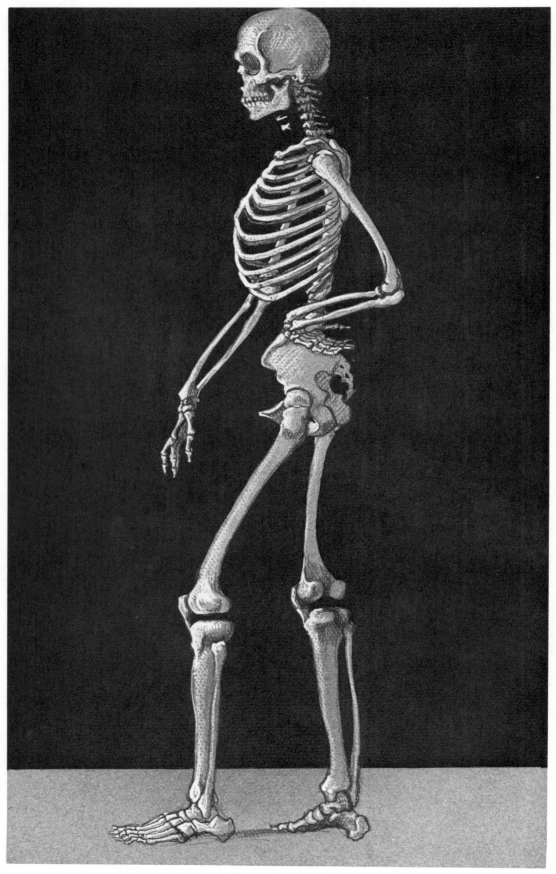

Skeleton, side view.

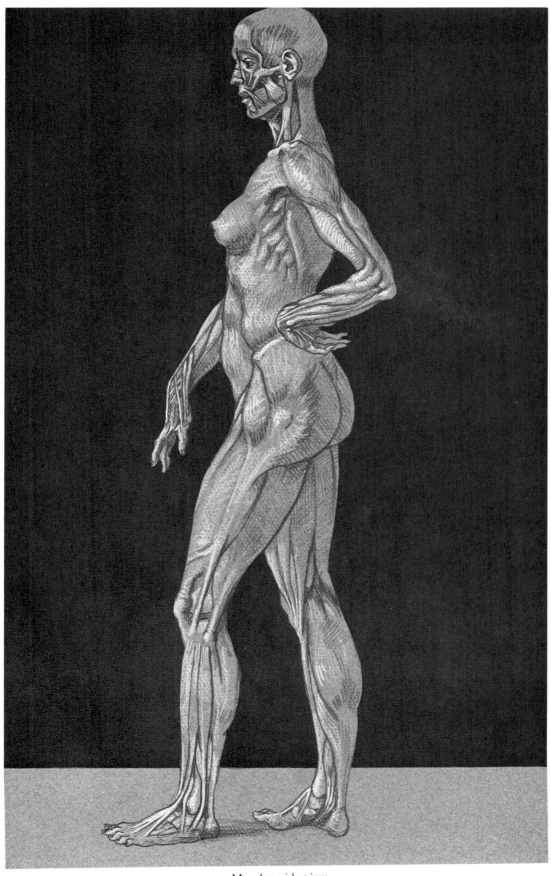

Muscles, side view.

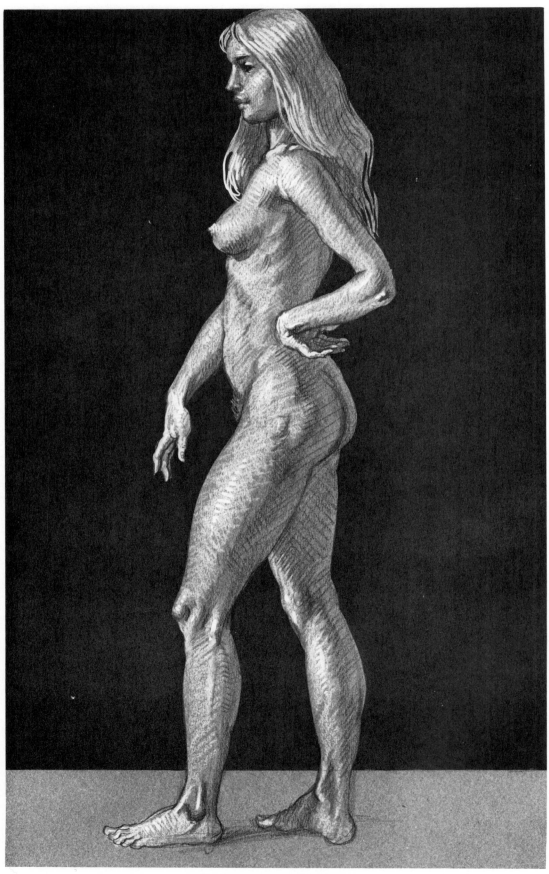

Surface anatomy, side view.

VEINS

The superficial veins are found immediately beneath the skin and are evident in several areas of the body. They are blue-gray in color and are like rivers, with tributaries flowing over and between the muscle contours. When circulation is quickened by exertion or excitement, the veins fill with blood and become more obvious on the surface. They are also prominent in the aged.

Key

Head and Face

A. Frontal vein
B. Supraorbital
C. Angular
D. Anterior facial
E. Superficial temporal
F. Posterior facial
G. Posterior auricular
H. Occipital

Neck

I. External jugular
J. Internal jugular
K. Anterior jugular
L. Posterior external jugular

Torso

M. Lateral thoracic
N. Superficial epigastric

Leg

O. Great saphenous
P. Small saphenous

Arm

Q. Cephalic
R. Basilic
S. Vena mediana cubiti
T. Accessory cephalic
U. Median antibrachial

Hand

V. Dorsal venous network
W. Venous arch

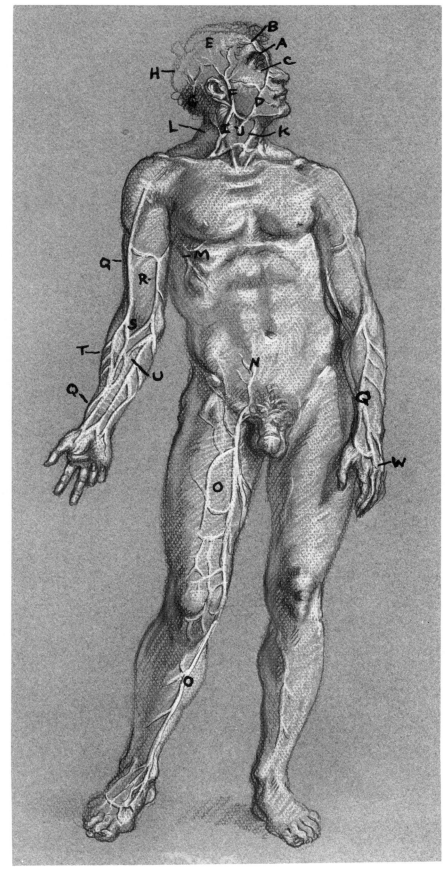

Front view.

Veins

Key

P. Small saphenous
Q. Cephalic
S. Vena mediana cubiti
T. Accessory cephalic
U. Median antibrachial
V. Dorsal venous network
W. Venous arch

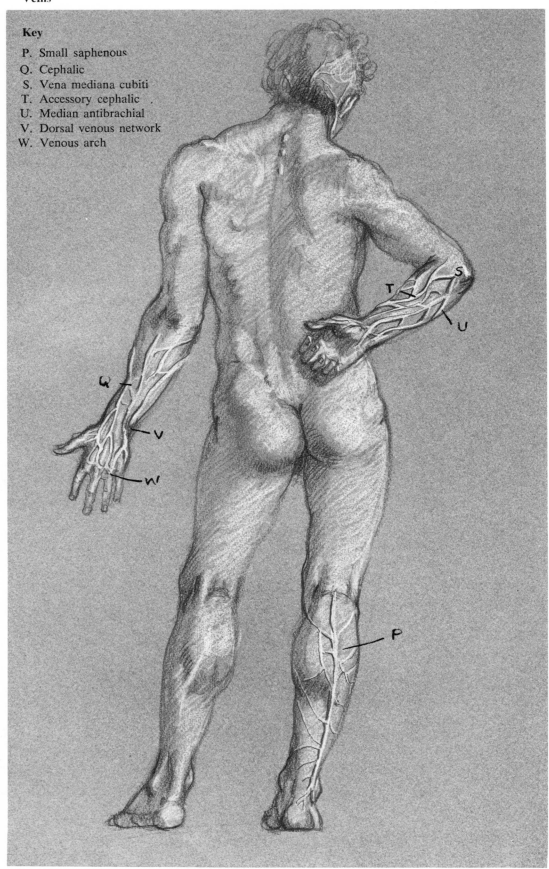

Back view.

Sheppard